THE MOST
INFLUENTIAL WOMEN
OF OUR TIME

WHITE STAR PUBLISHERS

Project editor
VALERIA MANFERTO DE FABIANIS

Graphic design
MARIA CUCCHI

THE MOST INFLUENTIAL WOMEN OF OUR TIME

Text

CHIARA PASQUALETTI JOHNSON

Contents

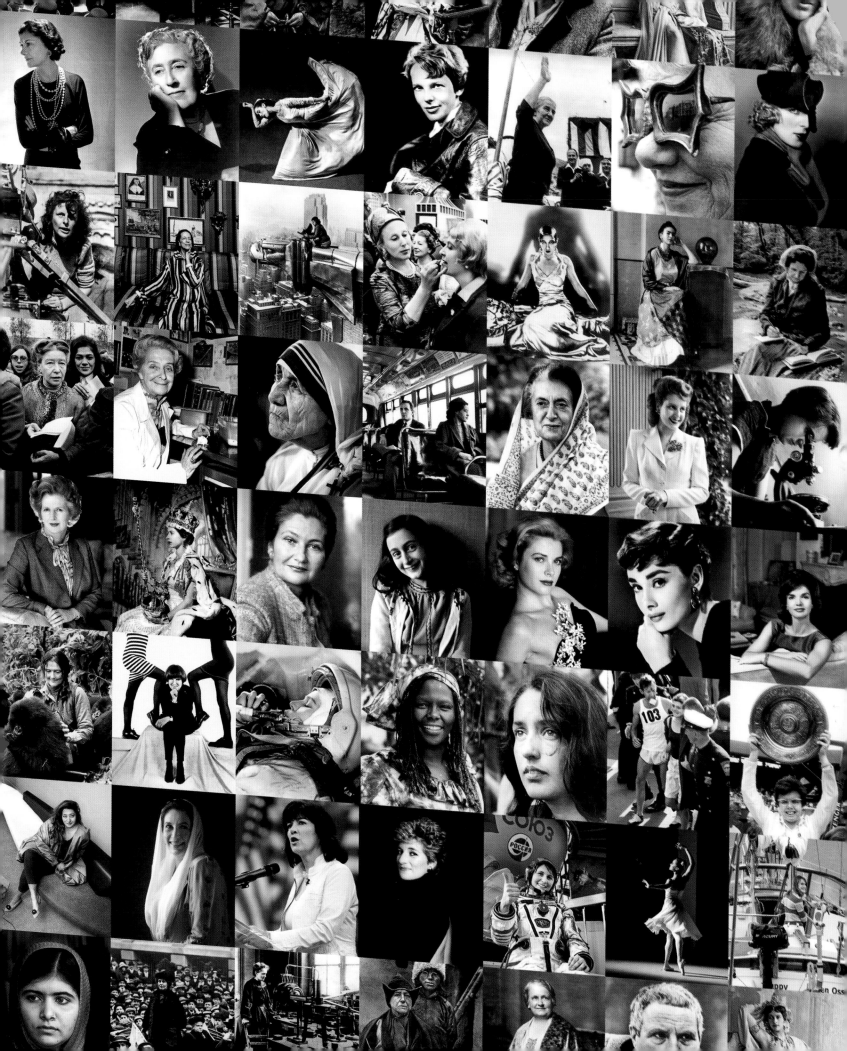

Introduction

The 20th century is the century of women. It is the century during which, more than in any other century, women raised their heads high, bared their teeth and stood up for their rights in any way possible. Today many of their conquests, such as the right to vote or to attend university, are taken for granted by most of the Western world. But this would not be the case had there not been other strong, creative, and courageous women a century ago who paved the way for epoch-making changes. Through their extraordinary lives they contributed to making history with a capital H, integrating themselves with grace and pride into a chronicle that had always been the prerogative of men, an infinite number of generals and dictators, presidents and scientists, inventors and artists. In the last 100 years, things have changed at lightning speed, and a multitude of exceptional women have overcome centuries of prejudices and rewritten the rules of our society with disruptive force. Thanks to these icons and their example, other women who came after them found it a bit less difficult to make their way, bequeathing to the world the fruit of their knowledge, experience, and imagination.

We have chosen 50, but the number could have been 100 or 1000 times more. Choosing them was a real challenge and triggered a seesaw of additions and deletions that not everybody will agree with. The women in this book are not necessarily the most famous figures, or those above all sorts of criticism, but they are certainly the ones who, with their example, still inspire new generations to become better.

They come from different continents; their skin color varies considerably; they are atheists, agnostics, Christians, Muslims (with or without a veil), or Jews; and scientists, artists, sportswomen, authors, politicians, actresses, and journalists – all exceptional, each in her own way. They are exceptional in their shortcomings as well, because they are real persons, not heroines in romantic novels. They are authentic, just like their life stories, which do not always have a happy ending because the stories are true and rightly narrate both success and failure – as well as enormous effort. Besides cultivating their creativity and talent (and at times their great power and world fame), these women

always had to come to terms with their daily life – as mothers, wives, and daughters. In fact, while it is true that "behind every great man there is always a great woman," the converse is certainly not always true, and many of our women could count only on themselves, often having to struggle with obtuse and reactionary fathers or egotistic and unfaithful husbands.

Looking through this book, you will see their faces one after the other in an array of photographs ranging from the grainy black-and-white ones dating to the late 19th century, to the vivid high-resolution pixel images of today. As in a movie, these fifty lives are depicted with broad strokes in the brief texts – written not as biographies but with the aim of stimulating the readers' curiosity and inviting them to delve deeper – that comprise the mosaic of the great events of the last 100 years, as viewed from the "other half of the sky."

The pioneering spirit, visionary courage, and female passion celebrated in this book began on the streets of London, the most modern European capital in the early 20th century, where women could be queens but did not have the right to vote. This injustice was remedied thanks to the battles waged by the suffragettes, whose leader was the indomitable Emmeline Pankhurst.

The path to emancipation in the last century also concerned scientific discoveries, and for women scientists, it was an uphill struggle in a period when female university students could be counted on the fingers of one hand. Such luminous stars as Marie Curie, whose life was spent among phials and test tubes, were sustained by immense willpower. But she is not the only one. The list also includes the biologist Rachel Carson, the first person to note the damage produced by DDT and pesticides at a time when they were even used for housecleaning, and Rosalind Franklin, the researcher known for her acute intelligence and abnegation, who deserved the Nobel Prize, although no one wanted to acknowledge this. Determined to overcome all prejudice on the part of males, free spirits like Maria Montessori laid claim to women's right to culture and education. These were powerful weapons in the hands of generations of new female warriors who, beginning in the 1920s, fought to have "a room

Introduction

to themselves," such as the novelist Virginia Woolf, who wanted to write without depending economically on a man, or Agatha Christie, who published bestsellers that would be translated more than Shakespeare's masterpieces, breaking all records.

Women triggered revolutions by means of the simple gesture of dipping a pen into the ink of truth. One example is Simone de Beauvoir, who laid the foundation of feminism in her exemplary essay *The Second Sex*; another is Anne Frank with her diary, a remarkable account of family life written to remind us all that we can retain our humanity even when the world seems to be going mad. In this period, art too finally became a "woman's job" thanks to Tamara de Lempicka's transgressive grit and the passionate nature of Frida Kahlo, whose self-portraits ended up obscuring the fame of her partner Diego Rivera, the most famous painter in Latin America. And precisely at this time, Peggy Guggenheim overturned the rules of art collecting by purchasing "one painting a day" from avant-garde artists whose worth she understood long before anyone else – indeed, she even married two of them.

In the 1950s, Hollywood stars were the ones who showed the way to a new type of femininity, more audacious and aware than ever. The cinema became the platform that immortalized such household names as Audrey Hepburn, as generous as she was beautiful, capable of transforming her fame into a powerful tool to help others (her work for UNICEF was remarkable) while retaining her sublime grace, becoming an ideal role model for millions of other women.

But the true revolution took place in the 1960s, the period of the pill, feminist demonstrations, and Mary Quant's miniskirt. Women monopolized everything, even space: in 1963, Valentina Tereshkova waved to the Earth from her Vostok 6 spacecraft, the first woman to achieve this historic feat. Many others followed her, as proof that the difference is not between men and women but, as the astronaut Samantha Cristoforetti stated, "between those who are competent and those who are not." As the century approached its final phase, the "confrontation" between men and women took place more and more on an equal footing. On the tennis court, the "Battle of the Sexes" ended with Billie Jean King defeating a former male champion (and male chauvinist), while it was the famous journalist

Christiane Amanpour who reported the horror of war on the front line. There was a surge of femininity even on building sites, thanks to the star architect Zaha Hadid, who prevailed in a world of male architects and engineers.

These women are the tip of the iceberg of a cultural revolution that saw millions of women rebel against a passive existence and being relegated to predetermined roles, women who were often the protagonists of adventures and achievements that were out of the limelight. We do not want to reveal anything in advance in this introduction, but leave you the pleasure of discovering the incredible achievements of personalities such as Alexandra David-Néel, Wangari Maathai, and Laura Dekker.

Owing to a twist of fate, or due to affinity, at times the paths of these exceptional women crossed. For example, Grace Kelly and Joséphine Baker were antiracists who became friends; in fact, the princess gave the Black Venus a house along the French Riviera where she could live with her "rainbow tribe," twelve children of different origin and religion whom she had adopted. History also linked the destinies of Coco Chanel and Jackie Kennedy: the First Lady wore one of Mademoiselle's creations the day her husband was assassinated in Dallas. That pink suit covered with blood became a symbol, "the most legendary article of clothing in American history," as the newspapers wrote. Queen Elizabeth II and the Iron Lady Margaret Thatcher were two women in positions of power who did not like one another but met frequently for years, without ever expressing their opinions of each other, since their character was much more akin to formality than to feelings. Lady Diana and Mother Teresa represented two worlds that were very distant yet became incredibly close. They supported one another in the latter part of their lives, sparking quite a buzz among the media, and died only five days from one another. Lastly, an item of clothing links Benazir Bhutto and Malala Yousafzai. While she was speaking at the United Nations, the girl who survived the fury of the Taliban wore a pink foulard that had belonged to the Pakistani leader who was brutally assassinated seven years earlier, thus symbolically sharing with her not only the foulard, but also the same disruptive power of femininity that is truly capable of changing the world.

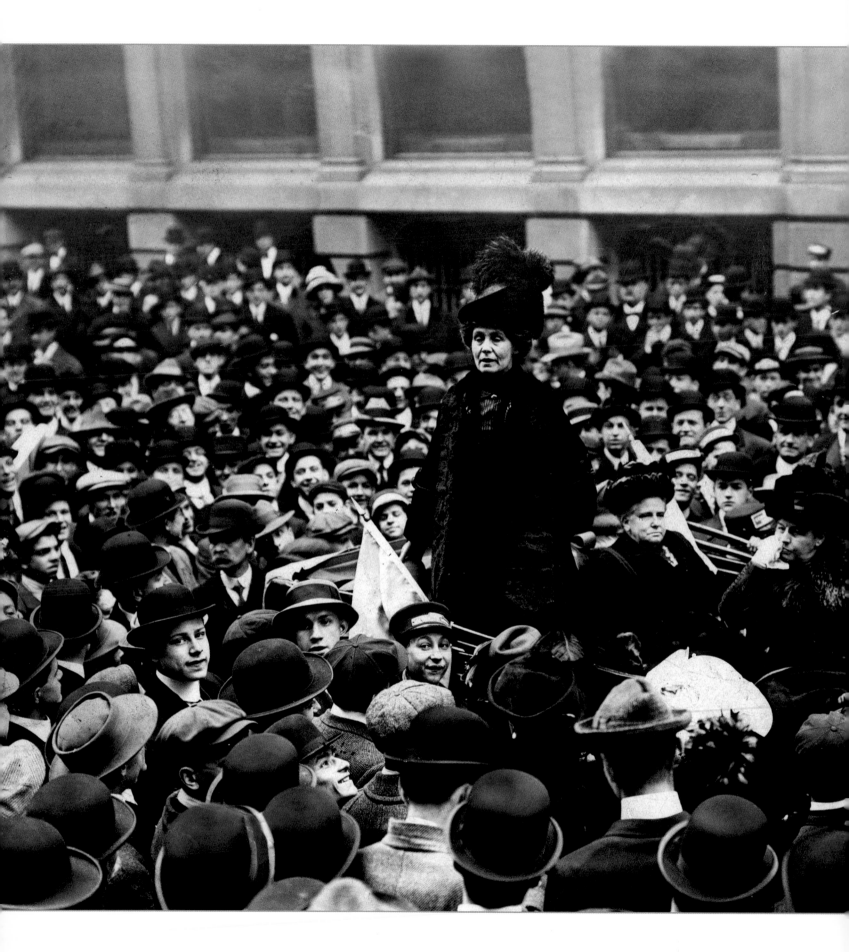

July 14th, 1858, Moss Side, Manchester, United Kingdom • June 14th, 1928, London, United Kingdom

Emmeline Pankhurst

She struggled together with the suffragettes to give women the right to vote by using a strategy worthy of a revolution and an army whose weapons consisted only of hats and handbags. Her rallying cry, "I would rather be a rebel than a slave," jolted society and inspired millions of women.

A multitude of apparently innocuous but unexpectedly aggressive women gathered in a march along the streets of London in the early 1900s. Their gaze was directed at a dainty woman who was exhorting the crowd to demand what they were entitled to have – the right to vote. She was soon immortalized in photographs on the front page of all the newspapers, together with her followers, the suffragettes. In no time at all, Emmeline Pankhurst became the symbol of the struggle for equal rights, a passionate mission that had become irrepressible when, as a young girl pretending to sleep one evening, she heard her father whisper: "If only she had been born a lad." She made the conquest of women's rights her very own battle, defying English politics, which allowed women to be queens, but not to vote.

After holding rallies throughout the United Kingdom, Emmeline Pankhurst began to travel to deliver her message outside Europe, in Canada and the United States, where she gave one of her most famous speeches, Freedom or Death. Here she is seen speaking in New York City, in 1913.

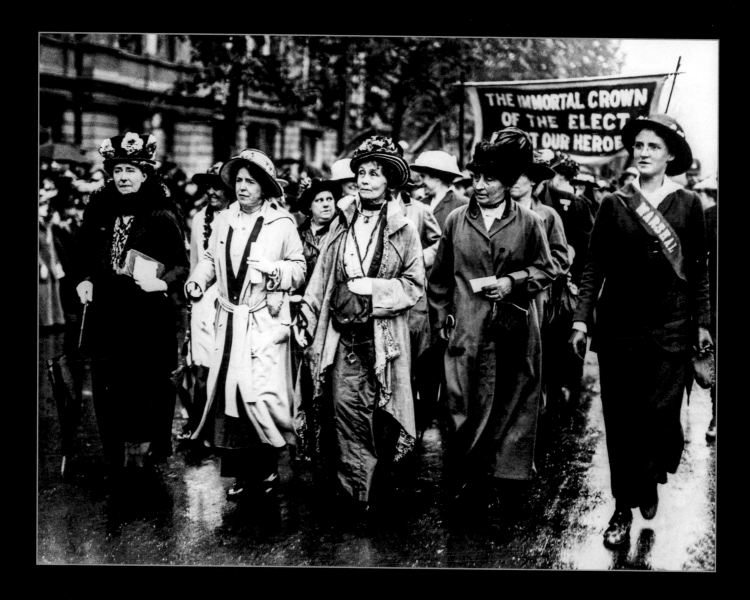

12 Emmeline Pankhurst (third from the left) leading the huge protest march along the Victoria Embankment to ask the British government to be able to replace the munitions factories workers who had been sent to the front. The protesters included mothers and workwomen, as well as exponents of London's upper middle class and aristocracy, who made a decisive contribution to the suffragette cause by financing the movement and putting great pressure on the most influential politicians.

13 A newspaper photograph of the police arresting Pankhurst and other suffragettes in 1908. Press coverage was indispensable for them, as they aimed at having their sensational protests on the front pages in order to influence public opinion. In fact, it was a journalist, Charles Hands, who coined the term "suffragette", in the *Daily Mail* of January 10th, 1906, when referring to the militant women.

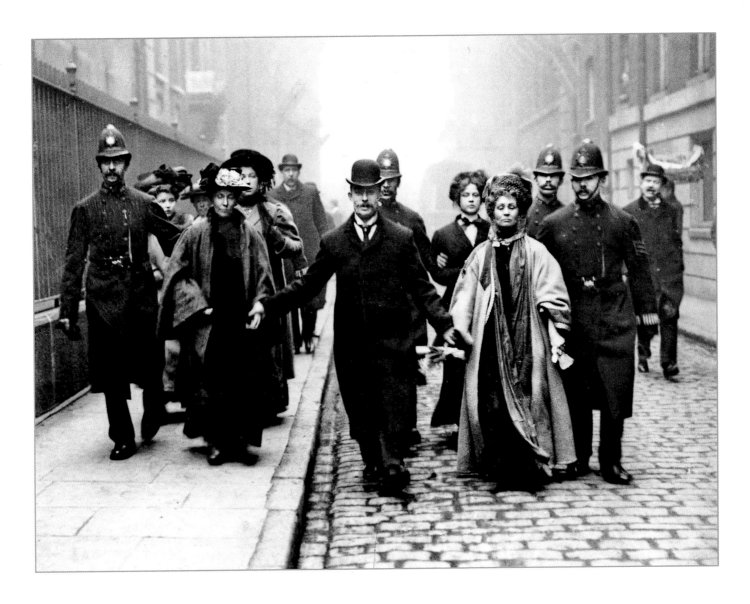

The government responded to the first demonstrations by using tubes to force-feed the demonstrators on a hunger strike. But it grossly underestimated the overwhelming sympathy elicited by those charming ladies, who surprisingly proved quite capable of tossing stones against government buildings and smashing shop windows. "These are methods such as have been adopted by men in every revolution," declared Emmeline, who was jailed and released time and again and who replied to the judges without lowering her gaze: "We cannot make any orderly protest because we lack the means whereby citizens may do such a thing: we have not a vote…" The English suffragette cause enjoyed its first victory in 1918, when married women over 30 were given the right to vote, but the struggle for universal women's suffrage ended in victory only in 1928. Emmeline was not able to see her dream come true; she died a few days before the Equal Franchise Act was passed, leaving behind three daughters, all activists, and millions of new women voters.

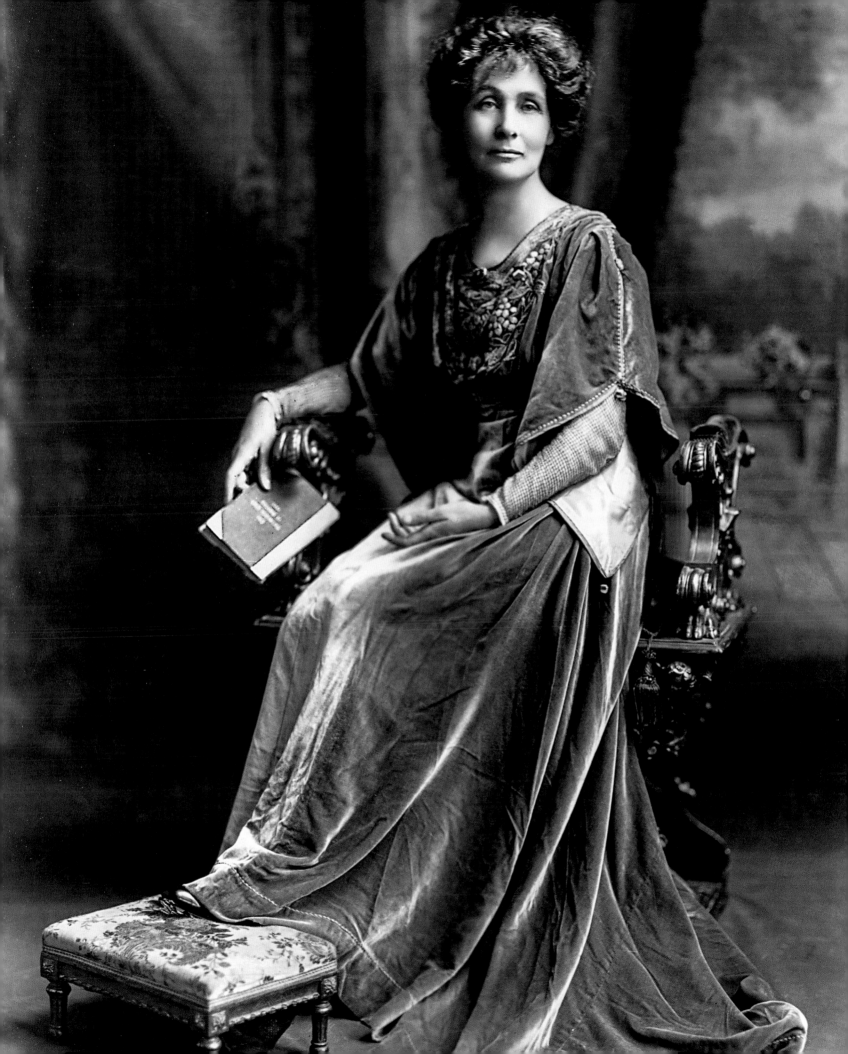

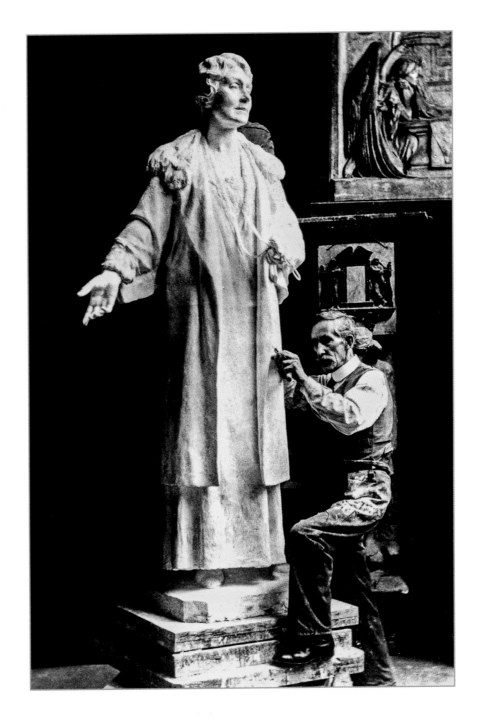

14 Raised in a family of political activists, in 1879 Emmeline Goulden married the lawyer Richard Pankhurst, a fine orator and advocate of equal rights. After his death, in 1898, she carried on the political activity she had begun with her husband, flanked by her daughters Christabel, Sylvia, and Adela.

15 Shortly after her death, the suffragettes were successful in having a monument created in her memory. Her statue, sculpted by Arthur George Walker, was inaugurated in 1930 and placed in a corner of the Victoria Tower Gardens, near the British Parliament.

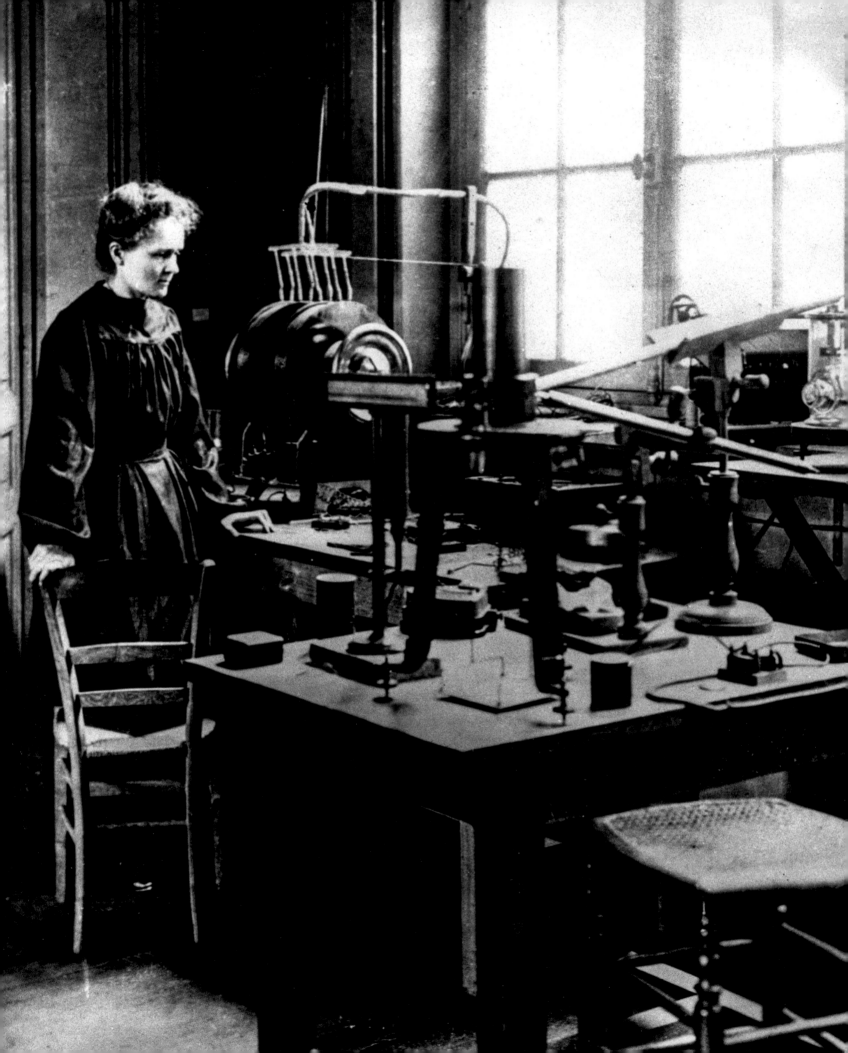

Marie Curie

Knowledge is a path leading to liberty, and research is a conquest to be shared by all humanity, because, as Marie Curie, the record-breaking scientist, once said, "Nothing in life is to be feared, it is only to be understood."

She was the first woman to earn a degree in physics, the first to teach at the Sorbonne, the first to win the Nobel Prize and to this day is the only person to have won a Nobel Prize in two different sciences. No one else was so able to show women the luminous and revolutionary path leading toward emancipation, paving the way with silent rebellion, single-mindedness, and great determination. The youngest child in a family of brilliant minds, at the age of four Maria Sklodowska had already learned to read by herself, was a prodigious student when only ten, and at the age of fifteen realized to her dismay that she could not continue her studies, as advanced study was forbidden for women by the tsarist regime that ruled this part of Poland. Consequently, she made an agreement with her sister Bronya. The latter went to Paris to study medicine, and Maria put her through school by sending her part of her earnings as a governess, and then Bronya in turn would support her younger sister when she was able to escape from the oppressive atmosphere in Poland and go to the French capital. So in 1891, Maria boarded a third-class carriage and spent three days perched on suitcases in order to go to a country where women could study. In Paris, she studied day and night in her tiny room, which had only a folding bed, a table, and a chair. She changed her name to Marie and struggled hard to learn French, but never lost sight of her objectives: a degree in physics and, without further ado, another in mathematics.

When she was introduced to Professor Pierre Curie, she immediately knew she had found her soulmate: "Soon he caught the habit of speaking to me of his dream of an existence consecrated entirely to scientific research and he asked me to share that life with him." Together they pursued the ideal of science understood as progress of humanity, based on a model that today could be called "open source."

For years, Marie Curie, seen here in her laboratory, had carried out her research without adequate equipment, and only in 1909 did she succeed in creating, at the Sorbonne University, the Institut du Radium, now known as the Institut Curie, a center of research on radioactivity and its applications in the field of medicine.

November 7th, 1867, Warsaw, Poland • July 4th, 1934, Passy, France

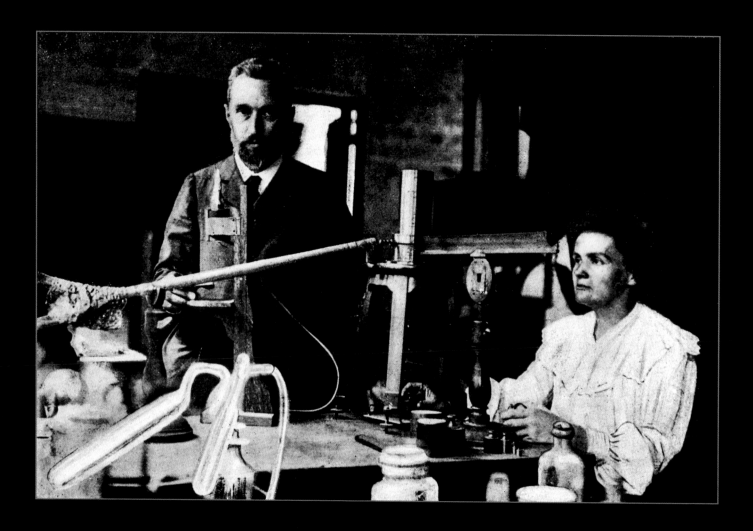

18 When Pierre learned he was a candidate for a Nobel Prize, he wrote to the Nobel Committee, stating that he would accept the prize only if his wife was also selected as a candidate with him. They both won the award in 1903, together with a colleague, Becquerel. But, because she was a woman, Marie was never admitted to the Académie Française des Sciences.

19 In the early 1920s, Marie Curie was an international celebrity. She had already won the Nobel Prize twice, was one of the very few women engaged in scientific research, and was a veritable icon of dedication and experimental acumen. In 1921, she went to the United States to raise funds needed to continue research on radium and was given a triumphal welcome wherever she went.

Marie Curie

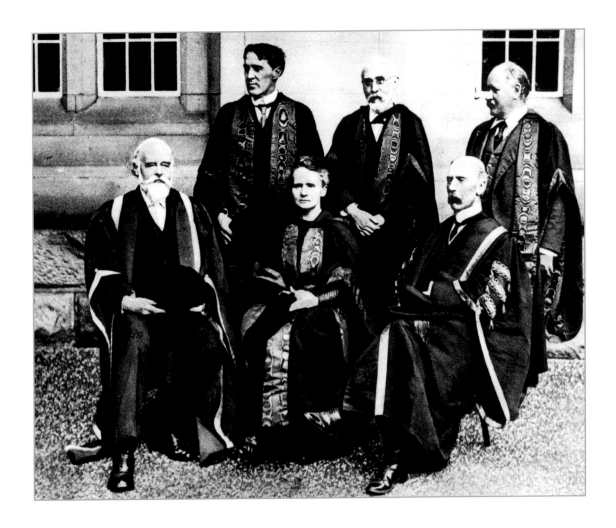

When they discovered radium, they refused to patent its production process. "We worked in the interest of science. Radium is not meant to enrich anyone. It is a chemical element, it is for all people." Unaware of the risks they were taking, in the evening the couple went to their shed-laboratory to observe radioactive emissions. "An enchanting and ever new spectacle. The luminous test tubes radiated lights, like fairies and phantoms," she wrote in her diary, which, like all her laboratory notes and even her cooking recipes, are now kept in lead containers in order to house the radiation absorbed during the Curies' experiments. Sadly, it was precisely radiation that led to Marie Curie's untimely death. However, she still had time to found the Curie Institute, create mobile X-ray ambulance units for wounded soldiers in World War I (the "petites Curies"), one of which she herself drove. She won a second Nobel Prize (in chemistry) in 1911, and had a daughter, Irène Joliot-Curie, who also won a Nobel Prize in chemistry.

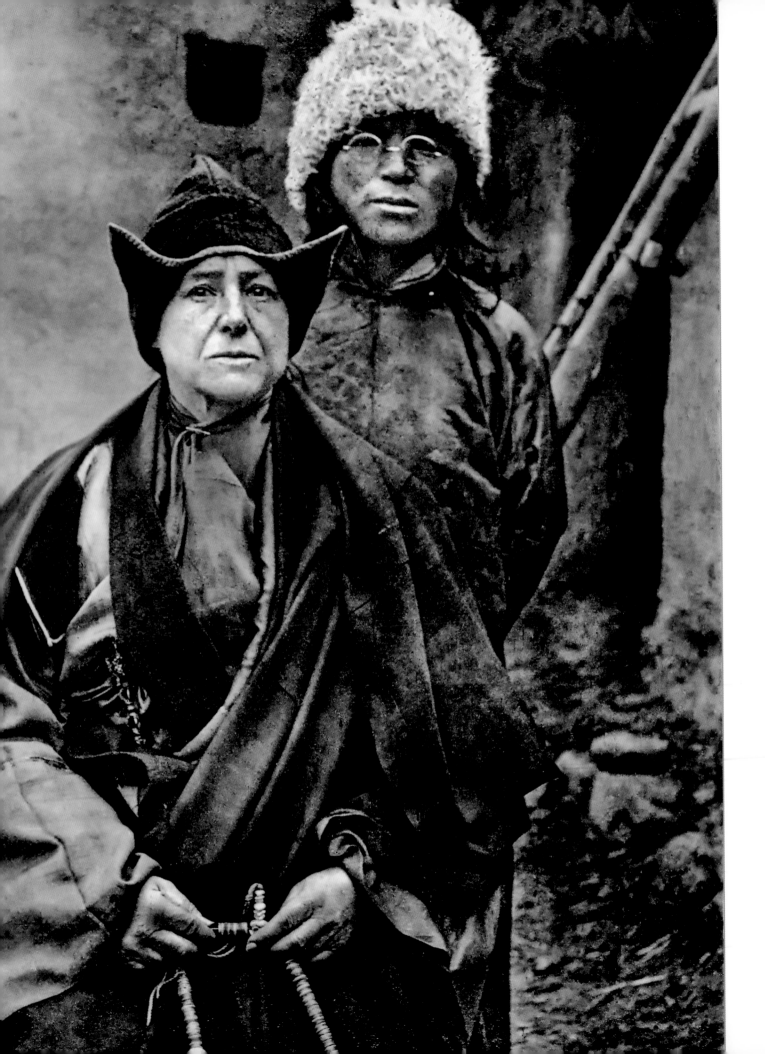

October 24th, 1868, Saint-Mandé, France • September 8th, 1969, Digne-les-Bains, France

Alexandra David-Néel

When she was 18, she discovered Buddhism and began to travel, without ever stopping. She arrived at the roof of the world, Tibet, achieving a feat considered difficult for men and impossible for a woman.

Alexandra ran away from home the first time when she was three years old. Her nursemaid found her a few hours later, but that act already heralded the restless nature that would make her one of the greatest travelers of her time. When only 18, she had already been to the Netherlands, England, and the Italian lakes; then she cycled for months through France and Spain, before stopping in Paris to study Oriental languages at the Sorbonne, spending hours and hours in the marvelous reading hall of the Guimet Museum, as luminous as the Buddha in meditation that dominates it from on high. This so inspired her that she decided she would become a "Buddhist, feminist, and above all an anarchist, because obedience means death," she wrote in one of her early essays. Thanks to an unexpected inheritance, in 1890 she was finally able to depart for India, where she stayed for a year. She went back there six years after marrying Philippe Néel, head engineer of the French railroad system in North Africa, who said goodbye to her from the terrace of their home in Tunis when Alexandra set off again for the Orient, promising she would return in roughly eighteen months. The trip, which was her most famous one, lasted fourteen years, during which she met Aphur Yongden, a young Tibetan monk who became the companion of her life and adventures, with whom she went to the Lhasa, the "forbidden city" in the heart of Tibet, which foreigners were not allowed to visit. She was 56, and her feat was reported in the international press, including the cover of *Time* magazine. The two would travel together again as far as China on the Trans-Siberian Railway. When Aphur Yongden died, Alexandra withdrew to the soft, rolling hills of Provence to write her travel memoirs. When she reached the age of 100, she asked to have her passport renewed; who knows, there might just be another opportunity to set off once again!

Alexandra with Aphur Yongden, the Tibetan monk who would become her adoptive son with a new name, Arthur David. In 1915 and 1916, they lived for two years in a cave in Sikkim, at an altitude of 13,000 feet (4000 m), before undertaking a long series of trips together.

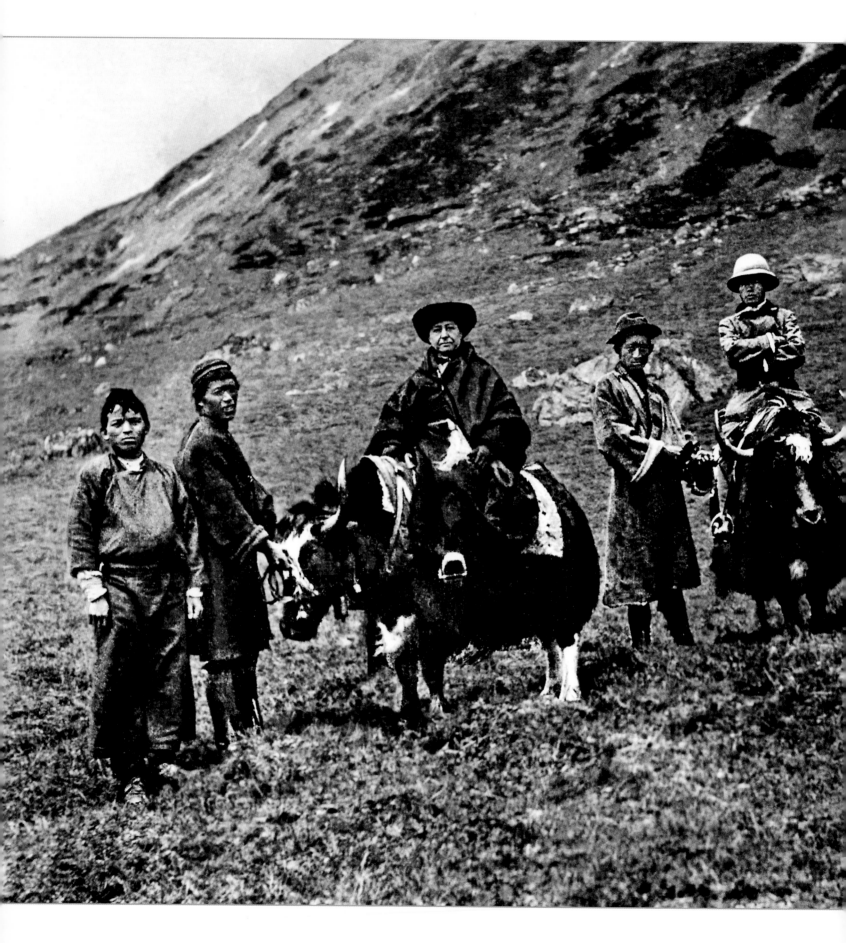

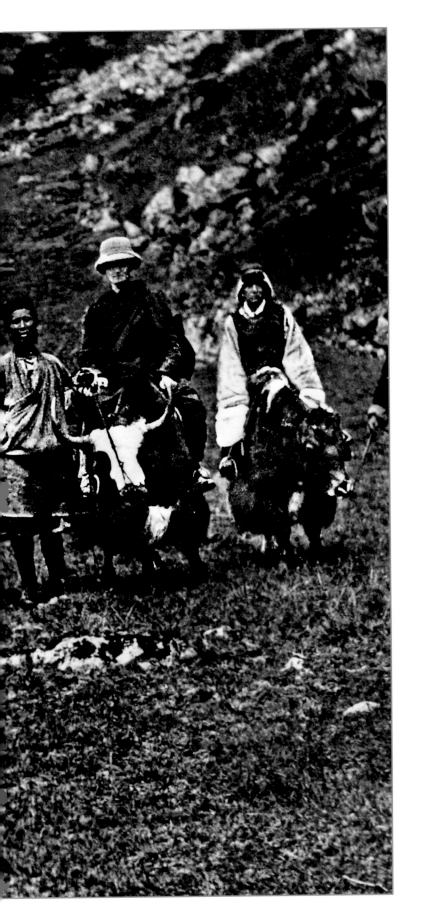

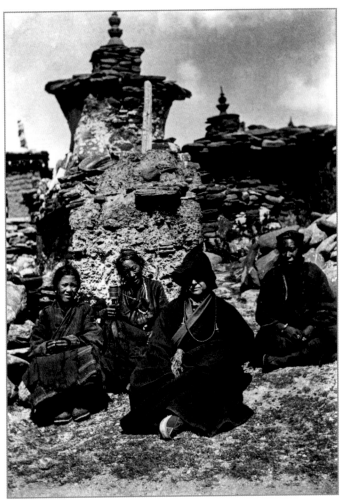

22-23 After walking for about 1200 miles (2000 km), Alexandra David-Néel and Aphur Yongden reached Lhasa in 1924. "*Lha gyalo!*" ("The gods have triumphed!") she shouted, so moved that she cried as they mingled with the crowd of pilgrims. They spent months visiting the holy city and the great monasteries, before being exposed as foreigners because they paid too much attention to personal cleanliness.

23 After a life of travels, Alexandra set about writing more than thirty books, which were a major contribution to the spread of Buddhism in the Western world. Her most famous work is *Voyage d'une parisienne à Lhassa* (My Journey to Lhasa, 1927), the journal of her trip among the mountains of Tibet.

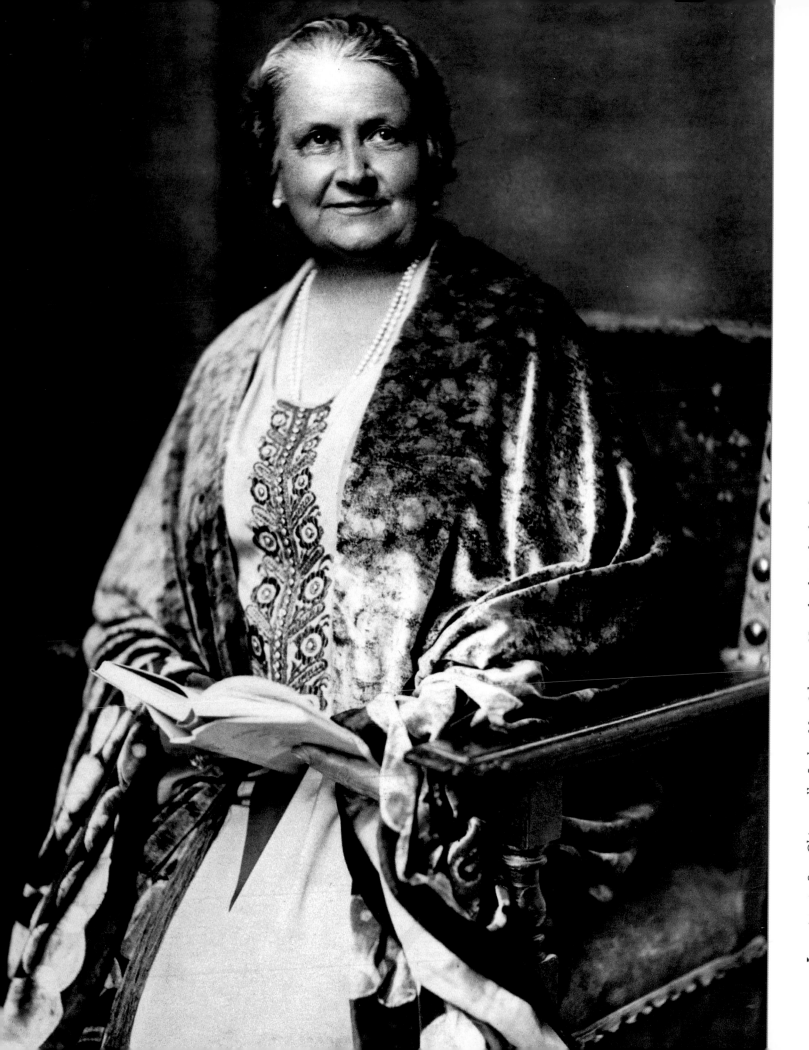

August 31st, 1870, Chiaravalle, Italy • May 6th, 1952, Noordwijk, Netherlands

Maria Montessori

The Great Teacher's pedagogical reform changed the rules of teaching. Her method, famous the world over, was based on a simple but revolutionary concept: "play is a child's work."

What do the founders of Google, Sergey Brin and Larry Page, Bill Gates, Garcia Marquez, the guru of Amazon Jeff Bezos, and the father of Wikipedia, Jimmy Walls, have in common? They all studied in Montessori method schools, which were conceived a century ago by a woman who defied the conventions of her time and created a method of study that has produced geniuses, innovators, and Nobel Prize winners. Maria Montessori revolutionized pedagogy by placing children, their creativity, and individuality, at the core of everything. "Much has been said about the rights of man, especially workers' rights, but the moment has come to speak in favor of the social rights of children," she stated in Rome at the 1907 inauguration of the first of her schools, which were later established throughout Italy and the world. They were called *Case del bambino* or Children's Houses and were luminous and cozy, conceived tailor-made for young children so that they could finally feel free to express their most positive energy. Even more extraordinary was the gamut of didactic material that Montessori developed immediately after earning a degree in medicine (she was one of the three first women in Italy to achieve this) while she was devising new teaching methods designed for mentally disabled children. Thus, she introduced letters made of sandpaper that children could learn to recognize by touching rather than seeing them, since "hands are the instruments of man's intelligence," as well as all the equipment that made the learning process in Montessori schools more like a game than a lesson, under the guidance of teachers able to offer activities related to things and experiences "that children already know." This apparently recreational method is really based on a very serious and far-sighted philosophy, in which every activity leads to the harmonious growth of mind and body, a method that would be confirmed by neuroscience only many decades later.

Since she was opposed by the Fascist regime, Montessori left Italy in 1934 and went to India, where she was revered as the Great Teacher. She traveled quite a lot and died in a small village along the North Sea. The epitaph on her tomb reads: "I beg the dear, all-powerful children to unite with me to build peace among men and in the world."

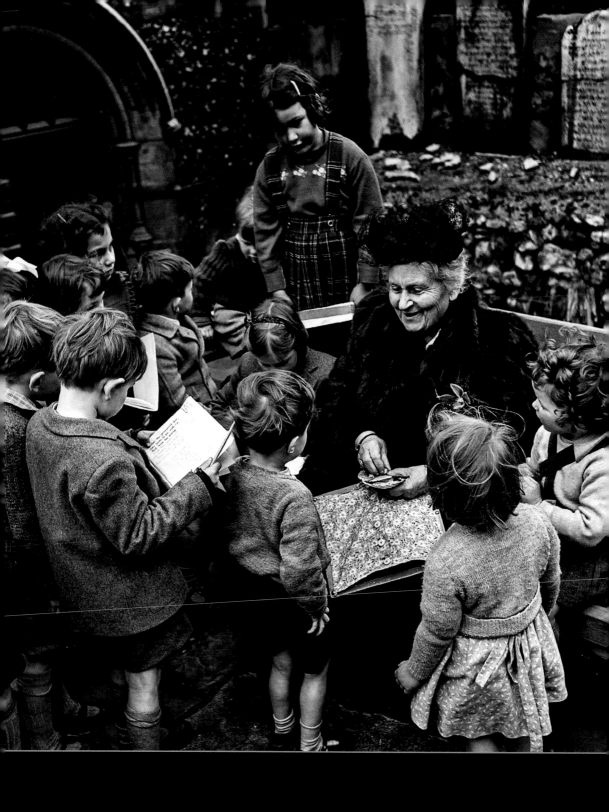

26 Maria Montessori in London in 1951. Her teaching method has spread throughout the world, with more than
22,000 certified schools of all levels: 5000 in the USA, 1200 in Germany, 370 in Ireland, 220 in Holland, 200 in
India, and 150 in Japan. The total number is 66,500 if we include those schools of Monstessorian orientation.

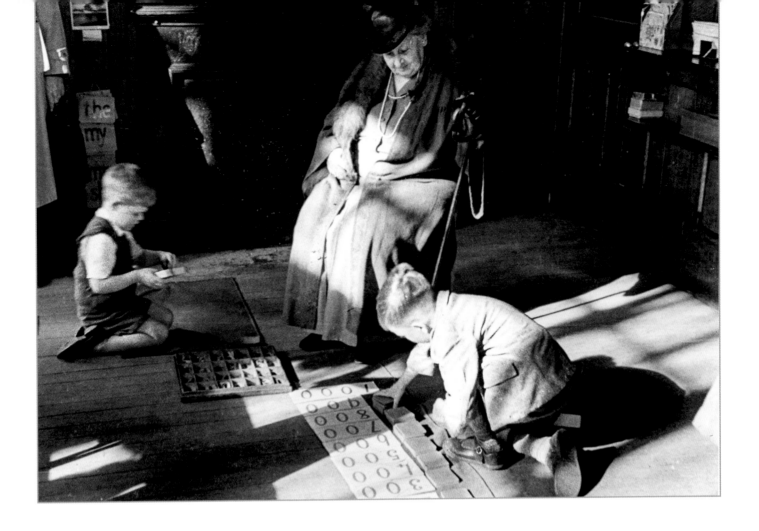

Montessori's private life did not correspond to her clear and serene pedagogical philosophy. This enormously successful, courageous, and intelligent woman fell into a state of depression when, during a passionate love affair with an Italian psychologist, she discovered she was pregnant and he refused to marry her. In the Italy of that time, this was considered a scandal of such enormity that not even the avowed nonconformist Maria was able to cope with it. She was forced to make a terrible decision; she left her son Mario in the care of another woman, and only fifteen years later were they finally reunited. Despite this terrible crisis, her love for her lost son made her even more determined to continue her studies and reassess her thoughts about pedagogy, pursuing the dream of a society made up of people who would be free and independent from their childhood and thus able to become critical thinkers, persons able to take responsibility for their own existence. Montessori entrusted this dream to parents and teachers, giving them only one duty, which is fundamental to children's development: "Help them to do things by themselves."

27 Play as a method of study is the basis of the pedagogic philosophy of Maria Montessori, seen here in 1946 observing two young pupils in one of the first of her schools established in London. She often repeatedly told the teachers: "The greatest sign of success for a teacher is to be able to say, 'The children are now working as if I did not exist.'"

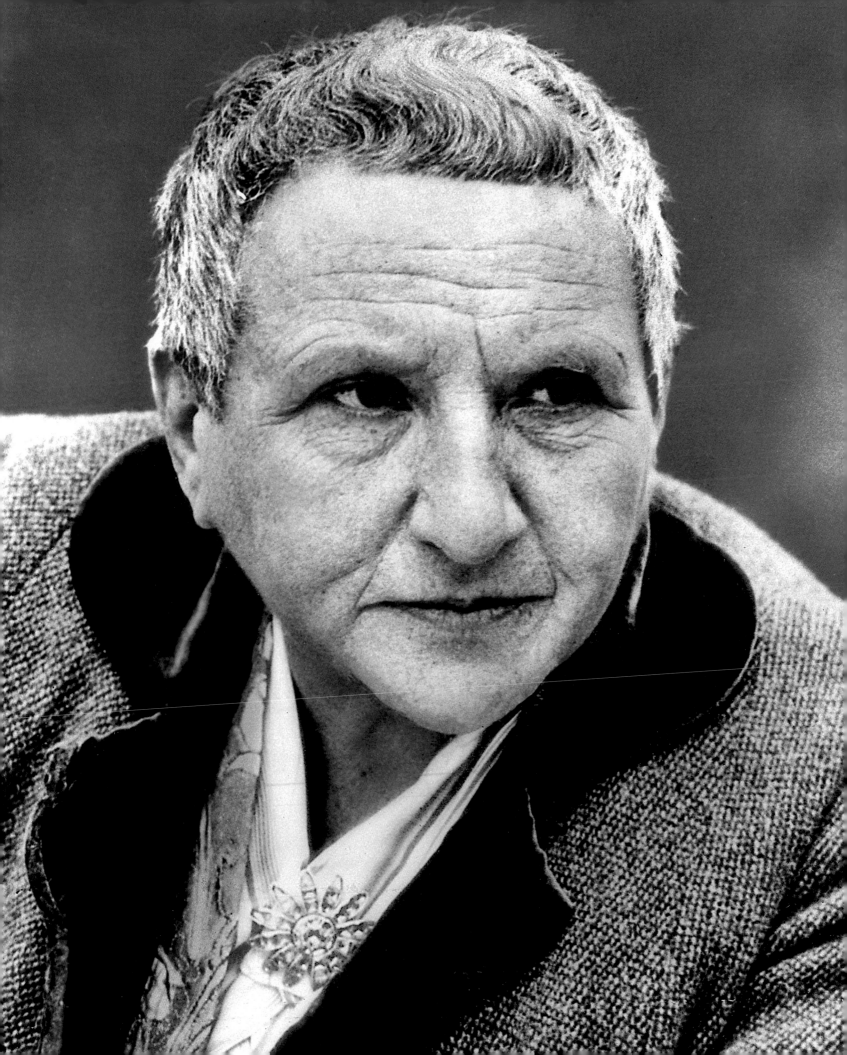

Gertrude Stein

She was an art collector, avant-garde author, and the hostess of one of the most vivacious artistic salons in Paris, as well as the muse of Picasso, whose portrait of her was destined to change the history of painting.

In the early 20th century, Paris was the capital of the world, and the Stein home in Rue de Fleurus was its vital focal point, a picturesque and disorderly salon frequented by avant-garde artists, poets, composers, and writers such as Pound, Apollinaire, Picabia, Satie, Cocteau, and Hemingway. The hostess was an American, Gertrude Stein, a stout woman with short-cropped hair who welcomed her guests garbed in a loose-fitting men's overshirt and flowery vests, with an air of self-assurance that verged on arrogance. She was also an art collector with an extraordinary nose for talent who covered every inch of the walls with works by still relatively unknown artists – Gauguin, Cézanne, Matisse, and Braque. Struck by her nonconformism, the famous art dealer Ambroise Vollard claimed she was the only customer who collected paintings "not because she's rich, but despite the fact that she isn't." With her mannish figure, she was certainly not beautiful, yet she posed for many of the great artists of her time, from Picabia to Cecil Beaton and Man Ray, and even Picasso, who in 1906 painted a portrait of Gertrude that marked the end of the artist's Rose period and arguably heralded Cubism. She said of the portrait: "[...] it is the only reproduction of me which is always I, for me." Gertrude wrote at night, after her friends had left, but her innovative style made it difficult for her to find a publisher. Yet she was a celebrity in Paris, thanks to the atmosphere of her salon, where anything could be said without hypocrisy, including expressing one's homosexuality. In fact, Gertrude never concealed her sexual orientation, and when she met Alice Toklas in 1907, she immediately knew she had found the companion she had been looking for.

Gertrude Stein was born in Pennsylvania to an upper-middle-class Jewish family and was supported by an annuity guaranteed by her brother Michael's company. At Radcliffe College, she was a student of William James, with whom she studied the relationship between writing and consciousness, which later played a crucial role in her avant-garde stream of consciousness writings.

February 3rd, 1874, Allegheny, Pittsburgh, Pennsylvania, United States · July 27th, 1946, Neuilly-sur-Seine, France

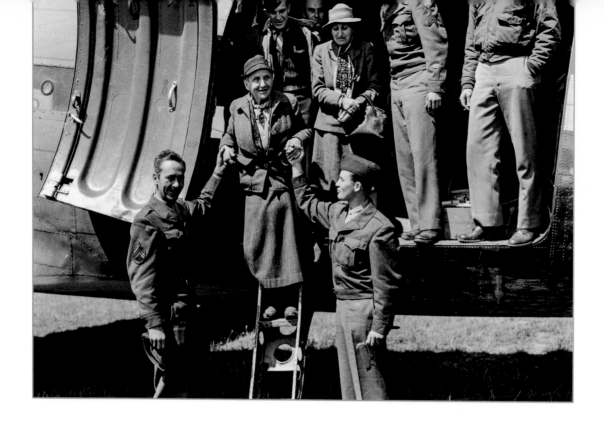

She took Alice to her house on the Rue de Fleurus and loved her as a wife for the rest of her life. But in exchange she asked Alice to tolerate her occasional affairs and to be her secretary, typing out her works, which she diligently wrote every day of the year, but only for half an hour, because, as she said, "If you write half an hour a day it makes a lot of writing year by year." After working for thirty years, in 1934 Gertrude Stein finally enjoyed success with *Autobiography of Alice Toklas*, an extraordinary best seller in which she borrowed her lover's name to create a perceptive, brilliant, and gossipy portrait of herself and her circle of friends. This unexpected success, which arrived when she was sixty, jeopardized her identity as an experimental author. But her style remained unique to the end, even when she uttered her last words. "What is the answer?" she asked her beloved Alice, who did not reply. "In that case, what is the question?" She then closed her eyes, holding the hand of the woman who had been her partner for forty years.

30 Stein traveled widely in the latter years of her life. Besides Europe (this photograph shows her during her trip to Germany), she spent six months in the United States in 1934-1935, giving 74 lectures in 37 cites throughout the country. This visit received a great deal of publicity and was even celebrated by a neon sign in Times Square: "Gertrude Stein has arrived in New York."

31 Gertrude Stein in 1944 in the village in the Alps where she had taken refuge at the outbreak of World War II. She and her partner, Alice Toklas, both Jews, were not persecuted thanks to the help of Bernard Faÿ, director of the Bibliothéque Nationale de France.

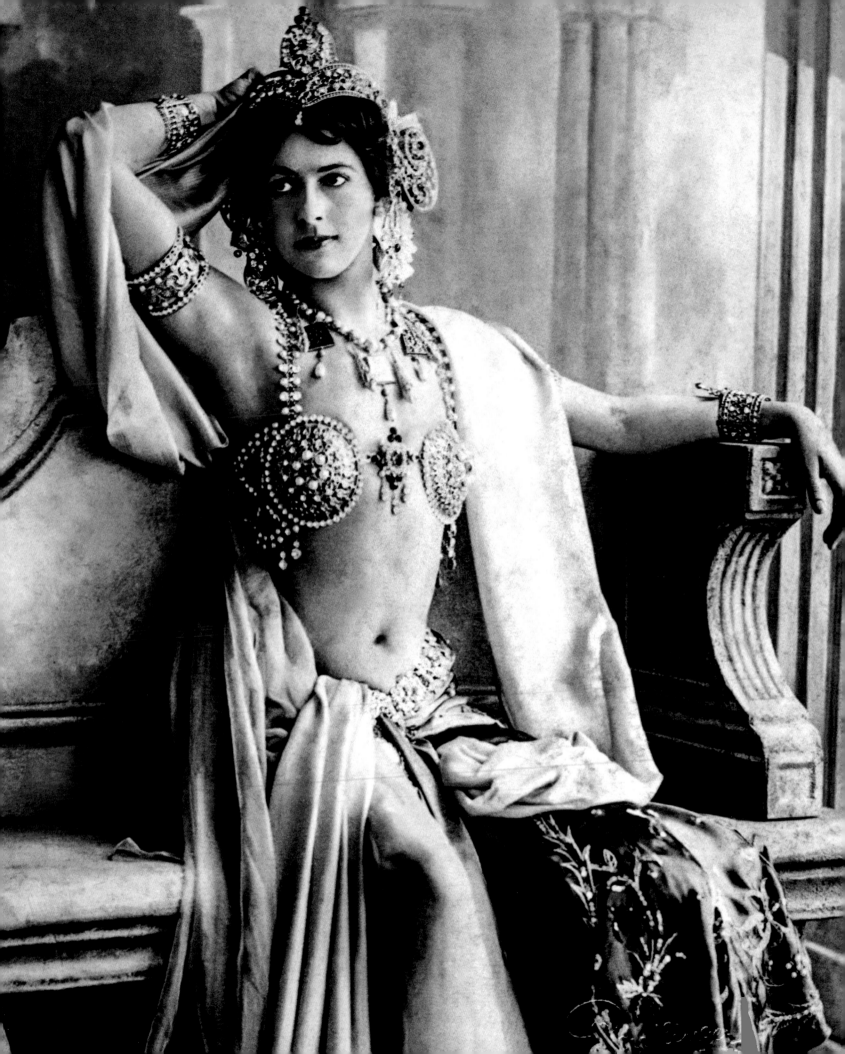

Mata Hari

Extremely intelligent, cultured, and enterprising, the most famous secret agent in history spoke six languages and danced like a goddess. Defying moralists with a whirligig of secret romances, Mata Hari ended up as the pawn in the game of double agent espionage that led to her death.

When the firing squad lined up to execute Mata Hari, she refused to be blindfolded in order to gaze into the eyes of the twelve officers who had been assigned to carry out the execution. Almost all the bullets missed, a gallant gesture on the part of the officers before the final blow struck her in the heart. No one claimed the corpse, which was buried in a common grave near Paris. And yet, only a few days earlier, this legendary dancer was still the object of desire of a host of men from many different countries who were mesmerized by her sinuous movements as well as by that mysterious exotic air she had learned to create by disguising her European origins, pretending to be Javanese, and wearing provocative costumes. Indeed, there was not one drop of oriental blood in her veins; her real name was Margaretha Zelle, and she hailed from a well-off middle-class family from a village in Holland, where she studied at a prestigious school, standing out among her blond schoolmates for her brilliant grades, unusually beautiful dark skin, and deep-set black eyes. She was barely eighteen when she left Europe to marry a Dutch officer stationed in Indonesia. Once there, her husband turned out to be an unruly alcoholic, and Margaretha was much more attracted by the local culture and Javanese dances, which proved to be very useful to her when she decided to return to Europe after their marriage broke down. She arrived in Paris in 1904, armed only with her fascination and ambition.

The archetypal Belle Époque femme fatale, Mata Hari (seen here in a photo taken around 1910, wearing a performance costume) inspired novels and movies, such as the masterpiece starring Greta Garbo shot in 1931, and the other films featuring Marlene Dietrich, Jeanne Moreau, and Sylvia Kristel.

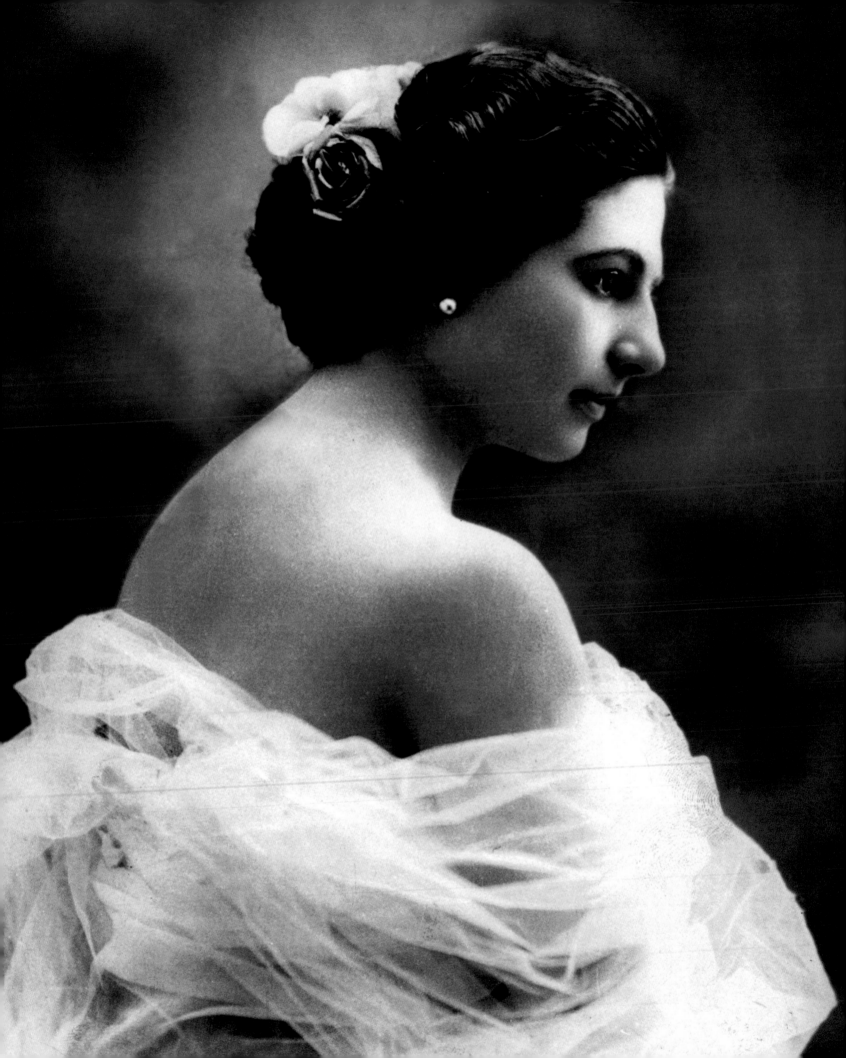

Despite being penniless, she stayed at the Grand Hotel, performing as a "dancer from the Orient" at sumptuous private banquets, where she was hailed by a group of admirers who were overwhelmed by her most famous number, during which she artfully shed her veils one by one. One of her most enthusiastic fans was the art collector Émile Guimet, who asked her to dance in his museum of exotic art and objects and suggested she change her name. So Margaretha became Mata Hari ("eye of the day" in Javanese) and transformed herself into a star. Wrapped in an aura of mystery, she was acclaimed in the temples of dance of Europe, from the Scala in Milan to the Olympia in Paris. The press raved about her as a "sublime artist who imparts the most profound and moving spirit of the Indian soul," and she was courted by princes and generals who, when enveloped in her embrace, ended up revealing state secrets and war strategies. The outbreak of war in July 1914 caught her by surprise while she was preparing to make her debut in a new, grandiose spectacle in Berlin that never took place because her life took a new, wholly unexpected turn. Her liaisons, which were much talked about, had attracted the attention of the head of the German secret service, who gave her 20,000 francs, a secret mission, and a code name, H21. From that moment on, Mata Hari became one of the most skillful spies in the German secret service. But, overconfident about the protection given her by many important persons, she began to be a double agent, spying for the French as well. When she was captured in Paris, there was no solid proof of treason, but she was guilty of something equally serious: she was a beautiful, rich, and cultured woman who traveled by herself and had no qualms about admitting she had had many lovers. At the time, that was enough to condemn, with no possibility of appeal, this free and nonconformist *femme fatale* who had defied men, nations, and social conventions, bringing the world to her feet.

This photograph was taken in Paris around 1900, when the dancer was still using her real name, Margaretha Zelle. She and her husband, the Dutch officer Rudolph MacLeod, had two children, a boy who died when only three years old, and a daughter who was given in custody to her father when they divorced in 1902.

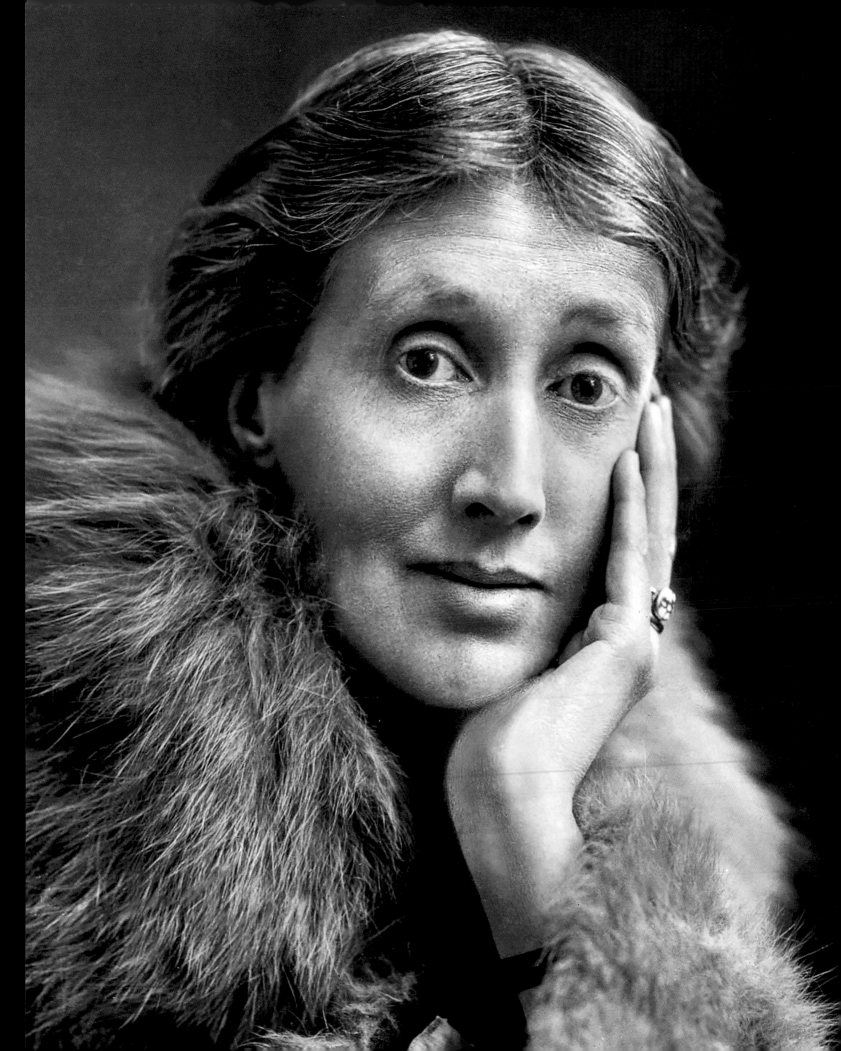

Virginia Woolf

She wanted to be a female novelist in a world of male novelists, and she succeeded. She dismantled the structure of traditional novels, in which she inserted memoranda to remind women of the recent roots of their struggle for independence.

"Who shall measure the heat and violence of a poet's heart when caught and tangled in a woman's body?" Virginia Woolf asked herself in 1929 in *A Room of One's Own*, an ironic yet implacable essay on women's relationship with writing. Her thesis is simple: economic and psychological subordination to men has conditioned women's literature. "A woman must have money and a room of her own if she is to write fiction," she declared. But this was much more than a theory. It was a declaration of independence, a hymn to emancipation, an act of rebellion against the stereotypes of a narrow-minded, bigoted society in which "Women have served [...] as looking glasses possessing the magic and delicious power of reflecting the figure of man at twice its natural size." Virginia Woolf turned her words into action. She became the hostess and the moving spirit of the Bloomsbury Group, a sophisticated but nonconformist intellectual circle that one entered armed with irony and exited even more open-minded, after discussing basic themes – literature, art, politics, religion, sex – with utter frankness. This wildly free woman lived suspended among contradictions: she was constantly worried that she was not dressed well enough; she did not conceal her love for women but at the same time was closely bonded with her husband Leonard; she had a caustic and unbridled sense of humor that culminated in guffaws that were followed by crises of utter despair that she attempted to emerge from by exhausting long walks and interminable writing sessions. All this was done without asking too many useless questions of, and requesting answers from, those near her: "We do not know our own souls, let alone the souls of others."

Virginia Woolf in a 1927 photographic portrait. Her mother died when she was young, and she was home-schooled by her intellectual and libertarian father, who, however, did not allow her to attend university because she was a woman. When she was 59, she fell into a deep state of depression and committed suicide by walking into a river with her pockets full of large stones.

January 25th, 1882, London, United Kingdom • March 28th, 1941, Rodmell, United Kingdom

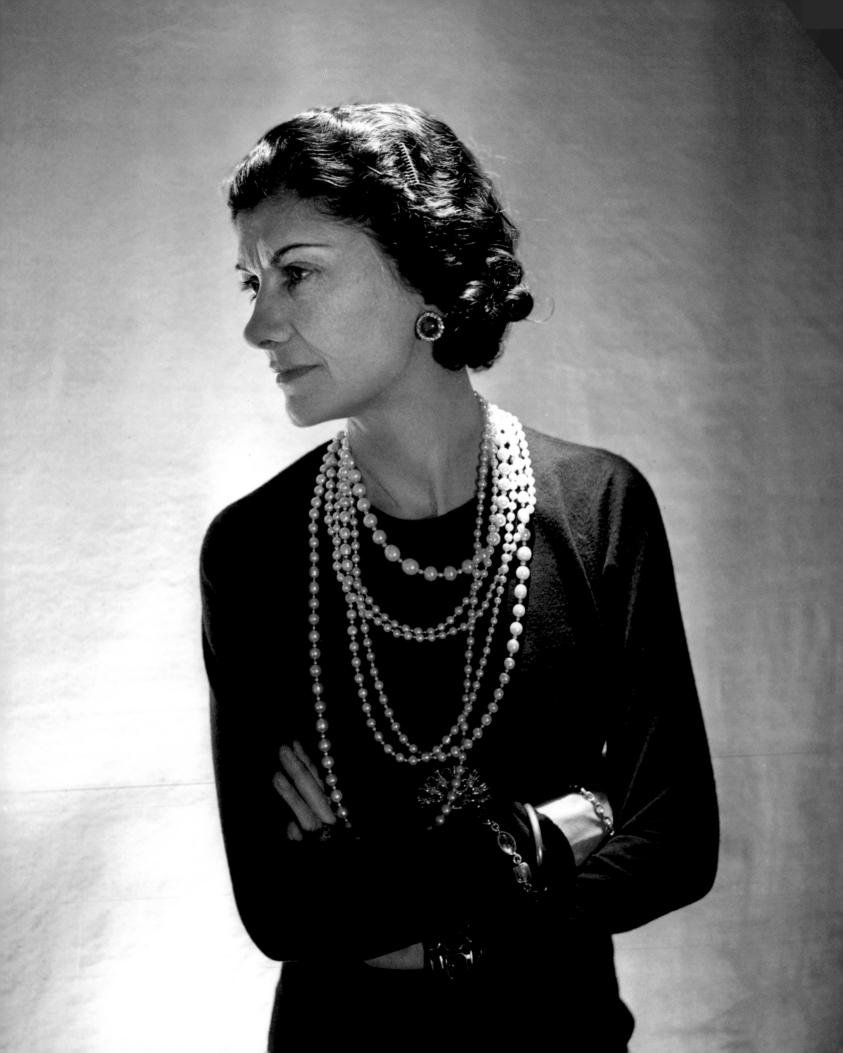

Coco Chanel

From a childhood marked by poverty, Mademoiselle Coco Chanel rose to become the queen of high fashion. She revolutionized the concept of female elegance and taught women the secrets of timeless elegance, because, as she said, "Fashion fades, only style remains the same."

"I don't regret anything in my life except the things I didn't do."

And indeed she did a great many things, having begun to knuckle down already when she was eighteen, just after leaving an orphanage, when she was still known as Gabrielle. In the evenings, she performed in cabarets singing a ditty, *Qui qu'a vu Coco*, from which she probably acquired the name that has become historic. During the day, she made straw hats that were different from all those then considered fashionable. They were simple and rather austere, worlds apart from the prevailing opulent Belle Époque hats ("How can the brain work under such things?" she wondered). She had already created her unique style, a mixture of elegance and simple linear design that would be the trademark of all her future creations. With the support of her great love, Arthur "Boy" Capel, an upper-middle-class industrialist from Newcastle, Coco inaugurated her first milliner's boutique in Paris, in Rue Cambon, which was destined to become legendary and which is still the headquarters of the Chanel fashion house. In 1913, she opened a second shop in Deauville, a sophisticated seaside resort, and established a third in the equally fashionable town of Biarritz. The 1920s witnessed the triumph of her style, which in one fell swoop overturned the 19th-century concept of femininity. "A man can wear whatever he wants. He will always remain a woman's accessory," said Coco, while revolutionizing women's wardrobes. Her skirts went below the knee, she lowered the waistline, and invented the *petite robe noire*, or little black dress, the quintessence of chic Parisian design. This simple, practical, and comfortable dress did away with the constraints imposed by corsets; *Vogue* magazine compared it to the Ford Model T, something the world could not do without.

In this 1936 photograph, taken by Boris Lipnitzki in Paris, Coco Chanel shows off her classic six-strand pearl necklace. She believed it brought her good luck and liked to combine it with showy yet rather inexpensive bijoux to wear around suits and blouses, either during the day or in the evening, as a contrast to the rigorous black of her garments.

August 19th, 1883, Saumur, France • January 10th, 1971, Paris, France

Her lovers' wardrobes inspired her to introduce trousers and tweed in her models, transforming the most masculine fabric into soft women's jackets. This was soon followed by the two-tone décolleté heel shoes – half beige to make the legs seem longer and with dark toe caps to make the foot seem smaller and conceal dirt or stains. Now rich and famous, she heightened her ambiguous and slightly androgynous fascination by popularizing the *à la garçonne* hairstyle, which caused as much of a sensation as her clothing. She made a big hit in the most illustrious salons, followed by the inevitable stream of gossip concerning her relationship with men and women, artists and aristocrats. She was a friend of Stravinsky, Picasso, and Cocteau (who said of her: "By a kind of miracle, she has worked in fashion according to rules that would seem to have value only for painters, musicians and poets."), and was at the height of her career when rumors began to circulate concerning her presumed sympathy for the Fascist movement. She decided to bow out/make her exit, but this was by no means a closure. In 1955, when she was 72, Coco resumed her activity at full capacity, challenging Christian Dior's New Look wheel skirts by presenting suits with slim skirts that immediately became popular among movie stars. Her name was identified with her signature interlocked C logo, the first in the history of fashion, and the camellia, the perfectly geometric Chinese flower that decorated the many Coromandel screens in Rue Cambon and at the Ritz Hotel, where she lived almost all her life. Coco chose this flower as the symbol of her style, partly because it has no scent and therefore does not interfere with the only perfume Mademoiselle would accept, the one that became part of the collective imagination thanks to Marilyn Monroe: "What do I wear in bed? Why, Chanel no. 5, of course."

In 1937, Coco's career was at its zenith. Her essential style, with few frills and high-quality fabrics, dominated the fashion world. One of her sources of inspiration was black and white garments worn by the nuns who had educated her at the Aubazine Abbey orphanage, where her father had left her when she was twelve years old.

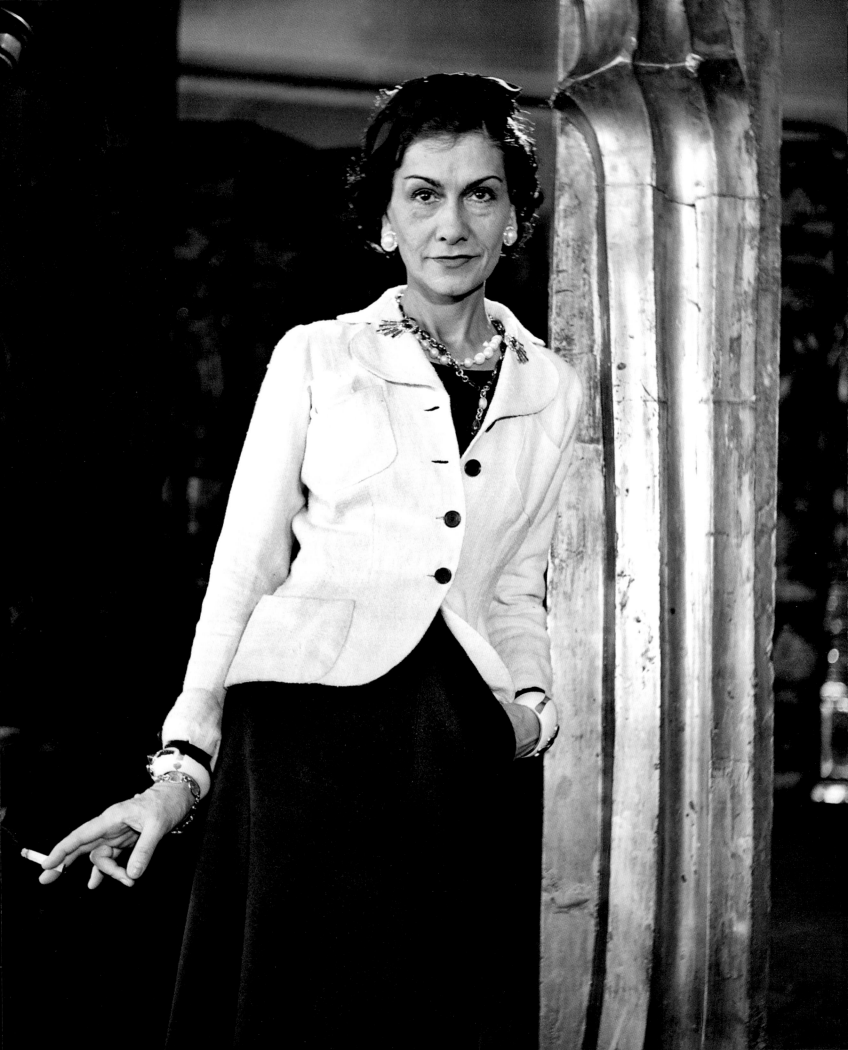

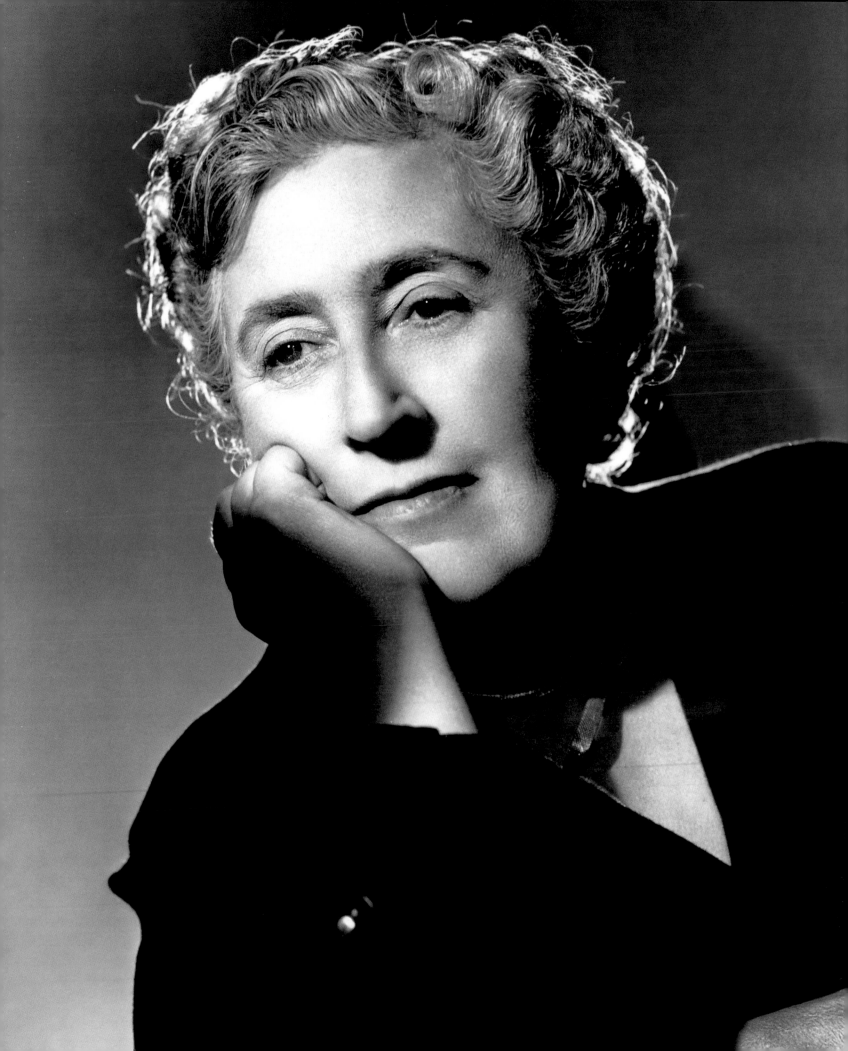

Agatha Christie

She never went to school and yet became the greatest detective novelist of all time. It has been estimated that more than 2 billion copies of her works have been sold; only the Bible and Shakespeare have been more popular than this reserved English woman who conceived the most atrocious homicides while enjoying a hot bath.

During her childhood, the timid and taciturn Agatha Christie did not like dolls but preferred to invent stories for her imaginary friends, just as she would do for the rest of her life, pecking away at her typewriter and writing more than 80 novels and short stories. The success of her first novel, *The Mysterious Affair at Styles*, transformed the dreamy girl into an independent modern woman who was destined to change the rules of detective stories forever. Caustic by nature but quite personable, she was a discerning observer of human nature, always ready to take in ideas for her plots, convinced as she was that "every murderer is probably somebody's old friend." She put to good use the atmosphere of the elegant seaside town of Torquay, where she had grown up, in order to interrupt the harrowing suspense of her stories with pages describing evenings spent in formal dress, living rooms meticulously dusted by butlers, and sandwiches served with tea. Her mother was an eccentric exponent of English high society, and her many friends inspired Agatha's gallery of unforgettable women characters who were strong and independent, as well as surprisingly astute old women such as Miss Marple, the perfect embodiment of old-time female wisdom.

Christie was an indefatigable traveler, and in 1922 she went with her first husband, Archie, a colonel in the Royal Flying Corps, on a trip around the world that included Australia, South Africa, and Hawaii.

When she was 60, Agatha Christie was world famous, and she also became interested also in theater. In fact, the year 1952 saw the debut of her play *The Mousetrap*, written for Queen Mary on her 80th birthday. It has been performed evening after evening ever since and boasts the longest run of any play in the history of theater.

September 15th, 1890, Torquay, United Kingdom · January 12th, 1976, Wallingford, United Kingdom

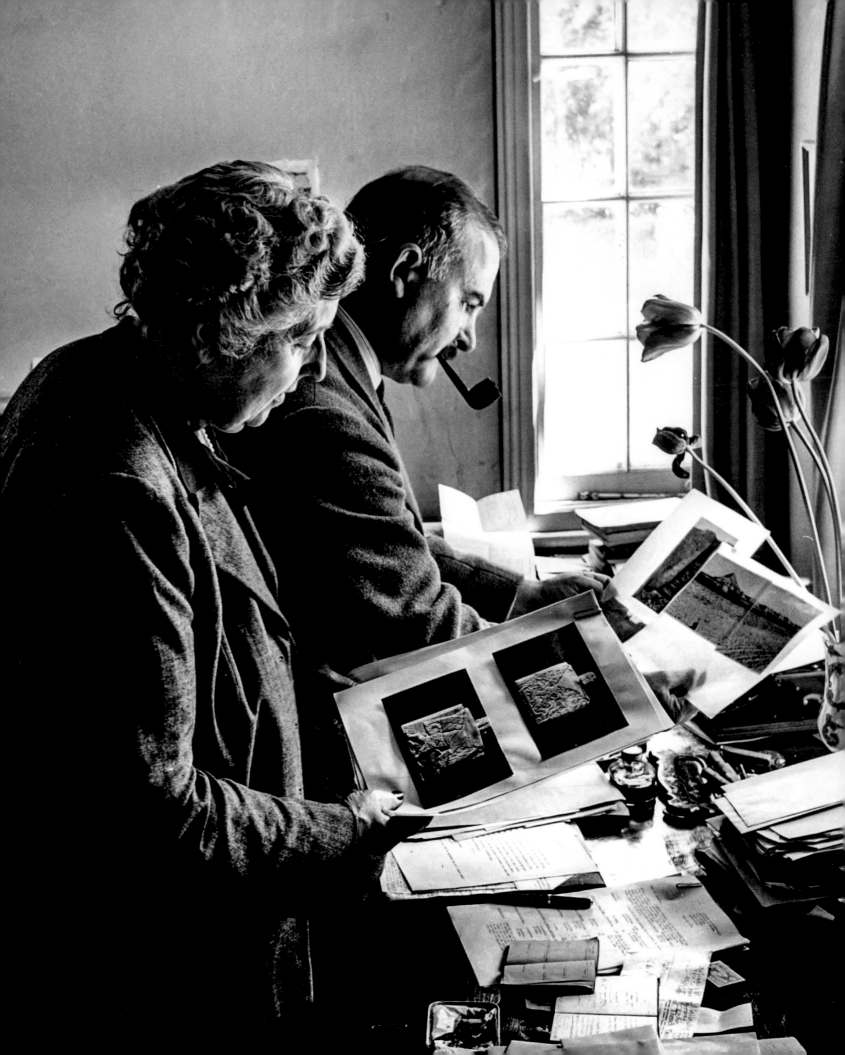

When he broke her heart by leaving her for another woman, she went to Baghdad by herself on a train in search of inspiration. Even before arriving, she had found the perfect setting for what would become her most famous novel, *Murder on the Orient Express*, and a short time later she met Max Mallowan, a brilliant archaeologist who was much younger than she. "An archaeologist is the best husband a woman can have. The older she gets, the more interested he is in her," she declared and then married him. He took her to Pakistan and Egypt, where the archaeological digs furnished material for her new novels, such as *Death on the Nile* and *Appointment with Death*.

But the mysteries of Agatha Christie are not only those in her books. Very little is known about her character, the bitter divorce with her first husband, and the eleven days when she disappeared without leaving any traces behind her, only to reappear in a confused state of mind as the guest in a hotel where she had registered under the name of her husband's mistress. "People should be interested in the books, not in their authors," she stated to those who asked too many personal questions. In order to put a stop to this flood of rumors, she wrote an autobiography, with the strict order that it be published only after her death. But the fans who had hoped for some sensational revelation worthy of Poirot were disappointed. Clues are to be found elsewhere, where one least expects them, exactly as in one of her detective stories: in the pages of six romantic novels by a certain Mary Westmacott, an "author" who never existed. In fact, those passionate romantic stories came from the pen of Agatha Christie, who used this pseudonym to conceal the most intimate and fragile part of the Queen of Mystery.

Christie with her second husband, archaeologist Max Mallowan, in 1946. Winston Churchill stated that she was the woman who, after Lucrezia Borgia, lived most in contact with crime. Another of her records is the best-selling detective story in the world, *Ten Little Indians*, which sold 110 million copies.

Martha Graham

She interpreted the 20th century by dancing vehemently: the two world wars, feminism, and psychoanalysis. Graham was the founder of modern dance and the pioneer of all its avant-garde expression in the West.

Martha Graham was never fashionable, but a timeless classic, still contemporary a century later. Yet her early career in the United States met with many difficulties. She was opposed by critics (with notable exceptions such as John Martin, who coined the epithet "modern dance" for her); she was light years away from the public taste of the time, which was still attached to the romantic dream of 19th-century ballet, interpreted by sylphs in tutus dancing on their padded toes. But Martha Graham knew what she wanted: she focused directly on research in the interior energies of the body through a new form of expressivity based on precise, angular movements closely related to the heartbeat. Her choreographies mirrored the culture of the time: Cubist painting, jazz, Jung's archetypes. As a true daughter of the "heart" of America, her bond with the history of her land was profound. "Dance reveals the spirit of the country in which it takes root," she wrote in a 1937 essay to explain the origin of her works, which drew inspiration from the traditions and stories of Native Americans, African Americans, and the Puritans. Graham was a free thinker and a vehement enemy of dictatorships, and when in a radio broadcast the Minister of Propaganda, Goebbels, asked her to participate in the spectacles to be held in Berlin on the occasion of the 1936 Olympic Games, she openly and vigorously refused the invitation, making it quite clear that her beliefs were totally incompatible with the Nazi regime. She had only one, short-lived marriage (in 1940, with choreographer Erick Hawkins), and her relations with men were always tempestuous. Of all her precepts, the most scandalous and iconoclastic was that ballerinas had to "move from the vagina."

Martha Graham's choreography also influenced the history of fashion by bringing onstage palazzo pyjamas, arabesqued hairstyles, and her unmistakeable and audacious combinations of colors (red with purple is the most famous). Her collaboration with stylists Donna Karan and Calvin Klein were famous.

May 11th, 1894, Allegheny, Pittsburgh, Pennsylvania, United States • April 1st, 1991, New York City, New York, United States

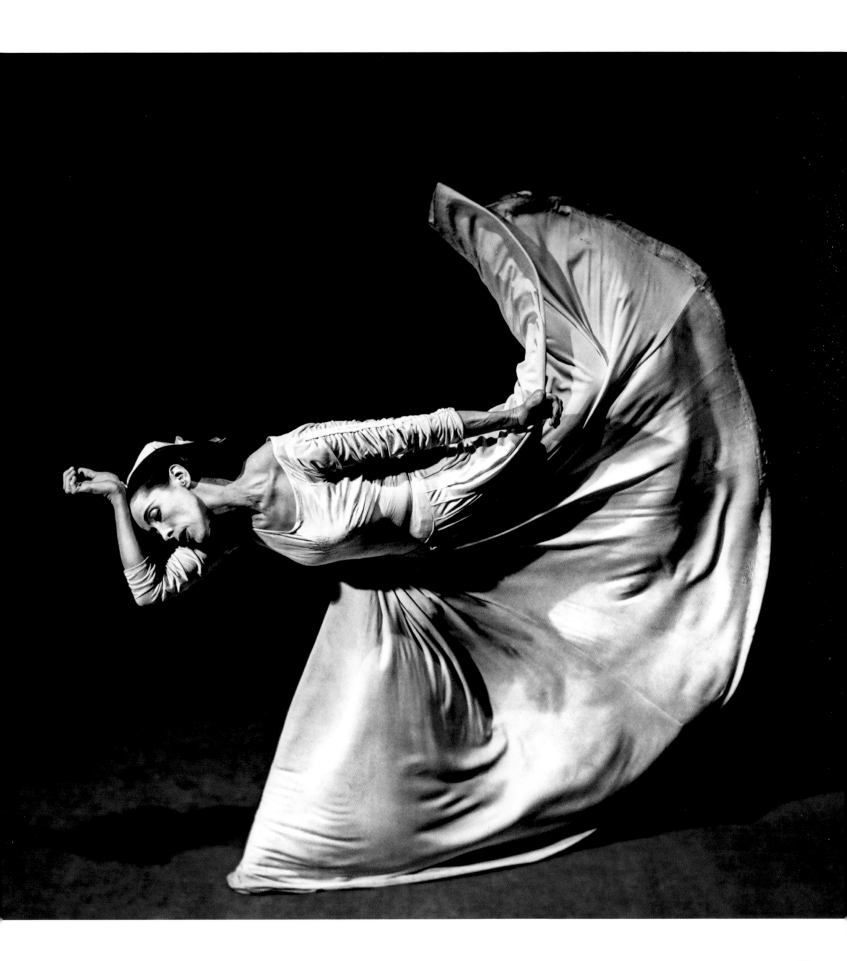

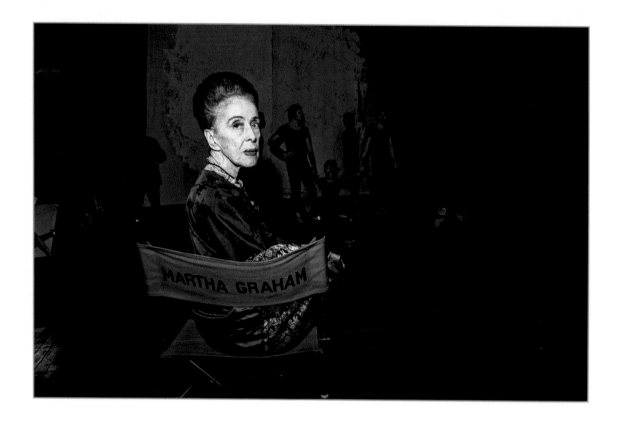

She declared that sex was a beautiful thing. "I don't know what life would be like without sex." At times fanatically egocentric ("I must be adored," she used to exclaim), she justified her detachment from the feminist movement by stating, "I've been surrounded by men all my life, so the women's liberation movement has never really affected me. I've never felt inferior in any way." But then, with almost derisive irony, on stage she wrapped her ballerinas in fabrics, while the male dancers were practically nude. "Women," she said, "don't need to undress to be sensual, while men do." During the course of her dazzling career, she created 181 choreographies, which are still eminently modern. She was the first to dance at the White House, and the highest civilian award in the United States, the Presidential Medal of Freedom with Distinction, was bestowed on her. In defiance of all biological laws, Martha Graham was miraculously active well into her nineties, always alert and creative to the end.

48 and 49 Martha Graham in Taipei during a 1973 tour (left) and in New York the same year. In her long career, she taught many actors and musicians to use their bodies as expressive instruments; they included Bette Davis, Kirk Douglas, Liza Minnelli, Gregory Peck, and Madonna. Even Woody Allen took part in her courses, describing them with his characteristic caustic irony: "For me, it was a very serious matter. For those watching me, exhilarating."

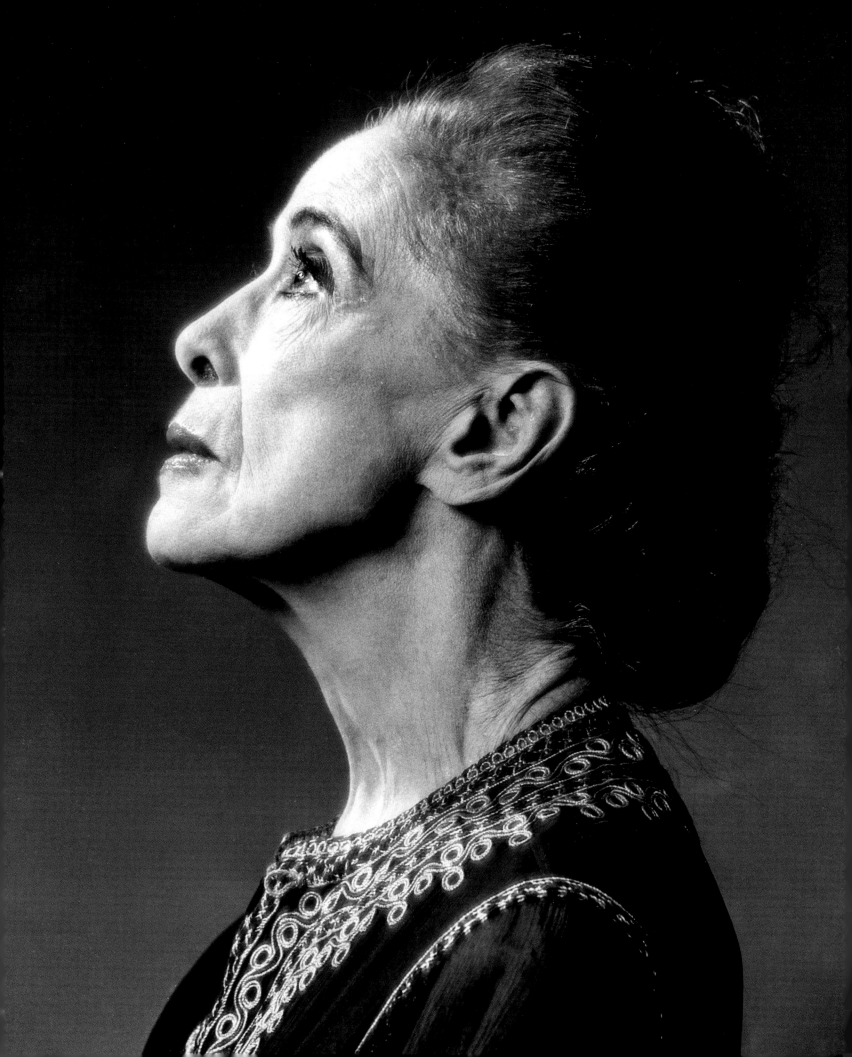

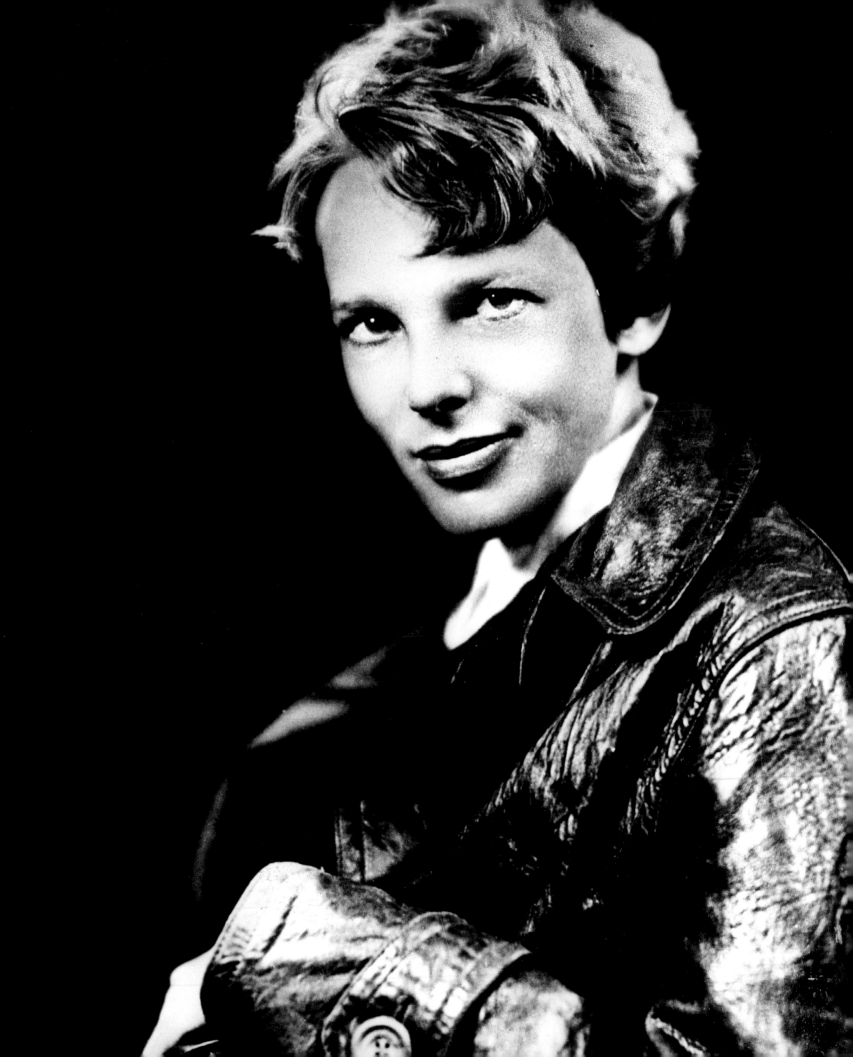

Amelia Earhart

She was charismatic, courageous, audacious. And pilots' leather jackets fit her to a T. Her life and death became legendary, so much so that to this day people are searching for the wreck of her plane, which disappeared mysteriously while she was flying over the Pacific Ocean in 1937.

One bright, clear day in April 1920, Amelia Earhart persuaded her father to take her to Long Beach, California, to visit one of the many airplane shows that had become so popular in postwar America. For a fee of one dollar, she was able to take a short ride in a biplane for the first time. She was 23 years old and the experience was overwhelming. "By the time I had got two or three hundred feet (60-90 m) off the ground, I knew I had to fly." So she went about gathering money to pay for flying lessons taught by Anita Snook, another female aviator pioneer, and on May 15th, 1923, Amelia became the 16th woman in the world to earn a pilot's license. At that time, aviators' equipment was particularly rudimental, consisting of leather jackets, headphones, and goggles. Since she did not want appear to be a "greenhorn", she slept in her leather jacket for three nights to make it look well-worn and cut her hair short to look like the other women aviator pioneers. "The most difficult thing is the decision to act. The rest is merely tenacity. The fears are paper tigers," she stated, while purchasing a second-hand yellow biplane that she called The Canary, which she flew up to an altitude of 14,000 feet (4300 m), thus immediately setting a new record for female pilots. The year 1928 was marked by her first true challenge, a transatlantic flight. This feat was sponsored by the publisher George P. Putnam (who later became Earhart's husband), who proposed that she make the flight together with the veteran aviator Wilmer "Bill" Stultz and the mechanic Louis "Slim" Gordon.

The Queen of the Air, or Lady Lindy, as the press nicknamed her – likening her to world-famous Charles Lindbergh, with her short hair and aviator's leather gear – was not only mistress of the heavens but a true icon, as is attested by the many plazas, statues, stamps, and movies dedicated to her.

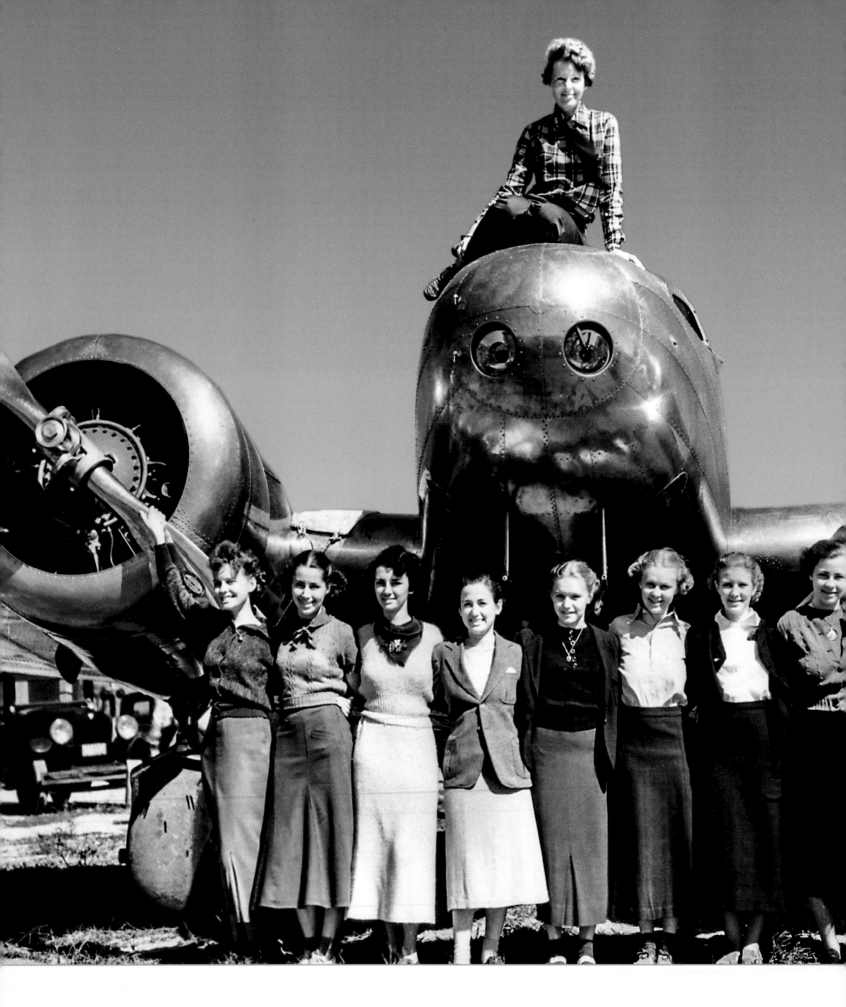

She was not at all satisfied with how the flight went: "Stulz did all the flying – had to. I was just baggage, like a sack of potatoes." Consequently, in 1932 she decided to make a solo transatlantic flight from Newfoundland to Londonderry, Northern Ireland, where she landed, after flying almost 15 hours. Young, pretty, lauded and supported by the press and the recently established civil aviation industry, Amelia Earhart became a star as well as an icon for feminists. To reporters who interviewed her, she declared: "Women, like men, should try to do the impossible. And when they fail, their failure should be a challenge to others." Four years later, Amelia began to plan her most ambitious feat, a round-the-world flight along the Equator. After flying for 22,000 miles (35,000 km), that is, when she had gone more than two-thirds the required distance, she and her copilot, Frederick Noonan, disappeared in the Pacific Ocean.

Amelia inspired an entire generation with her feats and conquered hosts of women admirers for stating that in future expeditions, women would take on more and more responsibility and their gender would be less and less a factor in the recognition of their value, which would emerge hand-in-hand with their achievements.

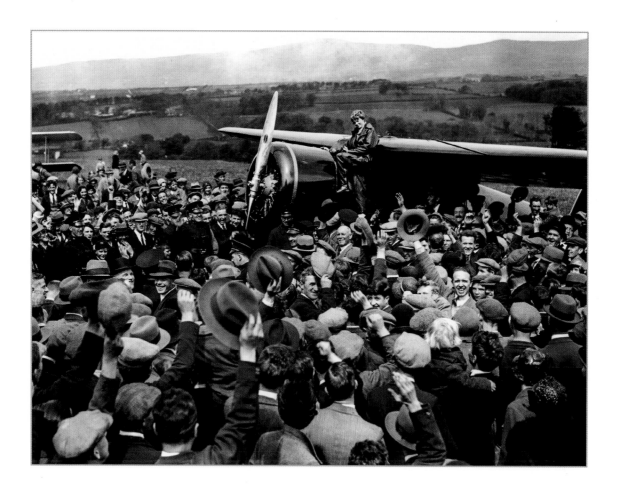

This occurred on July 2nd, 1937. President Franklin D. Roosevelt ordered a vast search campaign, utilizing nine ships and 66 planes (at an estimated cost of 4 million dollars), to no avail. This search, which covered 250,000 square miles (650,000 square km) of the ocean, was interrupted on July 19. Amelia Earhart was never found and became a myth that, after a century, is still an example that encourages young women to try to realize their dreams by setting their sights higher and higher, above the clouds.

54 1932: Amelia on the nose of her Lockheed Vega, surrounded by an enthusiastic crowd after her arrival in Londonderry, Northern Ireland, from Newfoundland. She was the first woman aviator to make a nonstop solo transatlantic flight.

55 Earheart in Honolulu on December 27th, 1934, before her solo flight over the Pacific from Honolulu to Oakland, California. Two years earlier, she had established another record by crossing the United States nonstop from Los Angeles to Newark, New Jersey.

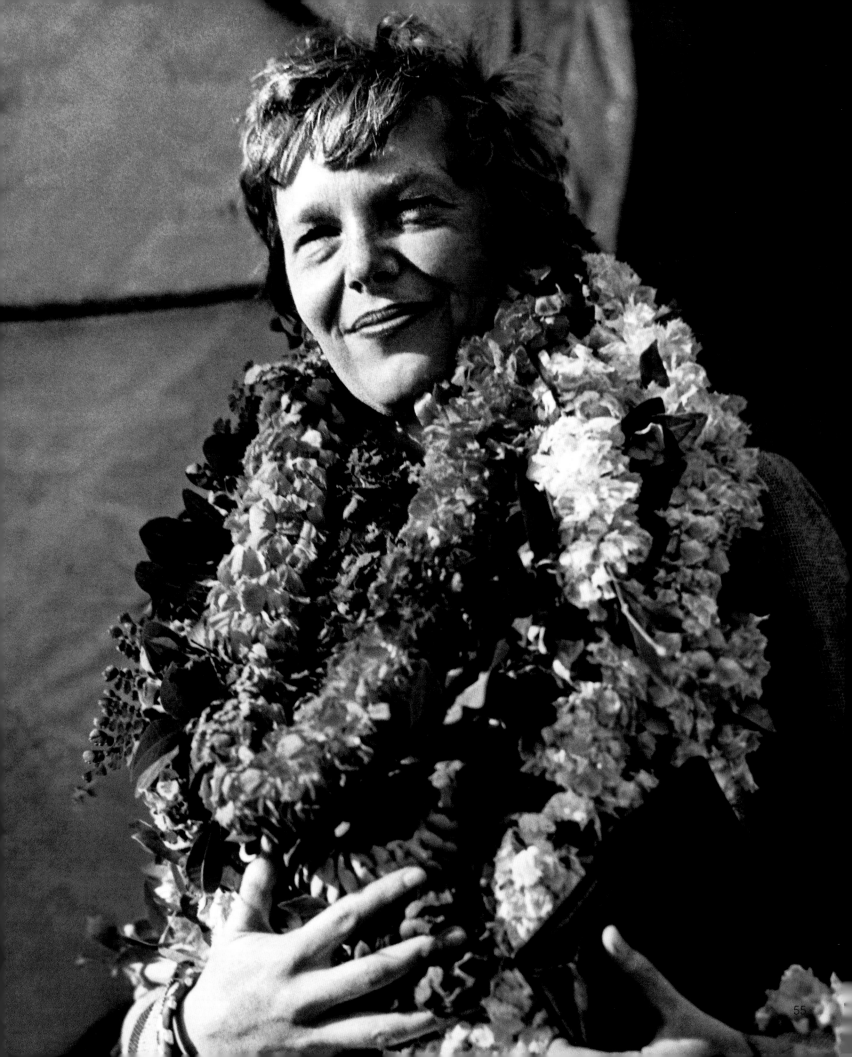

55

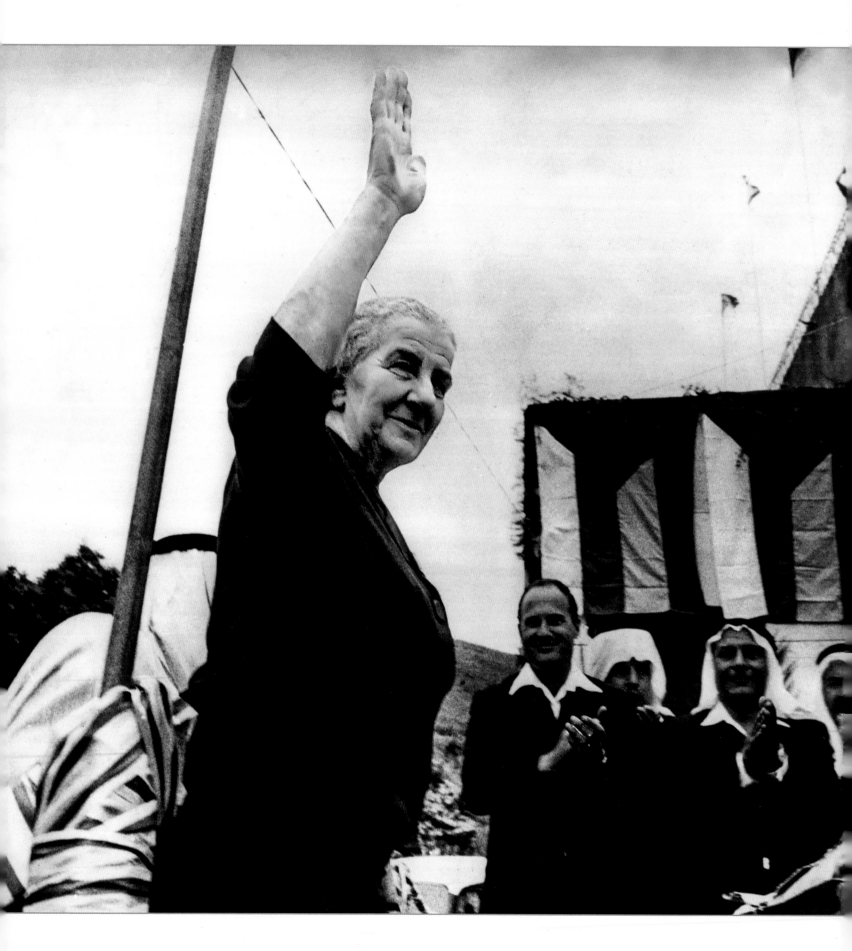

Golda Meir

Energetic and strong-willed, with a mere blink of the eye she could condition the destiny of the Middle East. The founding father of Israel, Ben Gurion, called her "The best man in the government" and gave Golda Mabovitz her new Hebrew family name, Meir, or "illuminated."

She was known the world over as the "Iron Lady" long before Margaret Thatcher, and even more as the Pasionaria of Zionism and pioneer of the state of Israel. When still a child, she witnessed the barbarous anti-Semitism that struck the Jewish community in Russia, experiencing pogroms at first hand. "Pessimism is a luxury that a Jew can never allow himself," she stated when describing her family's escape from the Ukraine to the United States, where her father wanted her to abandon her studies and get married. This was in 1912, when she was 14 years old. Rather than obey, she fled to her sister's home in Denver, where she became acquainted with feminism and joined the Jewish cause. She then married her American fiancé, Morris Meyerson, a dreamer who adored music and poetry, and dragged him to Palestine in 1921 to plow the land and share the hard life of a kibbutz, convinced that the creation of a Hebrew state was the only possible way to guarantee the safety of her people. On May 14th, 1948, the birthdate of the state of Israel, Golda was one of the 24 persons who signed its declaration of independence. From that moment on, she devoted her life to the construction of her country, first as Minister of Labor and then as Foreign Minister, eventually becoming Prime Minister, taking upon herself the responsibility of decisions that would terrify any man in power: dealing with the oil crisis, the Suez Canal crisis, the clashes with Egypt and Syria, and the 1972 Munich Olympic Games massacre, when a command of Palestinian terrorists kidnapped and killed eleven Israelis, both athletes and coaches. Worn out by a life led at the front line and by a lymphoma, Gold Meir retired from politics at the age of 74, bequeathing to a world still at war one of her most famous sayings: "Peace will come when the Arabs love their children more than they hate us."

Golda Meir visiting Tiberias on April 29th, 1969. She was 71 and had just been elected Prime Minister. While never declaring she was a feminist, she never tolerated disparity between the sexes. When one of her ministers proposed establishing a curfew for women in order to put an end to a series of rapes, she replied irritably: "It's the men who are attacking the women. If there's to be a curfew, let the men stay at home, not the women."

May 3rd, 1898, Kiev, Ukraine • December 8th, 1978, Jerusalem, Israel

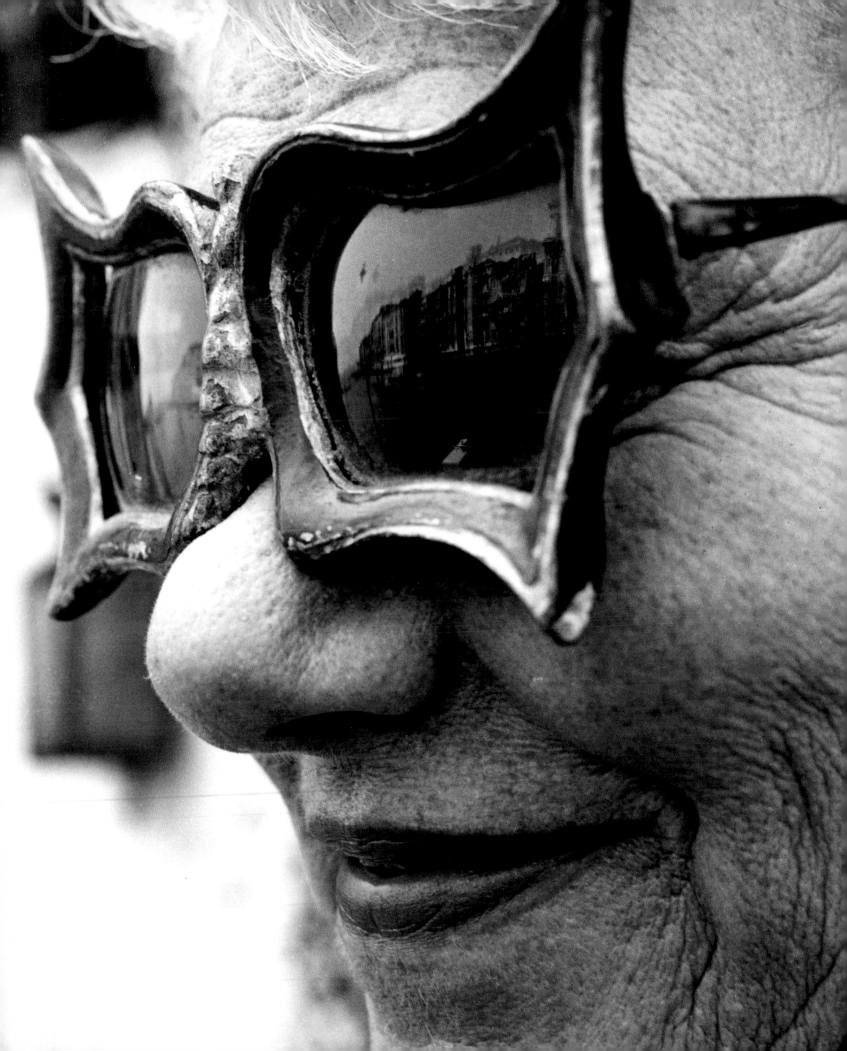

Peggy Guggenheim

A collector of art and artists, she married Max Ernst, posed for Man Ray, took art lessons from Samuel Beckett, and discovered Jackson Pollock. Starting off from New York, she took her nonconformist views from one side of the ocean to the other, ending up in Venice.

Her real name was Marguerite, but for the whole world she was Peggy, the nickname chosen for her by her beloved father, Benjamin Guggenheim, who died heroically on the Titanic by offering his life jacket to a woman. With that strange nickname and an equally bizarre potato nose resulting from an operation that was interrupted at the halfway point, this rich heiress of an American Jewish family was well aware she would never be able to use good looks to make an impression. But she was narcissistic, insecure, and vulnerable, and she loved being the center of attention, so she decided to make use of her eccentricity and devote herself to art collection. As Peggy herself stated, her destiny would be to seek the impossible while avoiding the easy things of life. She had no real academic background but made her way splendidly. She left New York as soon as she could to go to Paris, "the most stimulating place in the world," where from 1921 to 1928 she became a good friend of Marcel Duchamp, Man Ray (whose photographic portraits made her feel beautiful, she said), Jean Cocteau, and a penniless painter who later became her first husband, Laurence Vail. They had two children, Pegeen and Sindbad, but their marriage was not exactly idyllic and it ended seven years later. "He became my best friend: husbands always improve after the divorce," she explained. Then she moved from Paris to London to inaugurate the Guggenheim Jeune gallery, where she organized exhibits with children's drawings and was the first to feature works by Henry Moore and Lucian Freud. With her voracious appetite for life and art, she felt that the gallery was not enough and decided to open a museum.

August 26th, 1898, New York City, New York, United States • December 23rd, 1979, Camposampiero, Italy

Venice, 1965: Peggy Guggenheim wearing the sunglasses made in the 1950s by her friend, the American artist Edward Melcarth, in her honor. These iconic glasses of Surrealist inspiration were as eccentric as she was, and helped to create her persona and increase her already great popularity.

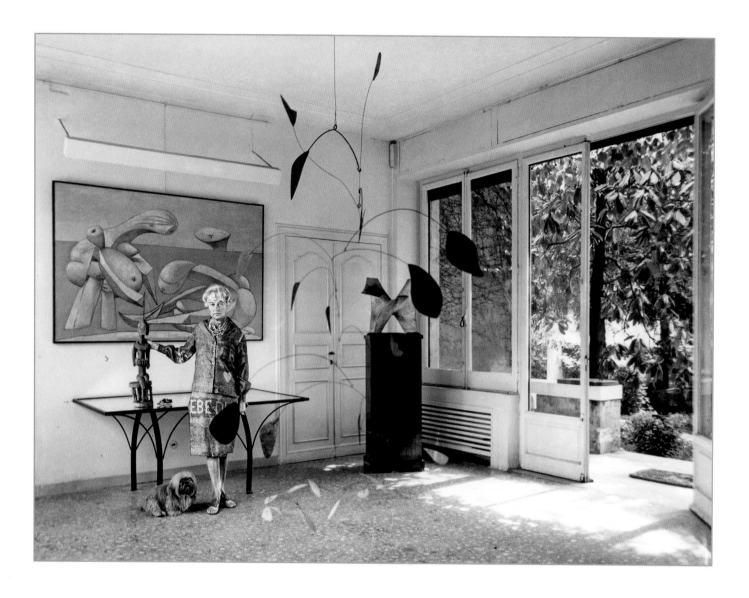

She vowed to "buy a picture a day," accumulating revolutionary and provocative masters without negotiating the price, "because everything was so cheap at the time." Thus, while Hitler was invading Norway, Peggy was in Fernand Léger's studio to purchase a painting, one of the many she managed to save during the war by taking them to New York, where she opened a new gallery, Art of this Century, featuring European avant-garde works, and married another artist, Max Ernst. In 1948, after having exhibited her collection at the Venice Biennale, Peggy decided to settle in that city. She bought the Palazzo Venier dei Leoni and lived along the Canal Grande with her army of small dogs. She spent the rest of her life in Venice, the city where "there is no normal life, because everything and everyone floats," she said, the city where "the reflections are more beautiful than those of the great artists." She left a museum bearing her name and that today, with 326 artworks by more than 100 artists, is one of the most important in the world, attracting millions of visitors every year.

60 and 61 1961: Peggy Guggenheim posing with one of her beloved Pekinese in her Venetian home along the Grand Canal. She is standing in front of a painting by Picasso and next to a work by Alexander Calder, the artist she asked to make the head of her bed in the other photograph.

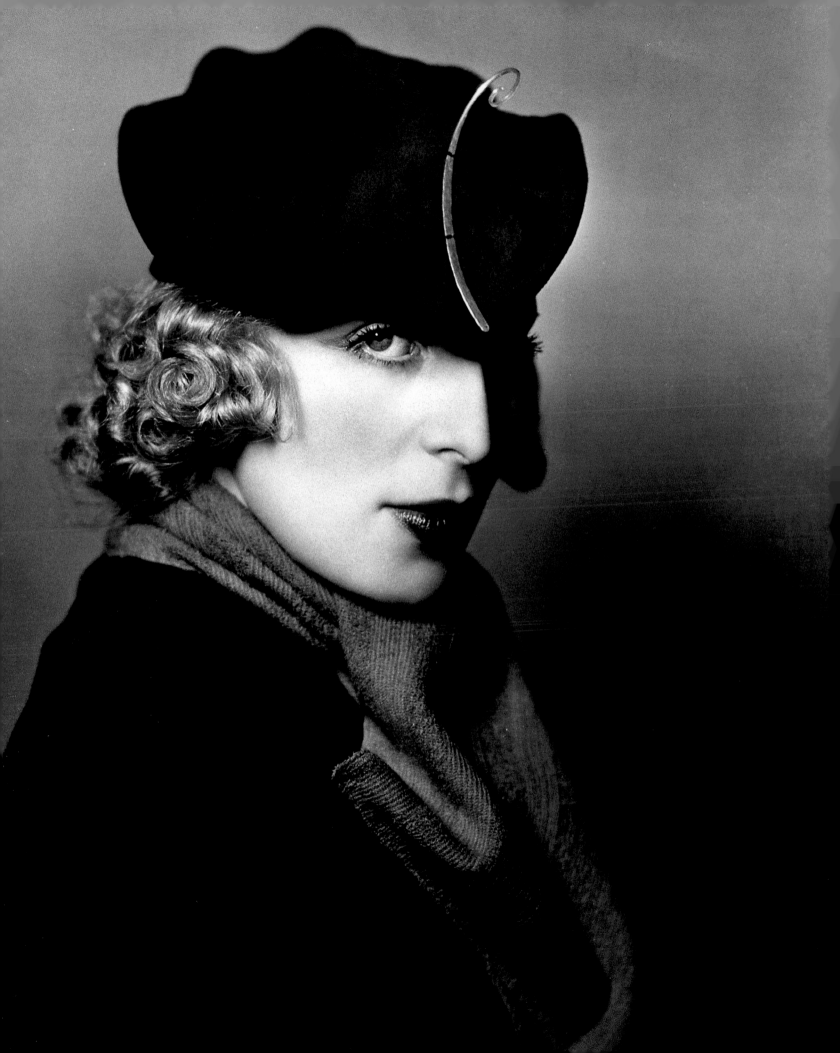

Tamara de Lempicka

Aristocratic and glamorous, transgressive and a free spirit, a star of the cosmopolitan jet, and an Art Déco icon. Tamara loved women and fashion, depicting them with superb craftsmanship in her portraits of beautiful and cheeky Amazons, who are just like her.

With her oblique glance, veil over her eyes, pearls and diamonds like a diva, Tamara was in her element, like a professional model posing for the photographers of *Vanity Fair* and *Die Dame* while smoking her three daily packs of cigarettes one after the other. She carefully planned the creation of her image and knew how to mix life and art, thus making herself a celebrity of legendary proportions. During the dazzling Roaring Twenties in Paris, Tamara shone like a star, embodying to perfection a role that in the society of that period was unprecedented – a professional woman artist. The Salon d'Automne, where she exhibited her works for the first time in 1922, had been an awesome springboard for her canvases, which enjoyed huge success thanks to her bold combination of classical art and the new Cubist current. Painting was the key that opened the doors of high society and aristocracy for Tamara, a world mirrored in her ambiguous portraits of *femmes fatales* with vermilion lips, rustling evening dresses made of silk, a telephone, and a Bugatti automobile. Her career began to wane when she married the rich art collector Raoul Kuffner de Diószegh (with a prematrimonial agreement that gave the artist total sexual freedom), together with whom she began the second season of her life, spent in the United States. At Beverly Hills, she hosted fabulous banquets, but her new abstract canvases were greeted with indifference by the critics. Tamara was so hurt by this that she thought of giving up exhibitions. She ended up withdrawing to Mexico, living in a splendid estate far from the hubbub of high society life. Near the end of her life, she left precise orders that her ashes be scattered over the Popocatépetl volcano: the final theatrical gesture of a diva on loan to painting.

Tamara Gurwik-Gorska declared she was born in Warsaw in 1902, but according to historical sources, she was born in Moscow three years earlier. When she was 18, she married the Polish count Tadeusz Lempicki, who was her first husband and the father of her only child, Kizette. They divorced in 1928.

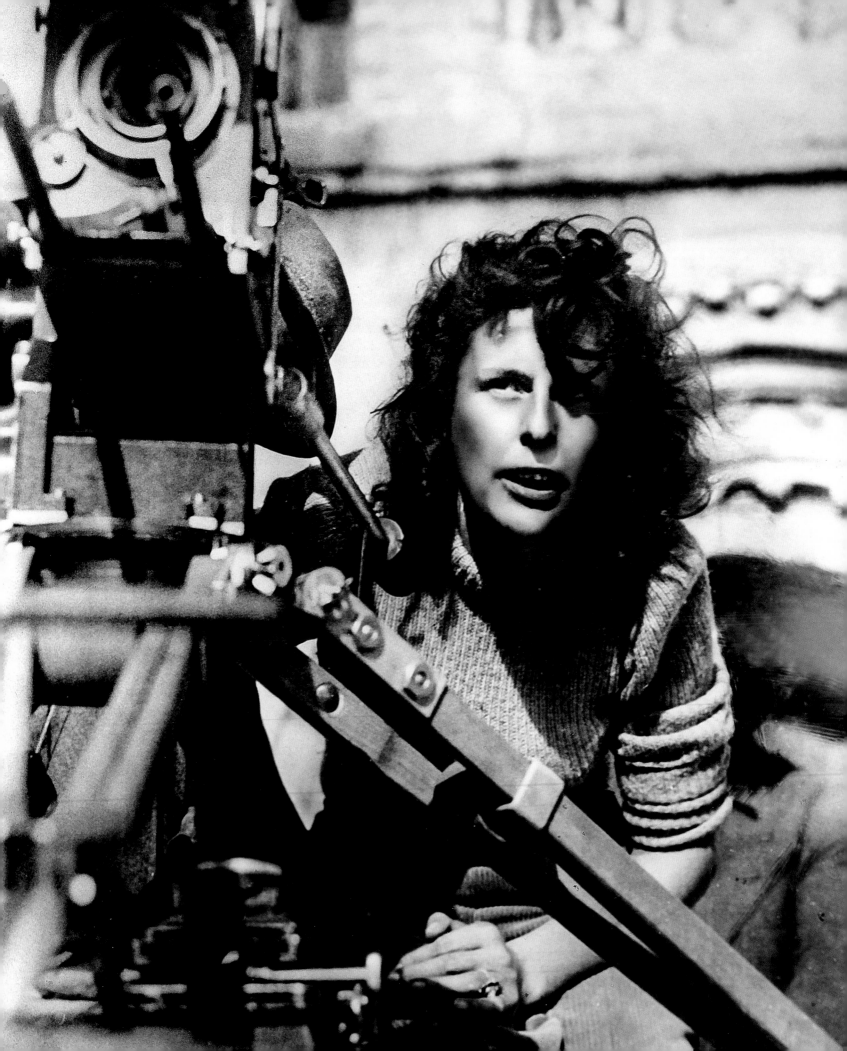

Leni Riefenstahl

August 22nd, 1902, Berlin, Germany • September 8th, 2003, Pöcking, Germany

The light and shadows of an extremely long life were suspended between genius and opportunism. Her black-and-white films celebrated the glory of the Third Reich; then she left her past behind her and immersed herself in the colors of Africa and the underwater world.

One warm spring evening in 1932, a couple was walking on a beach along the Baltic Sea talking about cinema and great ideals. The woman was the thirty-year-old Leni Riefenstahl, who was having a difficult time making a name for herself in the entertainment world. The man was Adolf Hitler, who was about to become the Führer and was bewitched by the fascination of this young film director, so much so that he promised: "Once we come to power, you must make my films." A year later, he kept his word and had her direct the films of the Nazi party's huge rallies, which Leni's masterful work transformed into powerful propaganda tools. International fame arrived with *Olympia*, which documented the 1936 Olympic Games held in Berlin, a grandiose film shot by a staff of 40 cameramen that took Riefenstahl two years to edit and was acclaimed by critics and public alike. She could count on all the best technology of the time to realize brilliant, pioneering techniques that produced memorable sequences. These included tracking shots, low-angle views of races, and mounting small cameras onto balloons and offering a reward to those who found and returned the filmed material. When World War II broke out, Germany seemed to be an irresistible force, and Leni followed the victorious troops with her cameras, at least up to the time the tide began to turn against Hitler. She was accused of being a collaborator of the Nazi regime, was imprisoned, and then acquitted by the war-crimes tribunal, which evidently believed her testimony and claims of innocence when she insisted she was merely a chronicler of the collective seduction the Führer had wrought on his people: "I only explained why millions of Germans believed in him."

Riefenstahl in 1940 on the set of the film *Tiefland*. This work was interrupted by the war and was finished only in 1954, taking its place in the annals of cinema as the feature film with the longest production time in history.

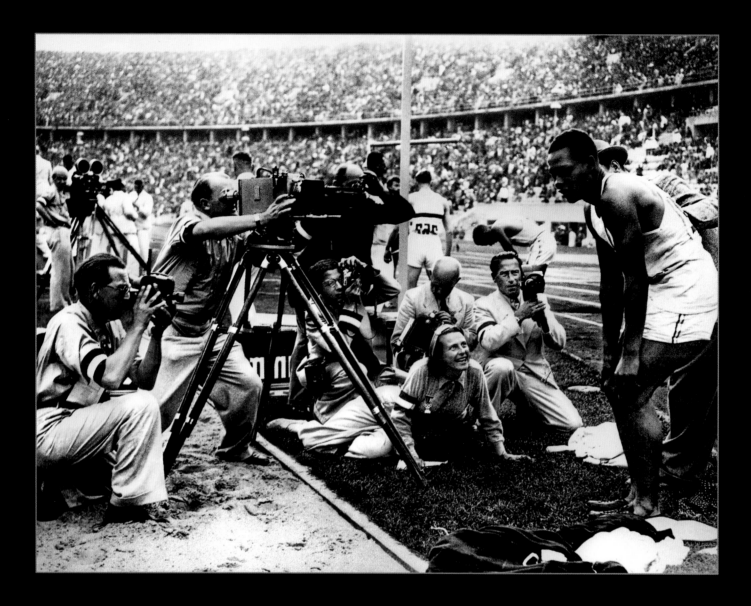

66 Leni Riefenstahl sitting on the grass, directing a scene of her masterpiece, *Olympia*, which documented the Olympic Games held in Berlin. This photograph was taken just after the African American Archie Williams had won the 400-meter dash on August 14th, 1936. Hitler had asked the great film director to capture every moment of the Games.

67 Leni during one of her stays in the Sudan. She began to visit Africa in the 1960s, documenting her trips with her camera in dozens of books, which then became the basis for two collections of photos, published in 1974 and 1976, that became very popular.

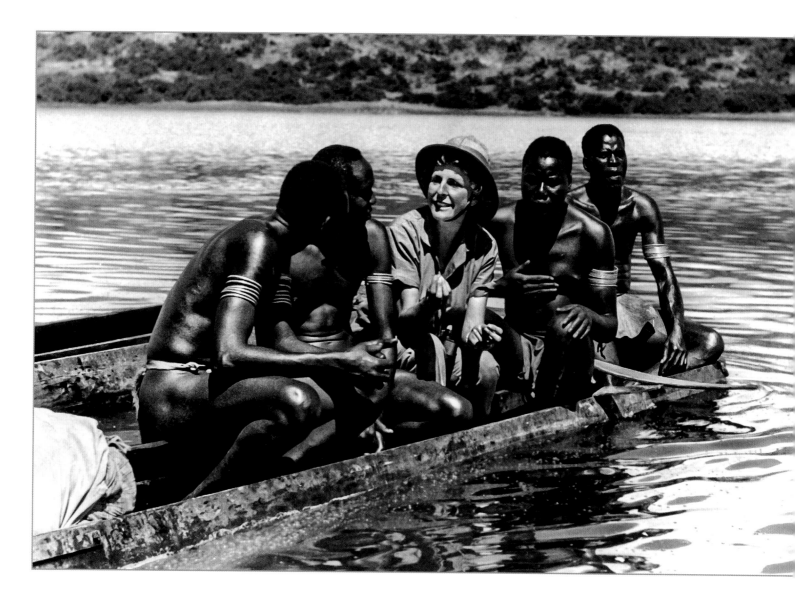

Now free but on the verge of committing suicide, Riefanstahl decided to leave Germany and seek refuge by abandoning the movie camera and replacing it with a "normal" camera. She traveled far and wide, including Africa, where she was enchanted by the sublime beauty of the Nuba peoples in Sudan. Leni learned their language, slept in their huts, shared their moments of work, rest, and festivities, and published exceptional photographs of them. At the age of 73, she still had a child's spirit and stamina and became passionate about underwater photography. And in 2002, when over 100 years old, she made her last film, the documentary *Underwater Impressions*, and married an assistant half her age. Then she said she was ready to end her terrestrial life. "The past has left such a shadow on my life that death will be liberation for me," she said, leaving behind doubts regarding her morality, as well as all the beauty of her absolutely extraordinary works, which defy all classification.

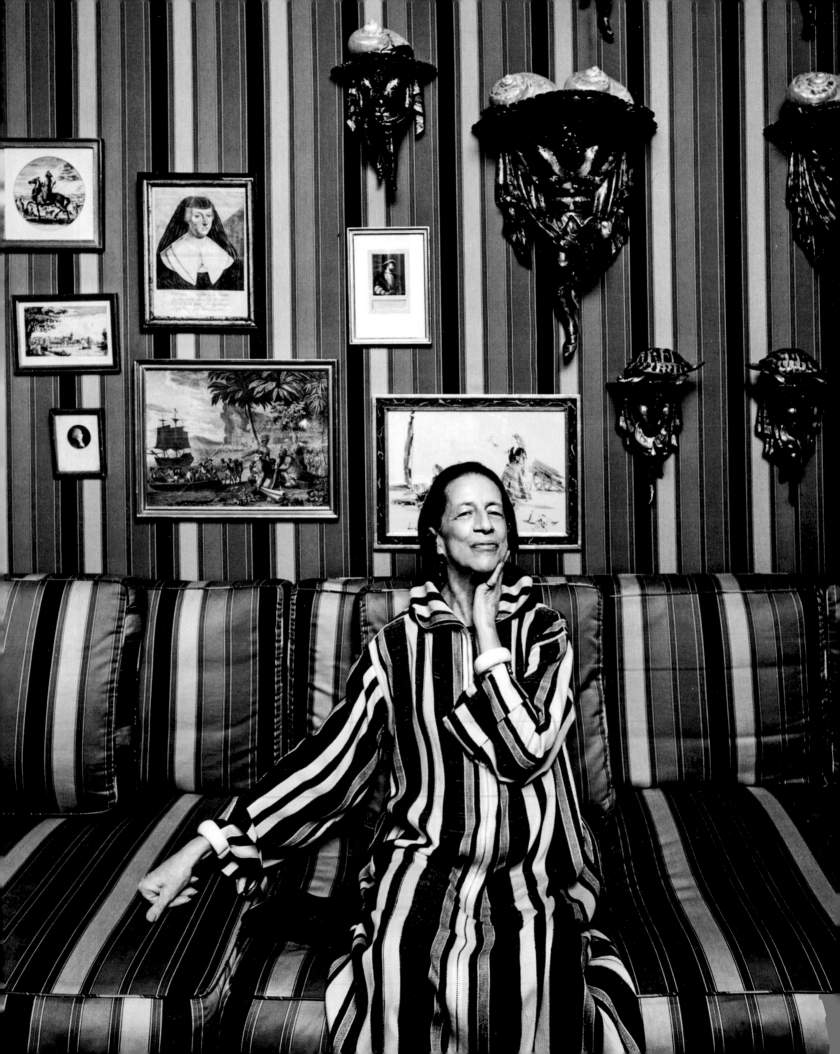

Diana Vreeland

She had charisma, good intuition, and an inimitable style, and was also gifted with caustic irony. When asked about the secret of her success, she replied: "The first thing to do, my love, is arrange to be born in Paris. After that, everything follows quite naturally."

This petite, thin woman with marked features and a large nose, was the absolute ruler of the fashion system for almost half a century, from the 1930s to the 1980s. A Parisian by birth and an adoptive New Yorker, Diana Vreeland married a banker when she was 21. At the age of 33, she began to work for *Harper's Bazaar.* And when she was 60, she became editor-in-chief of *Vogue,* when the pill, the miniskirt, and the Beatles were changing the world, and she succeeded in conquering a new generation of women readers who, like her, were irreverent and bold. Diana was gifted with infallible instinct, with radar that discovered promising persons and ideas. She was the first editor to put celebrities on the cover, concentrating on women with imperfect features who drew attention to themselves with their personality, such as Twiggy, Cher, and Angelica Huston. She asked Andy Warhol to illustrate the magazine because, long before any gallery owner ever realized this, her intuition had told her that that strange young man would make a name for himself. She launched the photographer Richard Avedon, who worked side by side with her for almost 50 years, invented the concept of lifestyle, and promoted aesthetic plastic surgery. She put the creations of young fashion designers such as Emilio Pucci, Manolo Blahnik, Missoni, and Valentino on the front page, making them superstars overnight. Only she could get away with saying, with reference to Hitler, "That moustache is horrible, just plain wrong." She alone could declare with utter certainty: "I always wear a sweater back-to-front; it is so much more flattering,"

July 29th, 1903, Paris, France · August 22nd, 1989, New York City, New York, United States

Vreeland was born in Paris in 1903. Her mother was the American socialite Emily Key Hoffmann, a descendant of George Washington, and the family moved to New York right after the end of World War I. In 1924, she married the banker Thomas Reed Vreeland.

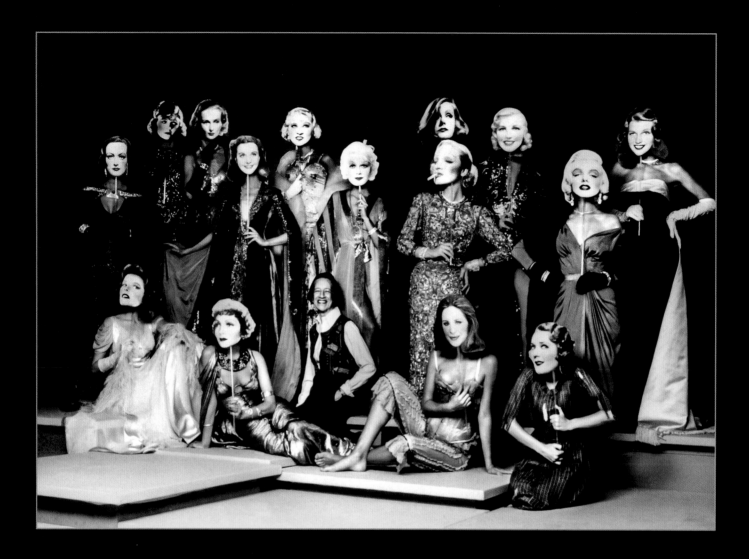

70 Diana in the middle of the first row, posing with models wearing the garments exhibited at the Metropolitan Museum of New York on the occasion of the exhibition *Romantic and Glamorous Hollywood Design*, which she organized in in 1974. Her friend Jackie Kennedy Onassis paid the following tribute to her: "To say Diana Vreeland has dealt only with fashion trivializes what she had done. She has commented on the times in a wise and witty manner. She has lived a life."

71 Vreeland lived in a large apartment on Park Avenue. She told the architect who was fitting out her home: "I want my apartment to look like a garden: a garden in hell," by which she meant flamboyant and abounding in shades of red, the same color she chose for her *Vogue* office (shown in this picture).

setting the trends in style by wearing almost outlandish tunics that extended to her feet, or simple turtleneck sweaters over black knit trousers, her jet-black hair with two 18th-century ringlets framing her long horsey face. Diana once stated: "Elegance is innate. It has nothing to do with being well dressed. Elegance is refusal." But she also said: "We need a splash of bad taste [...] No taste is what I'm against."

She lost her job at *Vogue* in 1971 but soon afterward was offered a position as consultant at the Costume Institute of the Metropolitan Museum, a titanic task for anybody but certainly not for her. After revolutionizing international fashion, she imposed her style not only on the institute itself, but on the entire museum, organizing historic exhibitions featuring Balenciaga and Saint Laurent, Hollywood costumes, and Russia. This woman, who enjoyed life to the full, transformed what should have been her sunset into yet another success, without ever resting and without letting anything pleasurable pass her by – including luxury, excess, and enjoyment. Because, as Diana herself said, "Never fear being vulgar, just boring."

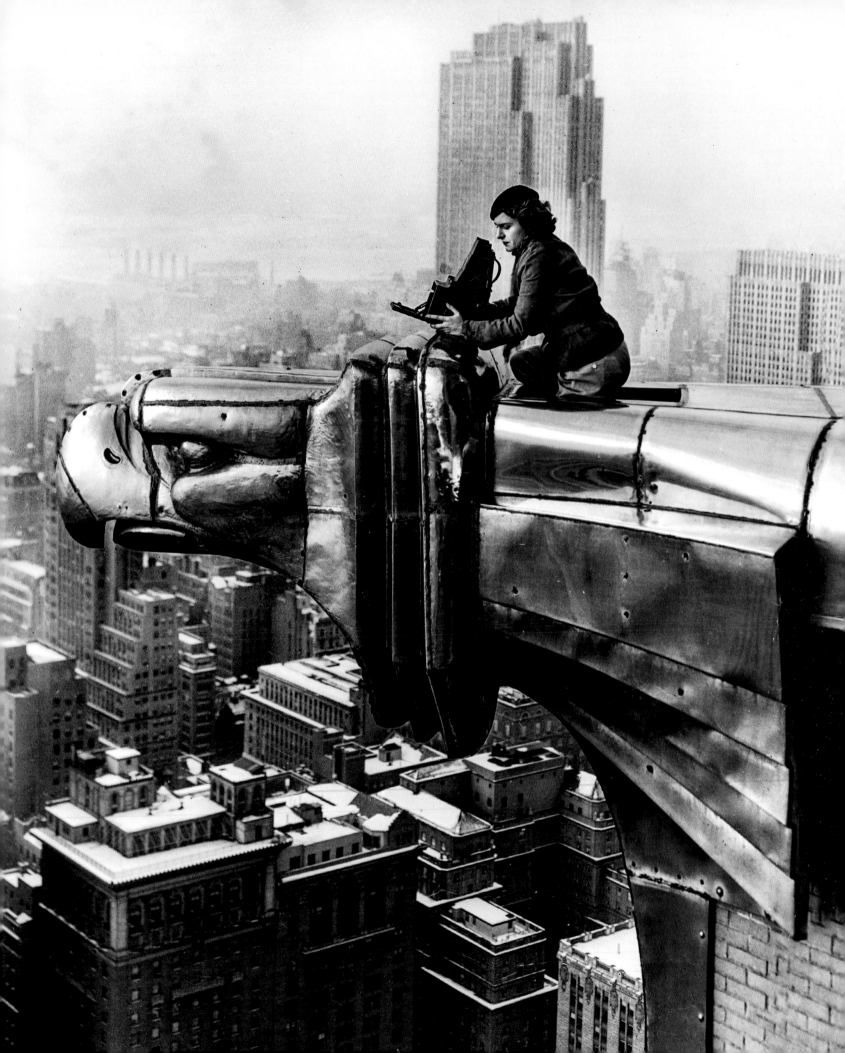

Margaret Bourke-White

June 14th, 1904, Bronx, New York City, New York, United States · August 27th, 1971, Stamford, Connecticut, United States

Her photojournalist work for *Life* magazine documented the major events of the 20th century. Thanks to her talent and courage, this intrepid woman set one amazing record after another and became a model for generations of women photographers.

For Margaret Bourke-White, taking photographs meant "finding something new, something unguessed in advance, something only you would find, because as well as being a photographer you were a certain kind of human being, and you would react to something all others might walk by." In search of that "something," she excelled in a man's profession without revealing any weakness (except the habit of always wearing clothes that went well with her camera case). Margaret grew up in the Bronx with a mother who always told her, "Reject the easy path. Do it the hard way," and a mechanical engineer father who took her to the factories where he installed printing presses. The first subject Margaret chose to photograph was the imposing steel mills in Ohio, which she metamorphosed into majestic cathedrals, among molten metal and huge reinforced concrete smokestacks. When the Great Depression struck the United States, she turned her attention to the drama of the Dust Bowl, a huge area in the central United States devastated by tremendous dust storms caused by disastrous agricultural policies. Her talent could not but be noticed by a publisher with such an extraordinary nose as Henry Luce, who made her the leading photographer for the magazine *Fortune*, and then, in 1936, offered her the honor and responsibility of the cover of a magazine that was destined to change the history of journalism, *Life*. Her picture of the Fort Peck Dam, as austere as an impregnable fortress, appeared on the initial issue of the magazine and made a sensation, soon becoming world famous and launching the career of Margaret, who from that time on set an impressive number of records.

Oscar Graubner took this photograph in 1935 in New York, immortalizing Margaret Bourke-White perched on the eagle head of a gargoyle on the top of the Chrysler Building, looking so elegant and serene at a height of almost 1000 feet (300 m). "Fortunately I was never really afraid of heights," she declared.

74 An indefatigable traveler, Margaret Bourke-White is seen here while preparing her suitcase. In 1937, she spent a long time in the southern United States with her husband, author Erskine Caldwell, in order to document and narrate the poverty of this area. Their reportage was later published as a book, *You Have Seen Their Faces.*

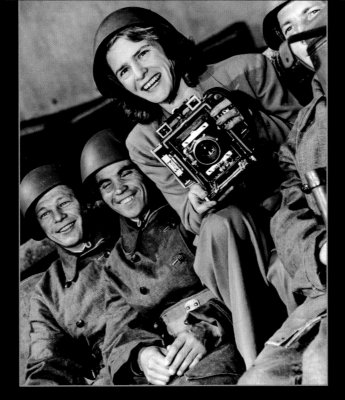

She was the first journalist to be granted a visa to go to the Soviet Union, where she documented the industrial revolution taking place there. At the outbreak of the war, she was allowed to stay on the front lines with the US troops, thus becoming the first accredited American war correspondent. She was the first person authorized to take photographs in a combat zone and the only foreign reporter who witnessed the Nazi invasion of Moscow, as well as the first woman to accompany the American fighter planes during their bombing campaigns against the Germans. "Register now, then reflect: history will judge" was the phrase she repeated in order to find the strength to shoot the most harrowing scenes. Her photograph of the prisoners standing behind the barbed wire fence at the Buchenwald concentration camp just after it had been liberated shocked the entire world. "Using the camera was almost a relief. It interposed a slight barrier between myself and the horror in front of me," she later said. After the war she flew to New Delhi to meet Gandhi, photographing him just before his assassination and witnessing his funeral, the only photographer beside Cartier-Bresson to be allowed there. When the tremor caused by Parkinson's disease began to compromise the sharpness of her shots, she abandoned photography, yet more proof of her prodigious willpower and of her honesty in coming to terms with the limits of her profession: "I like to do my work without lying, if I can. Telling the truth does not necessarily mean revealing the whole truth."

75 Margaret photographed with American soldiers during World War II. In the late 1930s, she was a photojournalist for *Life*, and most of her work was concentrated in Europe to document the rise of Nazism and Communism as well as the beginning of the war.

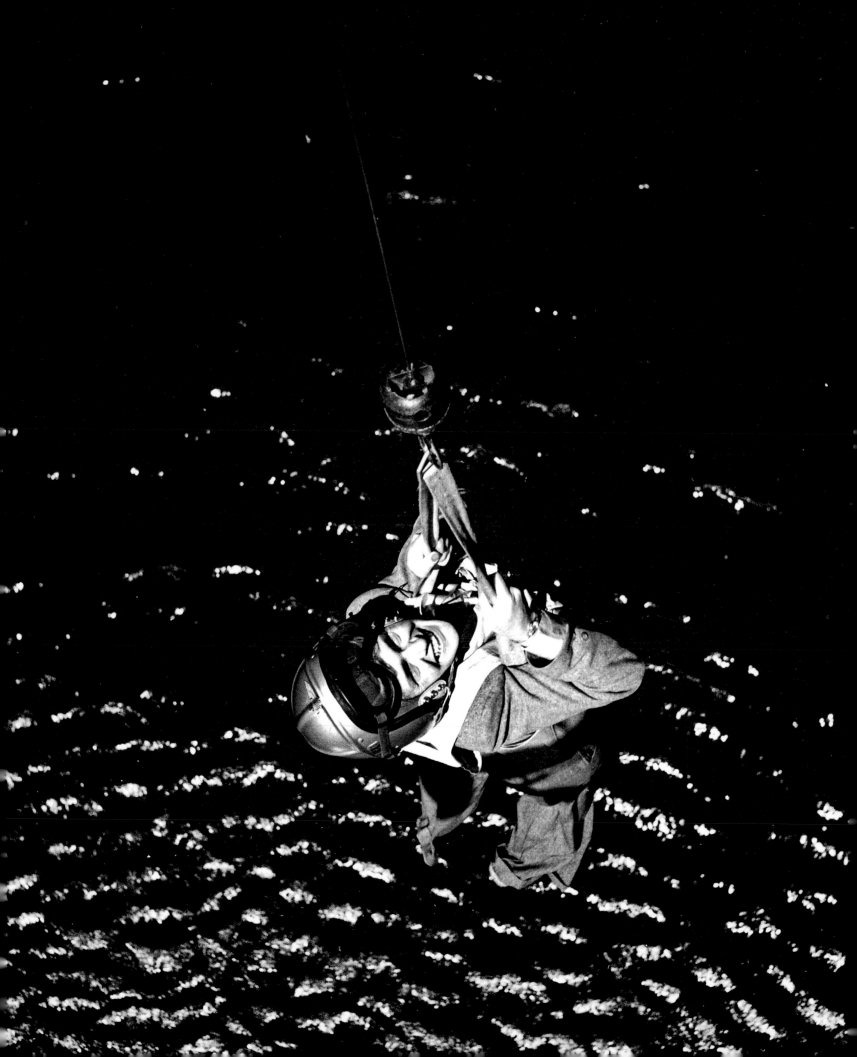

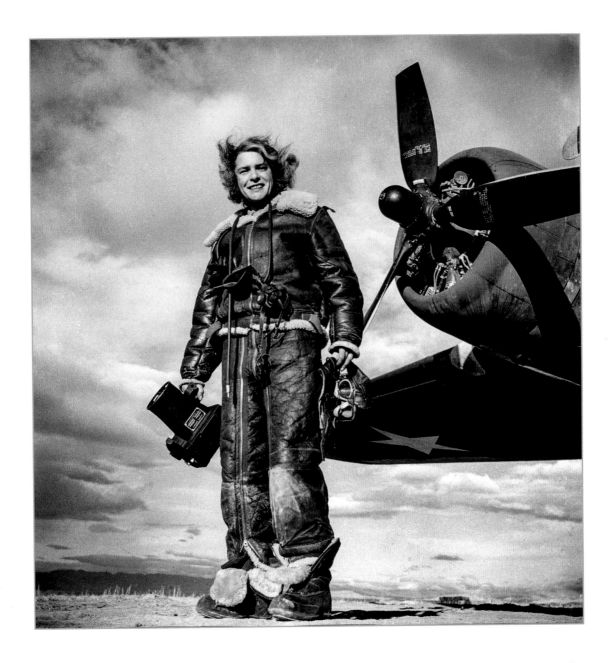

76 Margaret hanging from a helicopter in order to take shots of a US Navy rescue operation in 1951. The following year, during the Korean War, she took what she considered her best photograph: a Korean POW returning home and being embraced by his mother, which was described as the ideal combination of humanity and perfect timing on the part of the photographer, who was in the right place at the right time.

77 The photographer poses in front of the airplane she flew in to document the attack of the American troops on Tunis, in February 1943. Two years earlier, she had shot the first nonofficial portrait of Stalin ("the most ruthless man I've ever seen," she later said) and documented the German aerial bombardment of Moscow, taking sensational shots from the roof of the American Embassy there.

Estée Lauder

July 1st, 1908, Queens, New York City, New York, United States • April 24th, 2004, Manhattan, New York City, New York, United States

With a French mother, a Czechoslovakian father, and American inventiveness, Estée Lauder is the personification and the myth of the self-made American. Starting off from nothing, this woman introduced samples, founded a cosmetics empire, and made philanthropy a moral obligation.

"I never dreamed about success. I worked for it." This statement reveals the essence of the personality of Estée Lauder, the founder of one of the leading cosmetics empires, the only woman on the *Time* magazine list of the twenty most influential business persons in the 20th century. Her story – marked by talent, a great nose for business, and innovation – had humble beginnings in 1930, when she opened her first shop, earning the trust of her customers with an innovative sales technique called "talk and touch". This simple yet ingenious idea consisted in promoting her products by applying them on her customers' faces to demonstrate how effective they were and thus enourage them to make a purchase. A short time later came another stroke of genius: she skilfully obtained counter space at Saks Fifth Avenue, the luxury department store in New York City, which ordered 800 dollars of her product. And thanks to another brilliant idea, it sold out in less than two days, because the volcanic Estée offered a free sample of her products with every purchase. In 1992, Estée Lauder Companies initiated one of the most important campaigns to combat breast cancer, known as the Pink Ribbon. This initiative was begun by Estée's daughter-in-law Evelyn Lauder, who had entered the firm, demonstrating a talent for business worthy of her famous mother-in-law.

After eliciting the pride and vanity of a new generation of women, convinced that beauty is a moral obligation, a way of gratifying oneself first of all, Estée died at the age of 95 in her Manhattan home, leaving a company that now has almost 30,000 employees, hope for a cure for cancer, and one of her most famous quotations, which women should repeat every time they look in the mirror: "The most beautiful face in the world? It's yours."

Estée Lauder with a customer in 1966. Her relationship with her husband Joseph Lauder, who was also her business partner, was passionate but rather unstable. After the birth of their son Leonard, they divorced in 1939, only to remarry three years later (their second son Ronald was born in 1944) and remained together until his death in 1982.

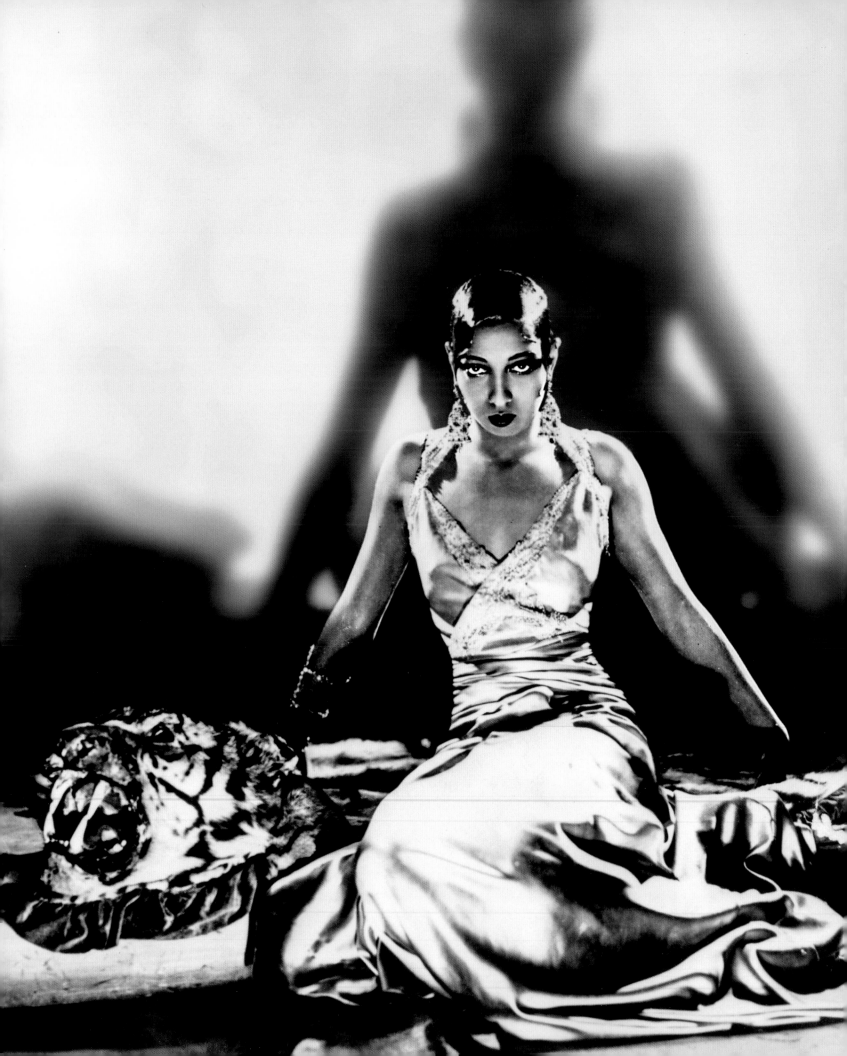

Joséphine Baker

She went from the ghetto in Saint Louis to the Champs-Elysées, where she made a sensation by wearing a skirt made of artificial bananas. Then she devoted her energy to combatting racism and adopted twelve children of different ethnic groups and religions, her "rainbow tribe."

Her name immediately evokes the image of an exuberant black Venus wearing a banana skirt who wiggles to the rhythm of the Charleston. A prisoner of a cliché that does not do justice to her real personality, the divine Joséphine Baker (with an accent on the 'e', in the French manner) was really an explosive combination of a sense of humor, humanitarian commitment, and a life that reads like a novel, filled with experiences that are beyond imagination. Joséphine was born in the black ghetto of Saint Louis, and when only seven was sent to work as a domestic for a white family who were careful to remind her every day "not to kiss their children." After leaving that house, she began to move her body to the music that at the time was the rage in every corner of the United States and she decided that dance would be her passport to freedom. At first, she performed in dives in Missouri, then on the stages of Broadway, and lastly, surrounded by the Art Déco stuccowork of the Parisian theaters, from the Champs-Elysées to the Folies Bergère. She arrived in France in 1925 with the *Revue nègre*, a show that was always sold out and mesmerized the Parisian public of those madcap years. Sensual, radiant, and beautiful, she "wore" nudity just as a queen would wear a wedding dress. With her instinctive eroticism and witty intelligence, she even managed to silence the conformists: "Who said that I was naked? I wasn't really naked. I simply didn't have any clothes on." She enchanted princes and diplomats, artists and writers.

Paul Colin designed the posters publicizing her spectacles, and Remarque (the author of *All Quiet on the Western Front*) wrote that Joséphine brought "a blast of jungle air, elemental

Baker photographed in 1927, when her career in Paris was at its height. She would befuddle critics with her amazing sayings ("I dance very well, but my shadow dances better than me.") and walked along the Champs-Elysées with her pet cheetah Chiquita, who accompanied her during her shows, while some spectators seated at the café tables were frozen with fear.

June 3rd, 1906, Saint Louis, Missouri, United States · April 12th, 1975, Paris, France

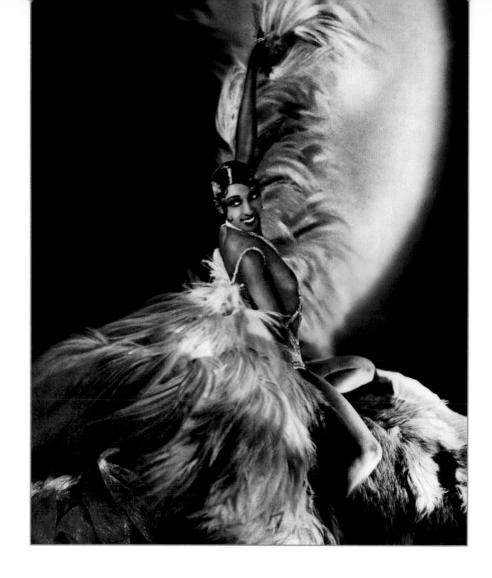

power and beauty to the weary Western civilization"; Hemingway adored her ("The most sensational woman anyone ever saw. Or ever will."), and Georges Simenon always sat in the first row for her performances.

However, Joséphine fell in love with a gigolo who became her manager. She married three times but had to wait for her fourth to find her true love, the orchestra conductor Jo Bouillon. When the Germans occupied France, she felt the time had come to make herself scarce, since her brown skin was no longer appreciated. But the truth is that she loathed Nazism and so rebelled, in her own way. She sang for the Red Cross and the soldiers at the front, then became a spy. Her international tours were like the "telegraph service" of the French Resistance, as she smuggled messages in code in her sheet music.

82 Joséphine Baker's performance apparel is legendary. Dressed only in feathers, and at times not even, she bewitched the public by wiggling to the rhythm of song such as *Yes, we have no bananas, Voulez-vous de la canne à sucre?* and *La conga blicoti*, combining typical risqué elements of French vaudeville and the rhythms of African music.

83 Acclaimed in France, Baker (seen here in a 1927 photo) went on tour several times in the United States, where racial prejudice was still very strong. In 1951, she was not allowed to dine at the famous Stork Club in New York City, and a young actress defended her: it was Grace Kelly, who became Josephine's dear and loyal friend for the rest of her life.

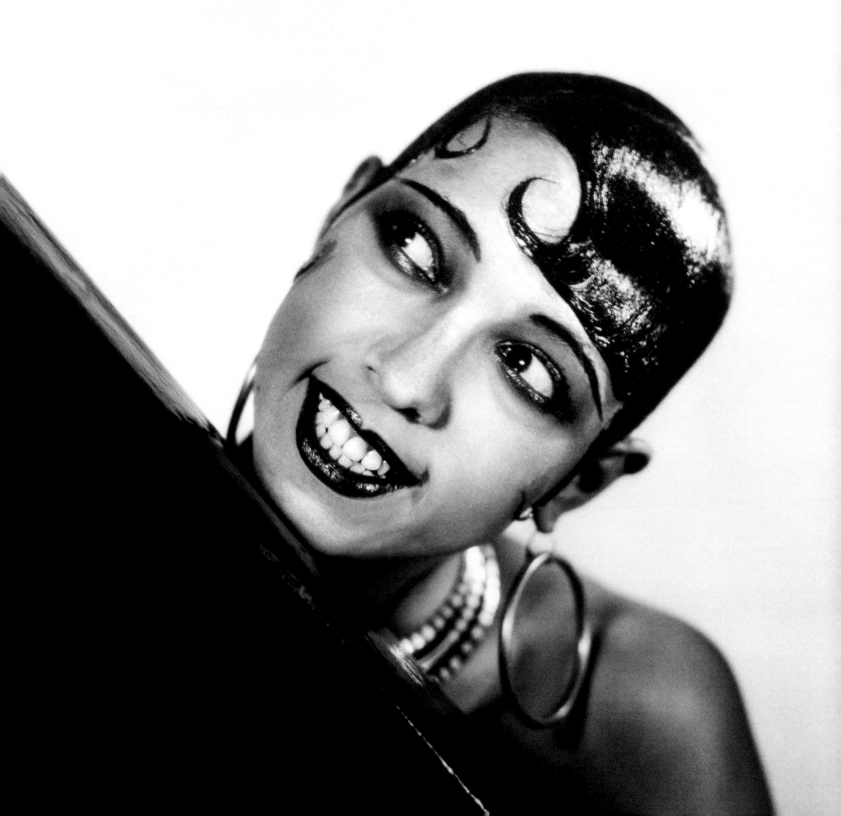

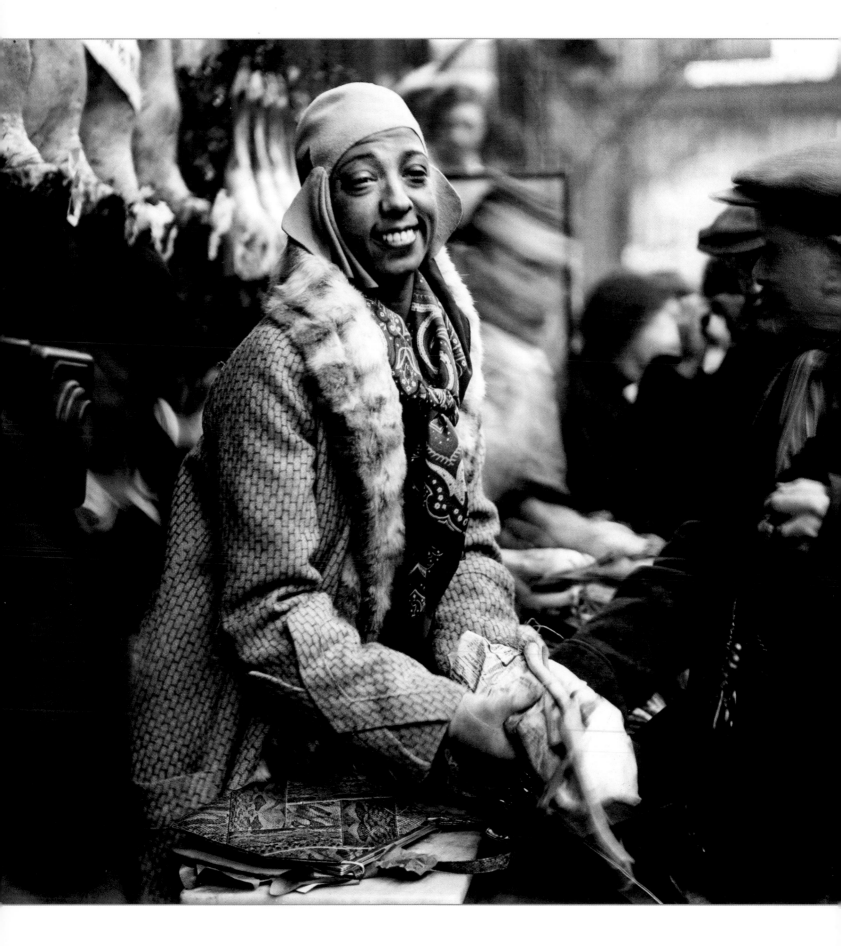

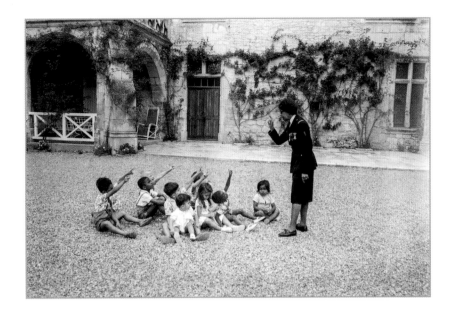

When the war ended, she became active in the Civil Rights Movement, alongside Martin Luther King. She gave free concerts, took part in antisegregation marches, and gave speeches wherever people were willing to listen to her. In order to show that equality is not a utopia, she adopted twelve children of different "races" and religions and took them to live in an estate she had purchased. But she always had financial problems, and was helped by Brigitte Bardot and Grace Kelly, her close friend who became the princess of Monaco and offered her refuge in the French Riviera. Josephine was 68 when she made a comeback on stage, but died a few days after opening night. A huge crowd took part in the funeral procession, which was also on television; this was the world's last tribute to the generous black dancer who was a woman of a thousand colors.

84-85 Joséphine Baker distributng food to the needy Parisians of Montmartre on January 20th, 1930. For her commitment to humanitarianism and activity during the resistance, after the war the French Government awarded her two of its highest military honors, the Legion of Honor and Croix de Guerre.

85 Joséphine together with her adopted children at Les Milandes, the estate in Dordogne where she lived with her "rainbow tribe" together with her husband Jo Bouillon. Adopting 12 children of different nationalities, ethnic groups, and religions was her way of combatting racism and showing the world that people can live together in peace and harmony.

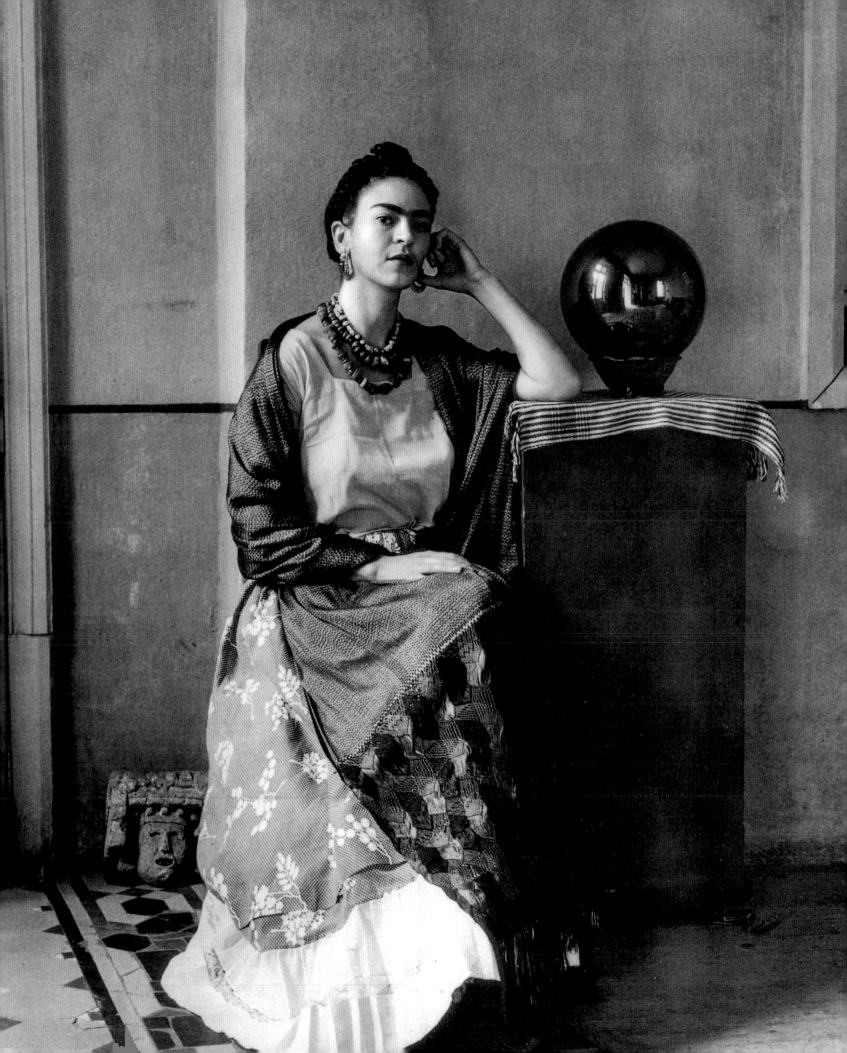

Frida Kahlo

Her fragile body concealed an indomitable spirit. With her brushwork, passion, and revolutionary ideals, she transformed her weaknesses into artworks that celebrate the beauty of imperfection.

"There have been two great accidents in my life. One was the trolley, and the other was Diego. Diego was by far the worse." Frida Kahlo's life was encapsulated in this statement, a perfect description of an existence marked by long illness and great passions. She was born with spina bifida (which the physicians diagnosed incorrectly, treating her for polio), and when 18, she was going home on a school bus when it collided with a trolley. It was a horrific accident. She survived miraculously, but was injured so badly that she had to undergo 32 operations. Bedridden for a long time, she began to paint her feet sticking out of the blankets ("Feet, what do I need them for if I have wings to fly?" she wrote in her diary). Then she painted the rest of her body, studying it in the large mirror her parents had mounted on the canopy. Frida's reply to those who asked her why she did so many self-portraits was: "I paint myself because I am so often alone and because I am the subject I know best." Thus began the long series of famous self-portraits, in which she was dressed in brightly colored traditional Mexican dress, her hair arranged in elaborate braids that made her look like a queen. Her king would be the artist Diego Rivera, who was twenty years her elder and was one of the most renowned Latin American artists. They fell madly in love and supported the cause of the laborers and native Mexicans, traveled widely, and frequented leading intellectual circles. But their marriage was undermined by the fact that Frida was so fragile she could not have the children she so desperately wanted, and also by Rivera's continuous womanizing, a situation that came to a climax when Frida discovered him with her sister Cristina. They divorced in 1939 and remarried the following year.

The daughter of a German photographer and a Mexican woman, Frida always insisted her birthdate was July 7th, 1910, but she was really born three years and one day earlier. This quirk had nothing to do with a desire to appear younger, but was her way of feeling she was a "daughter" of the Mexican Revolution, which began precisely on that year. This photograph was taken around 1938 in the Casa Azul at Coyoacán.

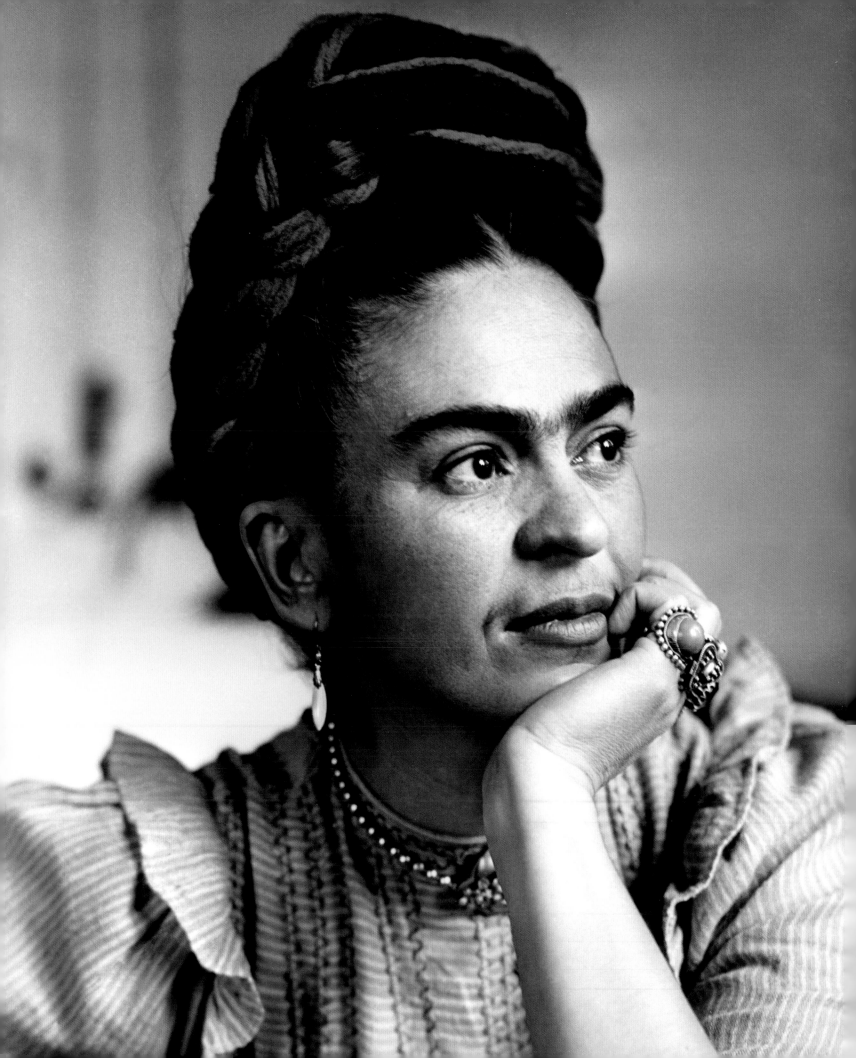

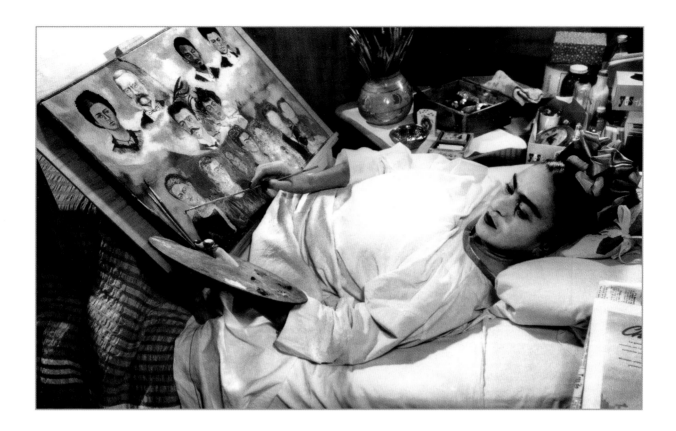

But by this time the disillusioned Frida had learned to give Diego a taste of his own medicine; she attracted both men and women and had passionate affairs with Leon Trotsky, with the photographers Nickolas Muray and Tina Modotti, and with the singer Chavela Vargas. This infidelity seemed to spark her art and stimulate her to travel and become acquainted with other artists and writers such as André Breton, who invited her to exhibit her works in Paris. She became famous when the Louvre purchased one of her self-portraits and no longer needed to have a man by her side to support and encourage her. In the late 1920s, she was a true celebrity, but her health was worsening day after day, so much so that when in 1953 an exhibition featuring her works was organized in Mexico City, she arrived at the opening lying on a bed that was transported there for the occasion. The pain was relentless, but Frida did not give in and continued to paint, up to the end, loyal to the motto she wrote with a blood red brush on a watermelon in her last painting: *Viva la vida!*

88 Frida's facial features are clearly seen in this close-up, revealing her mother's Mayan origin and her thick eyebrows, as well as the braids crowning her head, which became her "banner." She never attempted to conceal or alter her physical defects, not even the black bristles above her upper lip: "Beauty and ugliness are mirages, because others always end up seeing what's inside us," she stated.

89 In the latter part of her life, Frida was forced to paint while lying in bed. This photo, dating to 1952, shows her painting *My Family*, a sort of genealogical tree that remained unfinished. "I'm not sick, I'm broken. But I am happy to be alive as long as I can paint," she said. She died two years later.

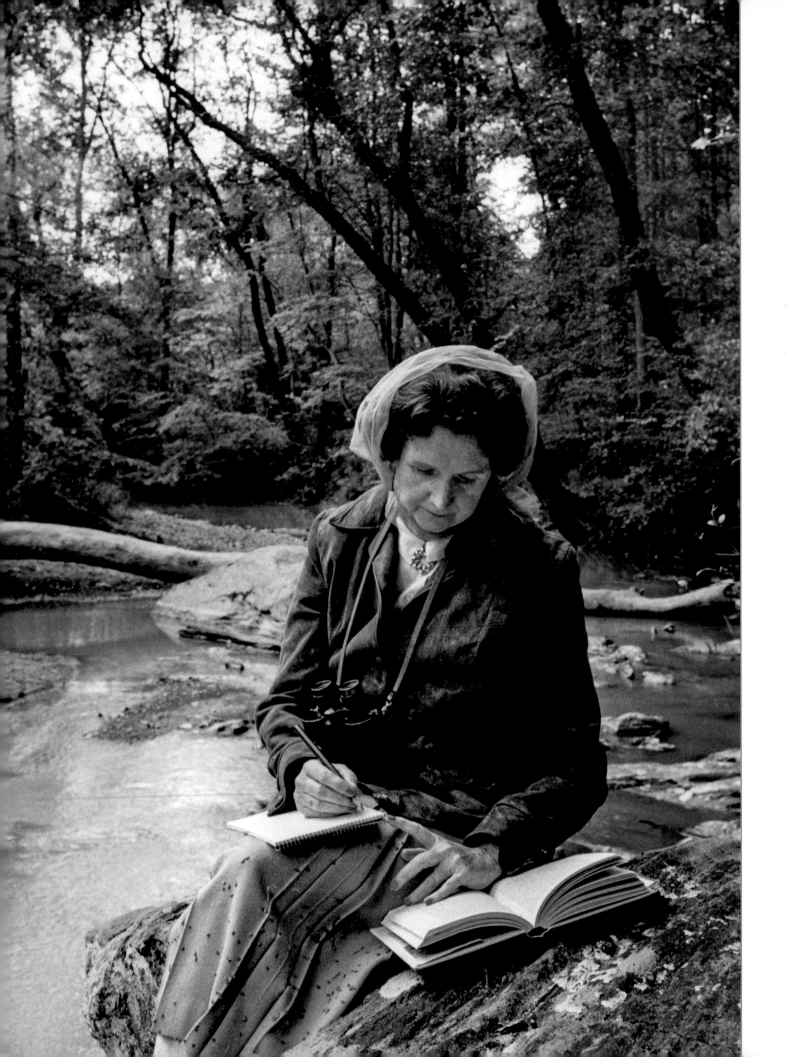

May 27th, 1907, Springdale, Pennsylvania, United States • April 14th, 1964, Silver Spring, Maryland, United States

Rachel Carson

The year 1962 witnessed the publication of *Silent Spring*, the book that sparked the birth of the environmental movement. The author was a passionate scientist and an elegant writer who was able to captivate the world with the power of her prose.

Spring had arrived in the garden that surrounds Rachel Carson's home in Maryland. The trees bloomed, but a strange silence prevailed; one could not hear the swallows chirping, insects buzzing, and the small rodents scurrying. Rachel meditated on these changes; she asked herself why they had taken place and found the answers in research that she would later publish in a book that was destined to change not only her own existence, but also that of a wide swath of humanity. She gave it the title *Silent Spring*, referring to the abnormal silence in the countryside, where the massive doses of pesticides were sweeping away various species of animals as well as parasites. "The more I learned about the use of pesticides, the more appalled I became," she wrote, explaining the origin of her research. "What I discovered was that everything which meant most to me as a naturalist was being threatened..." Rachel had loved nature since she was a little girl, observing the plants and animals in the family farm in Pennsylvania, where she had grown up, and was an avid reader of Beatrix Potter's illustrated books. She dreamed of becoming a writer but ended up earning a degree in zoology, after which she specialized in marine biology and worked in this field for the US Bureau of Fisheries, the second woman to have achieved this goal. In 1962, her *Silent Spring* was first published in installments in the *New Yorker* and them came out in book form. It enjoyed immediate success and prompted strong reactions. On the one hand, the book stirred the conscience of many Americans, while on the other, it was ferociously attacked by the chemical industry and the political Establishment. Accused of being hysterical, emotional, alarmist, and unscientific, Rachel was also denigrated in cowardly fashion by Ezra Taft Benson, the

Rachel Carson in a photograph taken by Alfred Eisenstaedt in 1962, the year *Silent Spring* was published. Carson died in April 1964, after a long battle with cancer; that same month, one million copies of her book had been sold.

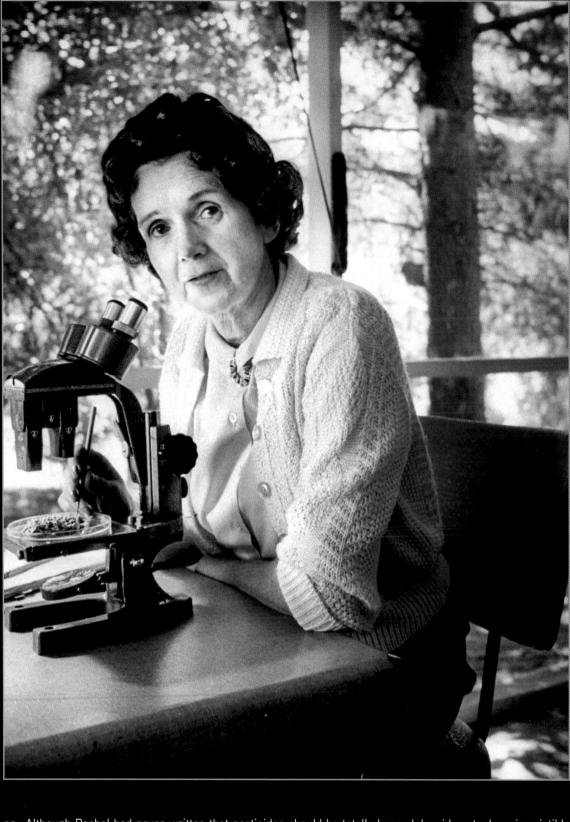

92 Although Rachel had never written that pesticides should be totally banned; her ideas took on irresistible power. President Kennedy set up a scientific committee to evaluate the matters discussed in her book, and in 1972 President Nixon banned the use of DDT in American agriculture.

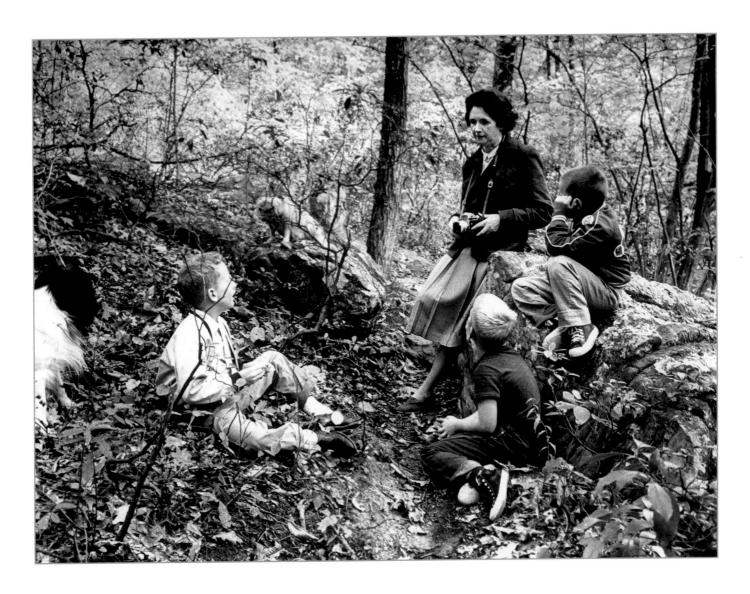

former Secretary of Agriculture, who wondered why a spinster should be so interested in genetics and stated that she was "probably a communist." Yet that book not only discusses the damage produced by pesticide, but also addresses the much more complex problem of the relationship between humans and nature, calling into question the notion of unlimited and unmonitored scientific progress. This is why it was so crucial to the birth of the environmental movement. As Rachel Carson stated in a TV interview one year before her death, "The human race is challenged more than ever before to demonstrate our mastery, not over nature but of ourselves."

93 Carson in the woods near her house in Maryland. By combining her writing passion and scientific knowledge, in 1941 she published her first book, *Under the Sea Wind: a Naturalist's Picture of Ocean Life*, which was given good reviews but had few sales. When it reissued years later, it became a bestseller for two years as well as a documentary that won an Oscar in 1953.

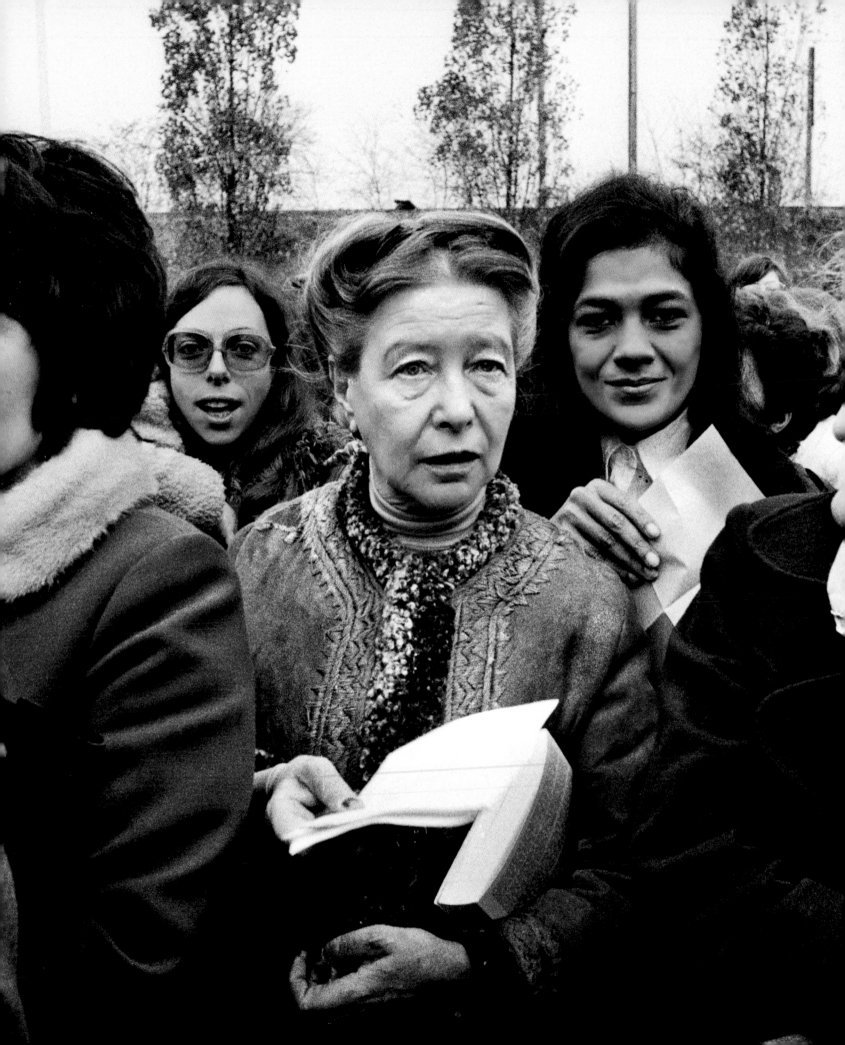

Simone de Beauvoir

What does it mean to be a woman? The answer is condensed in a sentence uttered by Simone de Beauvoir that became a battle cry of worldwide feminism: "One is not born, but rather becomes a woman."

Even when she was a little girl, she did everything possible to escape from the oppression that the women of her time had to bear. She refused marriage and maternity in order to never have to depend on a man. She decided to become a writer to fight her political battles in her novels and essays. She also decided to go to the Sorbonne to become a teacher so that she could spread her ideas and beliefs. And it was precisely while studying there that she met her life-long companion, the philosopher Jean-Paul Sartre, in 1929. Simone de Beauvoir left her family to be with him, becoming his lover, but only under one condition: each was to be totally free to have other romantic affairs. Their 50-year relationship, which became famous in the setting of the postwar Saint-Germain-des-Prés quarter, was celebrated as the new model of the modern couple, cemented by intelligence, literature, and philosophy, and free of the shackles of monogamy and lies. This condition of equality led to Simone's becoming aware that she could have access to the men's world, their knowledge, and literature.

Her ambition to live a pioneer's existence by publishing writings as explosive as those of her lover, was soon realized with the publication of her masterpiece, *The Second Sex*, a book that was to change the world much more than Sartre's works. This thousand-page essay, which came out in 1949, plummeted onto modern cultural history with the impact of a large meteorite. In stark opposition to a millenary philosophical tradition, De Beauvoir demolished the idea that obedience, faithfulness, and silence were typical female virtues. Her analysis of abortion, marriage, the female

January 9th, 1908, Paris, France • April 14th, 1986, Paris, France

Simone De Beauvoir in a 1971 photograph. In 2008, to celebrate the centennial of her birth, the *Simone de Beauvoir Prize for Women's Freedom* was established. It is awarded every year on the day of her birth to those who fight for sexual equality, women's freedom, and human rights.

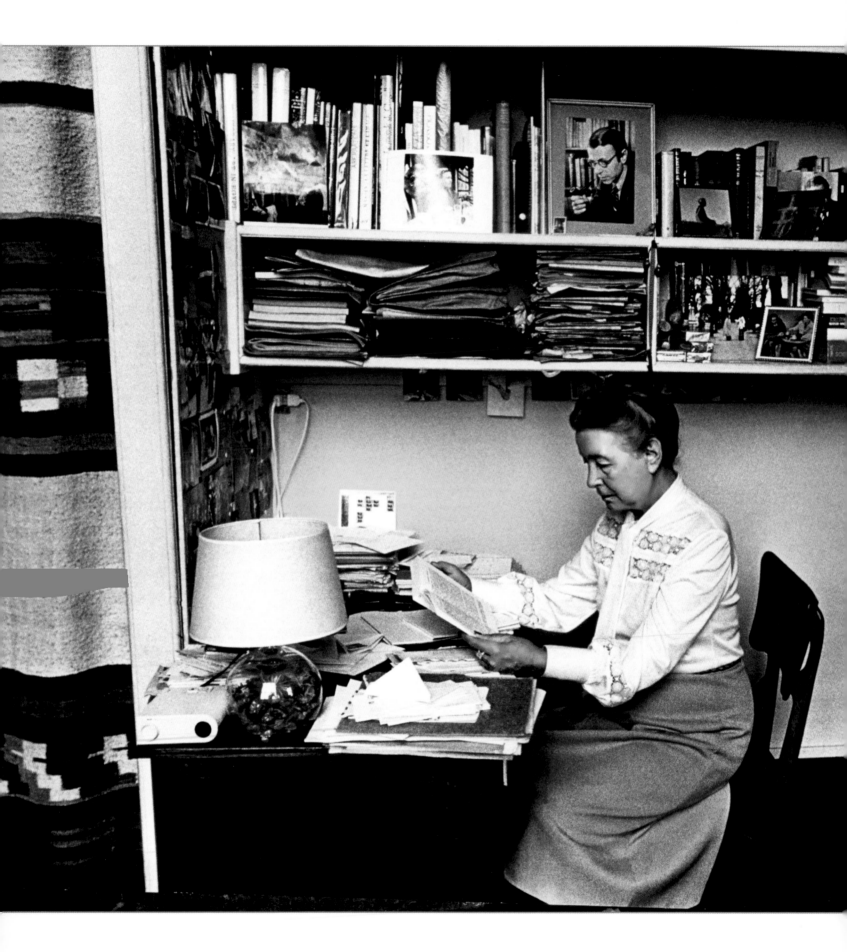

anatomy, and maternity dealt with subjects that until that time had never been discussed so openly, and, consequently, the Vatican put it on the Index. Publishing novels that enjoyed success and having been the champion of the feminists during the 1968 student protests were not enough for Simone, as she continued to devote much energy to such ticklish subjects (at that time) as old age, death, and renouncing religion. Her atheism is well expressed in her statement that God became an abstract idea that she cancelled one evening, while *A Very Easy Death* (1964) is an intense and moving book dedicated to and about her mother that deals with the end of life. In 1981, she published *Adieux: A Farewell to Sartre*, her last great literary work, in which she sought comfort in words in order to overcome the anguish she felt over her lifelong friend's death. She died six years later, leaving behind a key that would help women to open the cages in which they are trapped and attain immense freedom: being able to choose whether to be with or against her.

Simone in her home in Paris. In 1943, she published her first novel, *She Came to Stay*, a fictionalized account of the ménage à trois she and Sarte experienced with one of his female students. This was followed by such popular works as *The Blood of Others* (1945), *The Mandarins* (1954), and *Memoirs of a Dutiful Daughter* (1958).

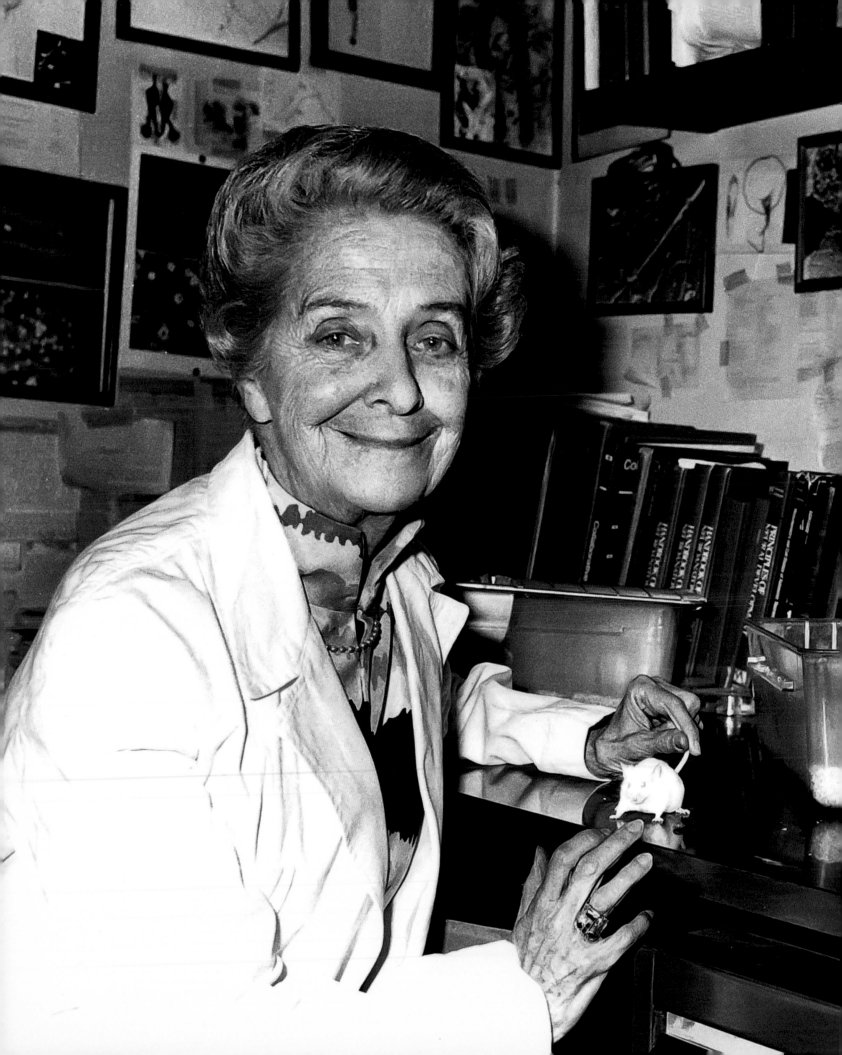

Rita Levi-Montalcini

April 22nd, 1909, Turin, Italy • December 30th, 2012, Rome, Italy

When she was three years old, she decided she would never marry so that she could devote her (very long) life to science. In 1986, she was awarded the Nobel Prize for Medicine, but she once said, "My intelligence? More than mediocre. My only merits have been commitment and optimism."

She had the sweetest smile, as well as a constitution of steel. When her father tried to deter her from attending university because she was a woman, she put her foot down and enrolled in the Faculty of Medicine. When the Fascist regime barred her from working at the University of Turin because of her Jewish origin, she built a small laboratory in her house and continued her research. By the end of World War II, her work had achieved such status that she earned a fellowship to do a semester of research at Washington University in St. Louis. The semester lasted 26 years and yielded ever more promising results. In the university laboratory, Rita Levi-Montalcini began to intuit that man begins from a single cell but with time becomes an organism of dozens of different tissues, and this led her to isolate the NgF (Nerve Growth Factor) in the early 1950s. "The discovery of Ngf," the Nobel Committee stated 30 years later when awarding her and her colleague Stanley Cohen the Nobel Prize, "is an example of how an acute observer can elaborate a concept out of apparent chaos." A convinced feminist, Montalcini participated in the campaigns to legalize abortion and fought for equal rights for female researchers. But she always retained her feminine grace and charm, and the illustrations she drew for her scientific papers were as elegant as the clothes she designed for herself. Again, she never forgot to listen to the voice of her heart as well as the voice of reason: "Everyone says the brain is the most complex organ of the human body; as a doctor I agree. But as a woman I assure you that there's nothing more complex than the heart. Even today we aren't certain of its mechanisms."

In 1992, Rita Levi-Montalcini, together with her twin sister, Paola, established the foundation named after her, the aim of which is to foster the integration of young persons into the world of research and to grant fellowships to African female students in order to strengthen the role of women in that continent. In keeping with her long-standing commitment, Levi-Montalcini used the Nobel Prize money to help young neurobiology students and researchers.

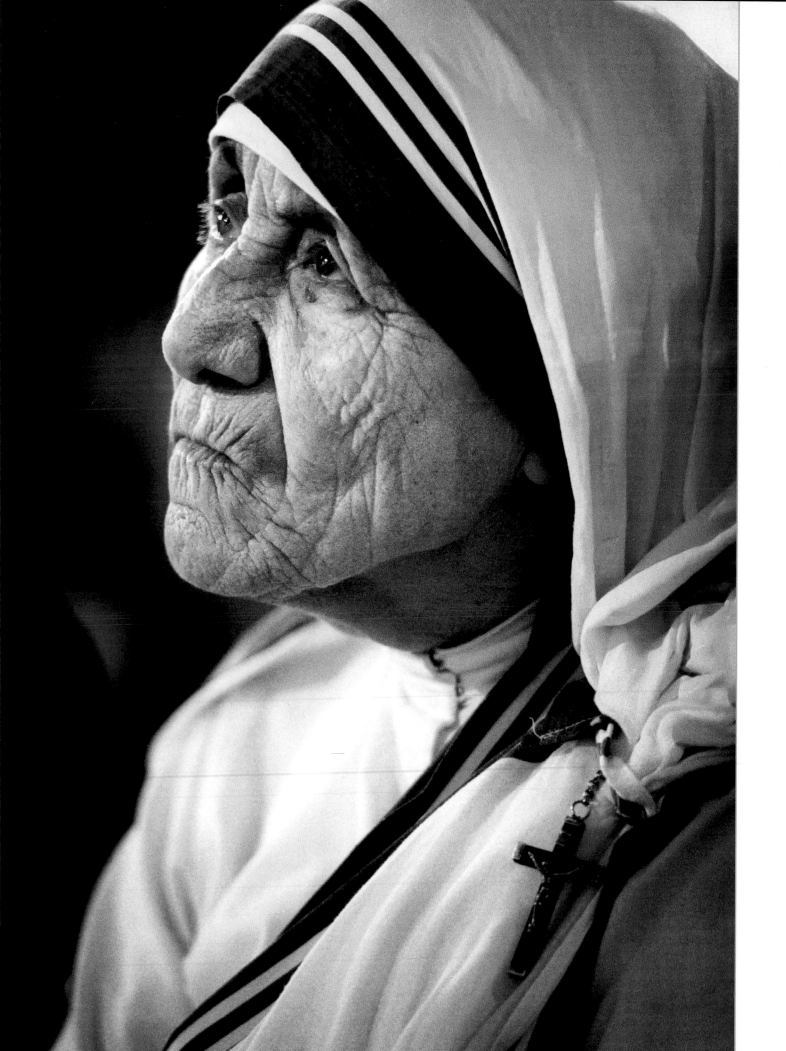

August 26th, 1910, Skopje, Republic of Macedonia • September 5th, 1997, Calcutta, India

Mother Teresa

It's true, she was as tiny as "God's pencil," as she used to say. But she had the strength and stamina of a giant. Mother Teresa dedicated her life to the poor while experiencing a dramatic religious crisis that, however, did not prevent her from becoming a saint.

At the formal banquet of the 1979 Nobel Peace Prize ceremony, among the men in tuxedos and women in evening gowns, she came dressed as usual, wearing a cotton sari and sandals. She was radiant, not so much because of the award she was about to receive, but because it included a check for one million dollars, to which were added the expenses of the traditional banquet in her honor, which she cancelled so that every penny could be given to the poor. The impulse to help those in need was instinctive in the heart of this woman and dated back to her childhood in the Balkans, when she was known as Anjeza Gonxha Bojaxhi, or Rosebud. The Jesuit missionaries' accounts of their experiences in Bengala had so fascinated her when she was a child, that she took her vows and completed her novitiate in Darjeeling, at the foot of the Himalayas, choosing to be named after the French mystic Thérèse de Lisieux, the saint who was the quintessence of humility. She was a teacher, and later headmistress, of a Catholic school in Entally, Calcutta, but the daily sight of the hungry, the homeless, the lepers, and moribund in the slums distressed her more and more. So in 1948, the Vatican gave her permission to leave the order and live by herself among the poverty-stricken. Once she had learned the basics in medicine at a hospital, she was ready for her new life in a hut and was joined by a community of nuns that in 1950 became an officially established congregation, the Missionaries of Charity, who dressed in a sari with the colors of the pariahs, the poorest caste in India. "We ourselves feel that what we are doing is just a drop in the ocean.

Besides the Nobel Prize, Mother Teresa received an impressive number of honors and awards, including the US Presidential Medal of Freedom, which Ronald Reagan gave her in 1985. Today, her congregation has 6000 sisters in 130 countries, as well as brotherhoods of the Missionaries of Charity.

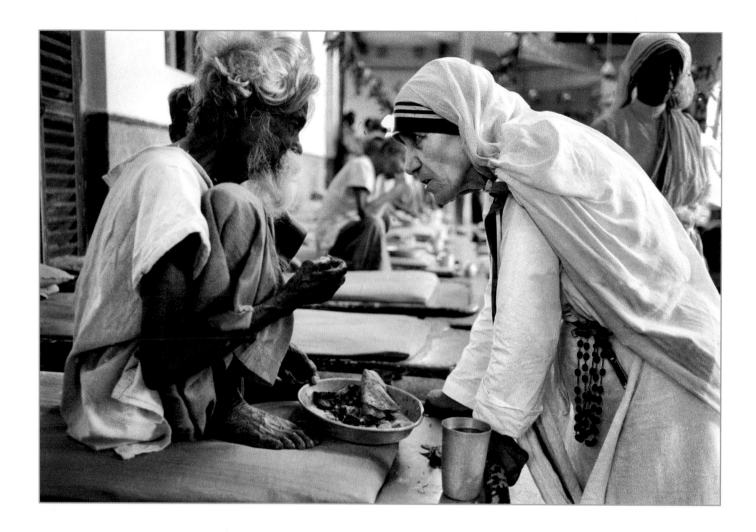

But the ocean would be less because of that missing drop," she would say while moving about asking for food and medicine for children and the ill.

This initiative began with a budget of 5 rupees, but with time donations brought this sum to millions, revealing Teresa's managerial gifts and great charisma, which often attracted criticism, as did her "overexposure" through the media and her friendship with controversial figures and celebrities. Her immense popularity grew even more after her death, to such a degree that only six years later she was beatified; she was proclaimed a saint in 2016, despite having undergone a profound religious crisis, which became known through the publication of her letters to her confessors. Both compassionate and intransigent, ecumenical and dogmatic (she was famous for her campaigns against abortion and divorce), even with her contradictions Mother Teresa was one of the very few who embodied the values and most authentic spirit of the Christian faith, dedicating her entire existence to "the poorest of the poor."

102 1979: Teresa among the poor in Calcutta. For them she opened a hospice, the Kalighat Home (or Nirmal Hriday, Home of the Pure in Heart, in an abandoned building near the Hindu temple dedicated to the goddess Kali). The hospice was open to those with incurable diseases who had been rejected by the hospitals and could now die with dignity in keeping with the rituals of their different religions.

103 In 1955, Mother Teresa opened the Nirmala Shishu Bhavan Children's Home. The year 1961 saw the establishment of the large Shanti Nagar (City of Peace) leper home. The government donated the land, while the first plots were paid for indirectly by Pope Paul VI, who also offered the saint his limousine, which she in typical fashion immediately sold and used the money to pay for the new structure.

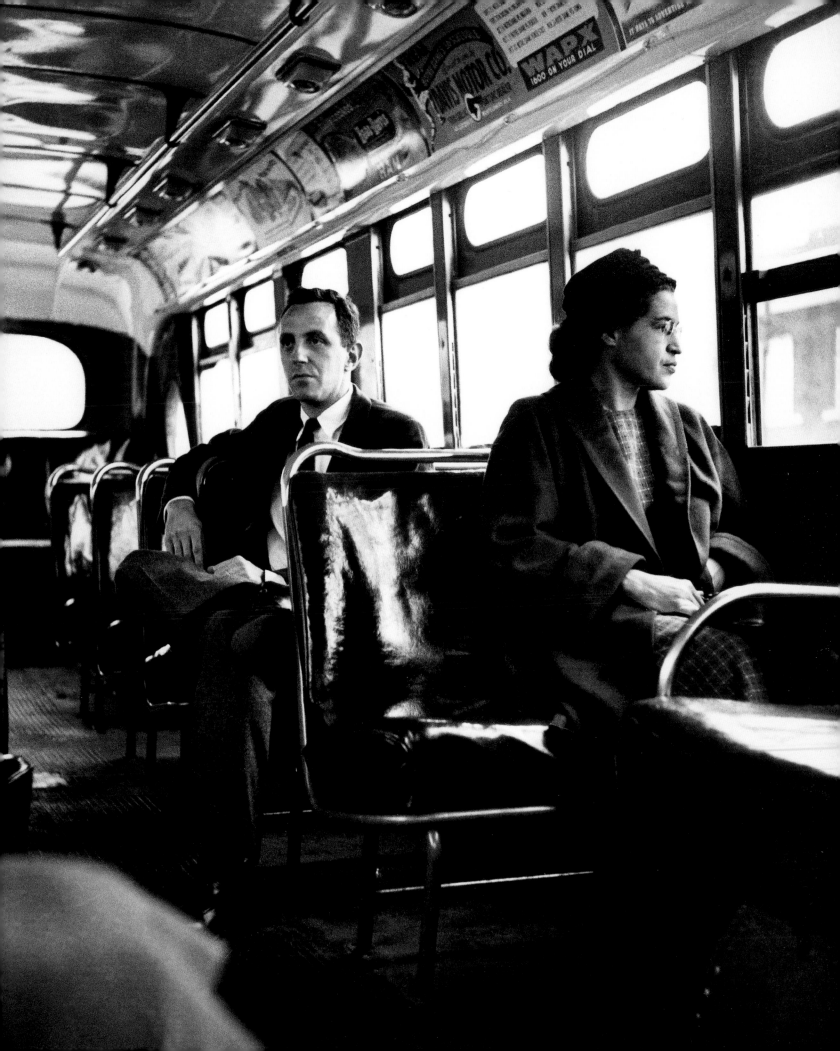

Rosa Parks

"By remaining seated, she rose up to defend the rights of everyone and the dignity of America," President Bill Clinton declared while presenting the Congressional Gold Medal to the seamstress from Alabama who started a revolution from the seat of a bus.

It was a cold December evening in Alabama in 1955 when Rosa Parks got on the bus she took every evening to go home after a long work day. She sat in a seat just behind the section reserved for white people, where all the seats were occupied. When other "whites" got on the bus, the driver told the "coloreds" in Rosa's row to give their seats to the whites. She defiantly refused. She was not old or tired, but as she said later, "The only tired I was, was tired of giving in." And this apparently minor act of rebellion, which led to her being put in jail, sparked an epoch-making change. That very night, Martin Luther King, together with dozens of leaders of the African American community, launched the boycott of the county transportation system as a protest against the hateful segregation ordinance that limited blacks' freedom, even the right to sit in a bus. It lasted for 381 days, triggering a crisis in the city's transportation system, since the great majority of those who used the buses and paid for their tickets were black. To add insult to injury, the black taxi drivers supported the boycott and offered rides to commuters at the same price as the buses. On November 13th, 1956, the US Supreme Court ruled that racial segregation on means of transportion was illegal, having judged that it was unconstitutional. The battle was won and became historic.

But who was this woman who was so courageous as to set off a revolution with a simple "no"? When she refused to vacate her seat, Rosa Louise McCauley Parks was already a seasoned opponent of racial segregation.

Two years before Rosa Parks died, the famous bus was found and restored. In 2012, the first African American president of the United States, Barack Obama, had himself photographed seated where Rosa had been sitting. The bus is now kept in the Henry Ford Museum, near Detroit.

February 4th, 1913, Tuskegee, Alabama, United States • October 24th, 2005, Detroit, Michigan, United States

Rosa Parks

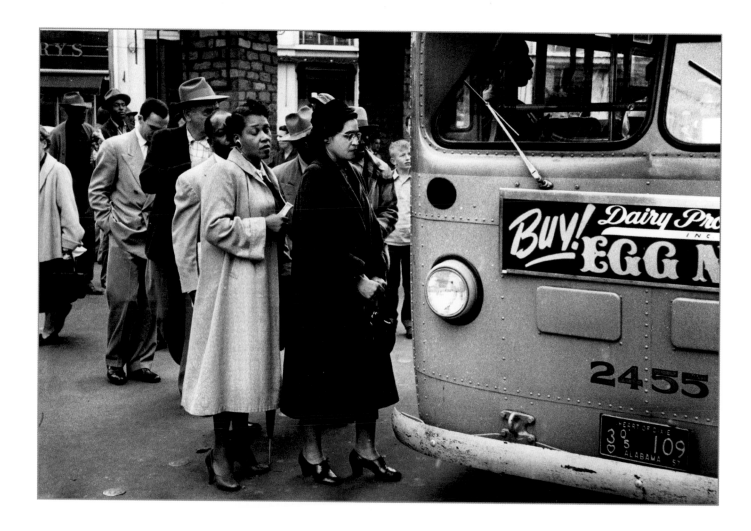

In fact, she had become active in the civil rights movement in 1943, joining the Montgomery section of the National Association for the Advancement of Colored People and becoming its secretary. After her arrest, she became a true standard-bearer of the struggle for equality, even though that gesture cost her her job as a seamstress in a department store. After years of temporary work, in 1965 she found a permanent job when she was hired as the secretary to Detroit Congressman John Conyers. "I would like to be known as a person who is concerned about freedom and equality and justice and prosperity for all people," she said when she was 77 years old. In reality, she was much more. She inspired books, songs, and films, and that momentous December 1st became a symbolic date in the struggle against racism and discrimination.

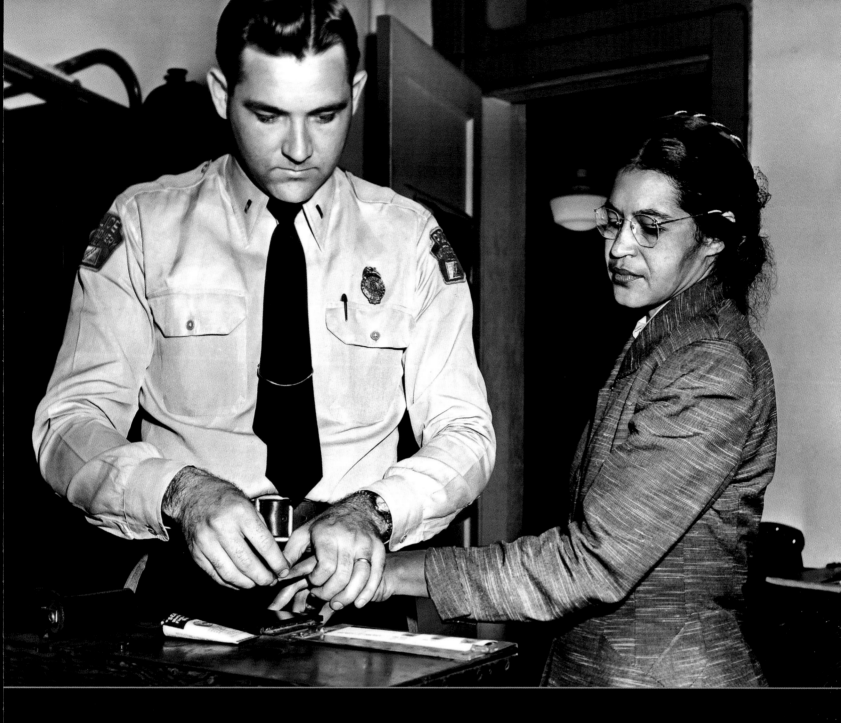

106 The woman with the black overcoat waiting to board a bus is Rosa Parks. At the time, in Alabama, the rule was that, after paying for their ticket in the front of the bus, blacks had to get off and board the bus via the back door. But at times the drivers drove off before they could do so, a typical instance of how badly black women were treated.

107 Rosa McCauley Parks having her fingerprints taken after being arrested on December 1st, 1955. She was freed the same evening after her bail was paid by the white antiracist lawyer Clifford Durr. Parks was a long-time activist in the civil rights movement in Alabama and later in Detroit, and in February 1987, she founded the Rosa and Raymond Parks Institute for Self Development.

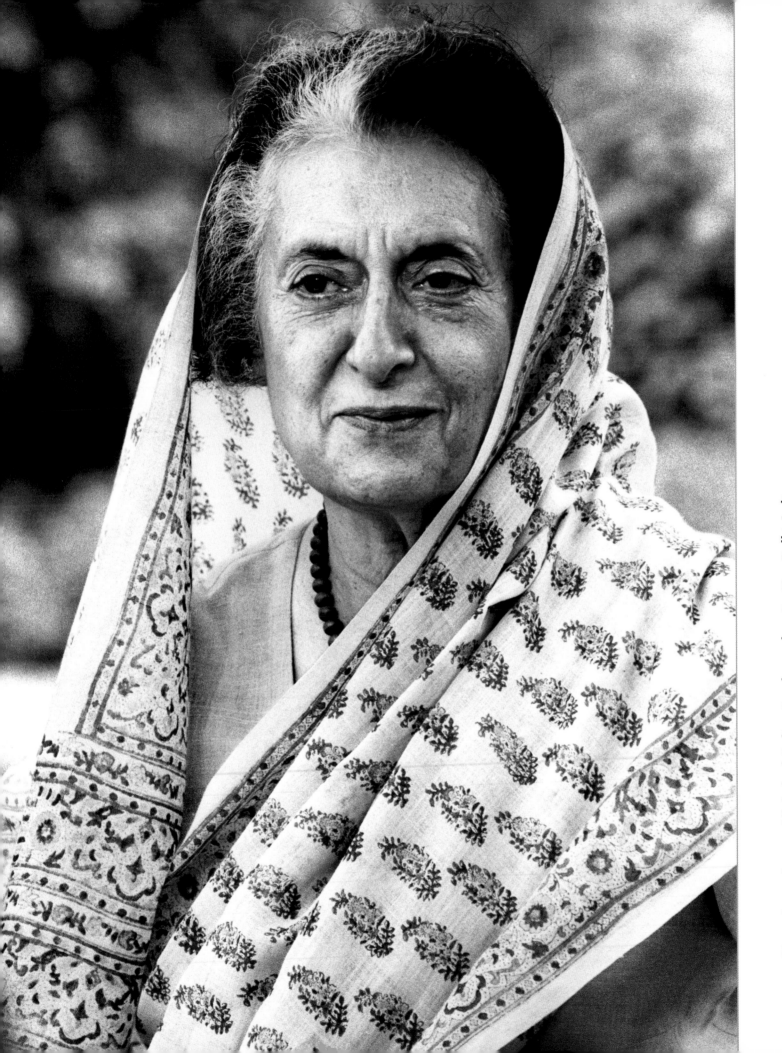

November 19th, 1917, Allahabad, India • October 31th, 1984, New Delhi, India

Indira Gandhi

On January 19th, 1966, a woman was nominated for the premiership in India for the first time. From that moment on, Indira put her life at the service of the nation, and showed Indians who "wore the pants", even if she really wore only saris.

Indira had politics in her blood. Her grandfather Motilal Nehru had worked with Mahatma Gandhi and had explained a fundamental principle to her: "My grandfather once told me that there are two kinds of people: those who do the work and those who take the credit. He told me to try to be in the first group; there was much less competition there." An even greater influence was her father, Jawaharlal Nehru, the prime minister and symbol of modern India. As a child, she followed him like a shadow and often accompanied him during his trips abroad, where she learned the secrets of international diplomacy by observing in silence the meetings that decided the fate of the world. Indira was a great admirer of her father, but she had a rebellious nature and felt cramped by the family climate and rigid Indian traditions. She went to Oxford to study but was expelled for misconduct and in 1942 married the lawyer Ferozi Gandhi, who was not related to Mahatma Gandhi but gave her that legendary family name. In the initial years of their marriage, while their adorable sons, Sanjay and Rajiv, were growing up, politics seemed a long way off, but when her father died, everything suddenly changed. The country was in a state of chaos, and she was obliged to take over. When she was elected Prime Minister in 1966, India was the second country in the world to have a woman as head of government after Sri Lanka under Sirimavo Bandaranaike. Indira dominated the domestic scene by ruling with an iron fist and won the 1967 and 1971 elections by a large margin. In the latter year, she also won the war against Pakistan, and under her rule New Delhi became an international power. She was known as Mother India and was a proud advocate of the strong role played by women, declaring that men will never know their own true nature until they let women be free so they can realize their own personality.

Indira Gandhi in a photograph taken in Fall 1984, few weeks before her assassination. Just before the attack, while she was on an election campaign tour in Orissa, she had concluded a speech as follows: "I have no ambition to live long. Even if I died in the service of the nation, I would be proud of it. If I die today every drop of my blood will invigorate the nation."

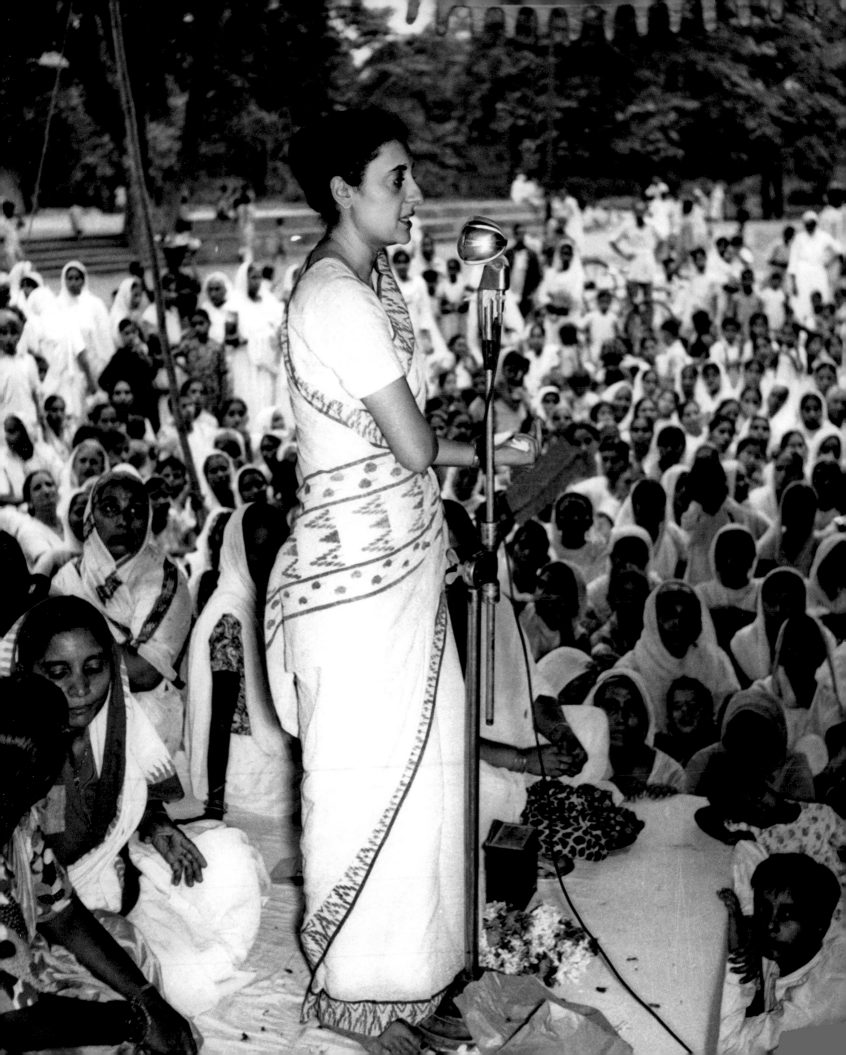

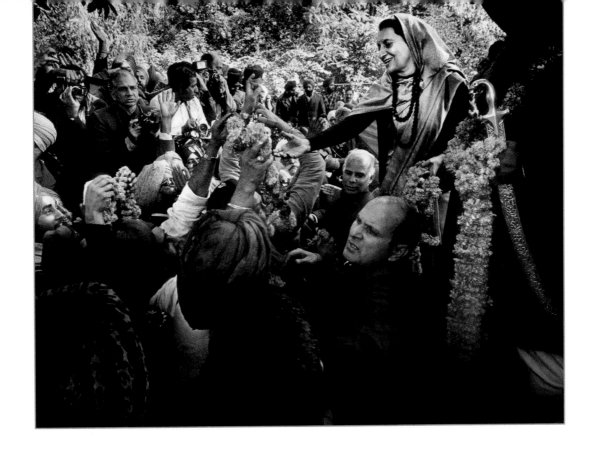

However, her strength of character was not sufficient to save her country from a serious economic crisis, which was followed a wave of strikes. When Indira felt that power was slipping out of her grip, she began to take authoritarian measures that were alien to the democratic tradition she had learned from her father. She was forced to call for elections, which she lost, and she was even sent to prison. But she made a comeback and three years later was once again prime minister. She made the following comment concerning that turbulent period: "Forgiveness is a virtue of the brave." While she was preparing her succession, fate took her favorite son Sanjay from her when he died in an airplane accident in 1980. So it was now up to Rajiv to flank his mother at a moment that marked the apex of her political career, when she was respected throughout the world as a great leader. But peace was short-lived. Four years later, Gandhi sent tanks to quell a revolt at Amritsar, the holy city of the Sikhs, and revenge soon followed: on October 31st, 1984, Indira Gandhi was assassinated by two Sikh bodyguards.

Only a few hours earlier, people had advised her to exclude Sikhs from her secret service, but she replied that one could not expect to make India a secular nation if persons were chosen on the basis of their community – an error that cost her her life.

110 Indira's marriage with Feroze Gandhi triggered a lot of discontent. He was a Parsi and she was Hindu, and at that time mixed marriages were rare. Again, she deviated from tradition by not having an arranged marriage. This photograph was taken in 1960.

111 The celebration of Indira Gandhi's victory in the 1980 elections. She had a precocious political career. It began when she founded the Monkey Brigade when she was 13. It consisted of 6000 young Indian independence fighters, whom she led by and who served as couriers among the dissidents and also attacked the British barracks.

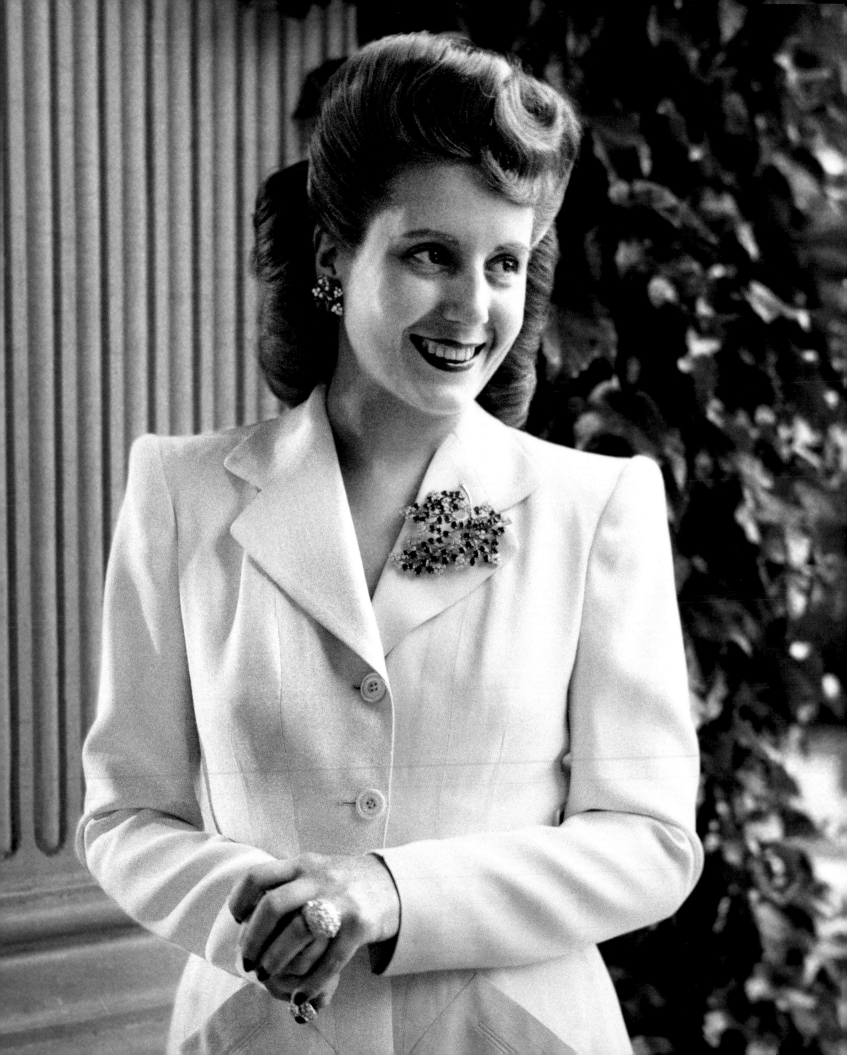

Evita Perón

The First Lady with a Cinderella-like past changed the technique of communicating with the masses. She had a short and controversial life, consisting of surges of generosity and overwhelming sentiment fit for a Broadway musical.

In February 1946, Argentina had just elected its new president, but when Juan Domingo Perón appeared on the presidential balcony of the Casa Rosada in Buenos Aires, all eyes were on the beautiful blond woman, as elegant as a queen, standing next to him and greeting the crowd. Eva Maria Duarte, better known as Evita, enchanted the crowd with her Hollywood star smile, her elaborate hairstyle, and her Christian Dior attire. But she had not forgotten her miserable childhood, marked by poverty and humiliation, when she was only the illegitimate daughter of a rancher in a dismal village in Las Pampas. With her charisma, she transformed those early years of suffering into powerful support for her husband's colorful populism: "I confess that I have an ambition, one single, great ambition: I would like the name of Evita to figure somewhere in the history of my country, and that people would say, 'There was a woman alongside General Perón who took to him the hopes and needs of the people to satisfy them, and her name was Evita." And she added: "May the nation let him save them as he saved me." When they first met, he was only an undersecretary at the Ministry of Labor and was 24 years older than Evita. But his charm immediately captivated her. They soon married, and in two years the young girl who had been an outcast became a revolutionary First Lady who played a role in her husband's policies as the spokeswoman of the poor and of women. It was thanks to her efforts that the law granting women the right to vote was approved by the Argentine Parliament in September 1947. She is also to be credited with opening new schools and the first summer camps for the poverty-stricken young, as well as with the construction of Ciudad Evita (Evita City), a new town with thousands of homes for the most needy, and of the Republica de los Niños (Children's Republic), which, it seems, inspired Walt Disney to create Disney World.

Evita Perón was an icon of style. In order to resemble her, all the women wanted to dye their hair blond, copy her hairdo with its elaborate chignons, and wear the suits she wore. Evita was painstaking about her image and watched the films of her public speeches at a private screening hall in order to correct gestures and words and be more prepared the next time around.

May 7th, 1919, Los Toldos, Argentina • July 26th, 1952, Buenos Aires, Argentina

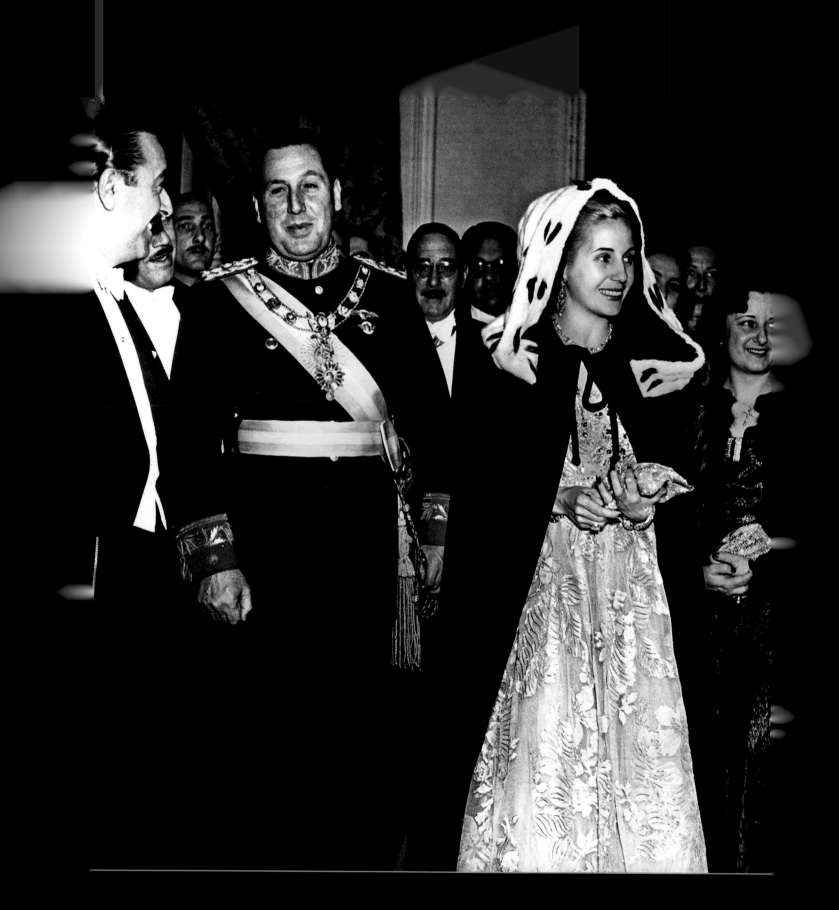

114 Eva and her husband, Juan Domingo Perón, at the Buenos Aires Opera House in 1949. Theater was Evita's great passion; she dreamt of becoming an actress when at the age of 15 she ran away from home to seek her fortune. Thanks to her intense voice, in 1930 she was hired by a radio station as a dramatic actress. A short time later, she met the man who would become her husband.

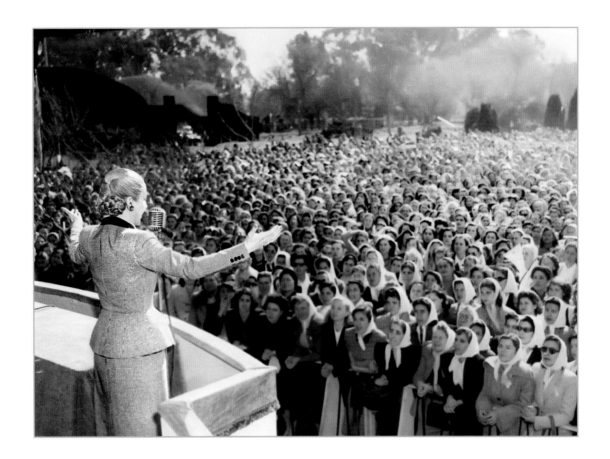

Evita became the Madonna of the *descamisados* (the shirtless, that is, the poor), but did so in her own way, mixing receptions and banquets with rallies, glamour with generosity. She attended charitable events dressed for a gala evening, with a fur coat and high fashion apparel she had ordered from Europe, displaying a beautifully groomed and grand image so that people would consider her the living proof that upward social mobility is achievable for everyone. "I have only one thing that matters, and I have it in my heart. It sets my soul aflame, it wounds my flesh and burns in my sinews: it's love for this people and for Perón. [...] If this people asked me for my life I would joyfully give it, for the happiness of one *descamisado* is worth more than my entire life." The announcement of her death, when she was only 33 years old, plunged the entire nation into despair, and she immediately became a myth. Evita's story was a modern fairy tale. She was immortalized in a film and a musical and occupies a special place in the collective imagination of her country.

115 After obtaining the women's right to vote, Evita founded the Woman's Peronist Party, winning one of her most important battles in a country like the Argentina of the time, which was still dominated by male chauvinists. She is seen in this photograph giving a speech at a rally in August 1951.

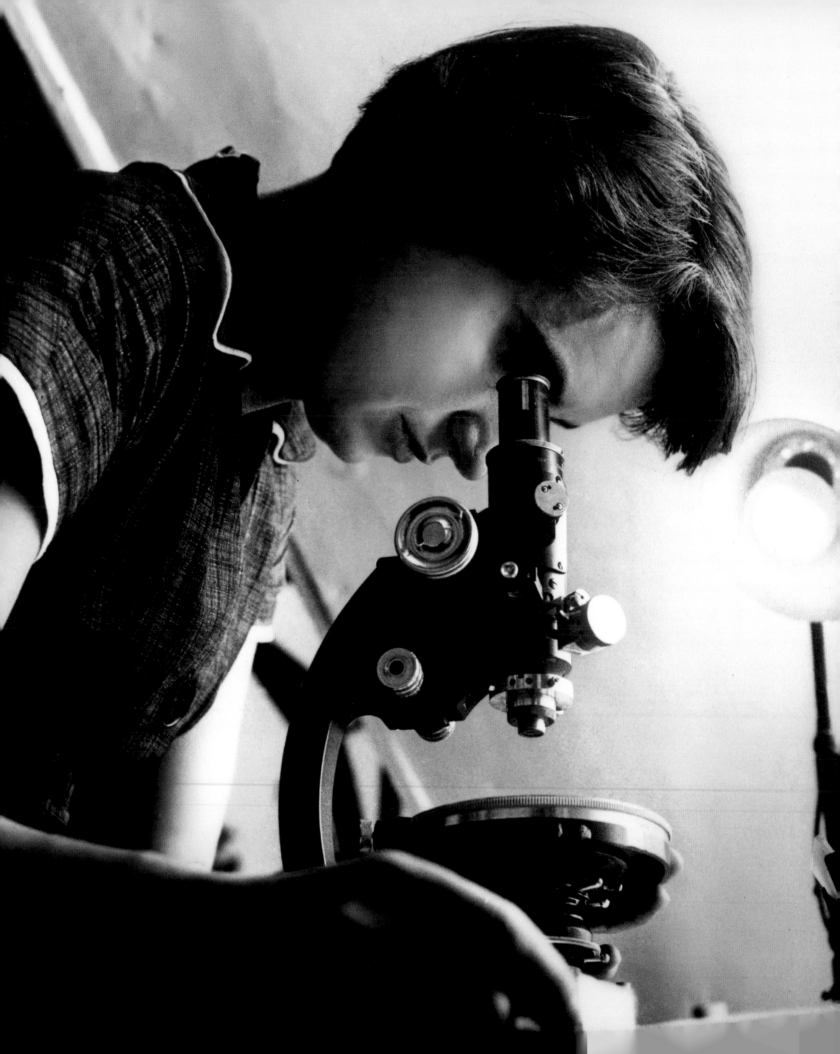

Rosalind Franklin

The only daughter of an upper middle class family in London, she was as determined as a man. But she was a woman, and thus became the heroine manqué of the discovery of DNA.

During the ceremony of the 1962 Nobel Prize for Physiology or Medicine, awarded for the discovery of the structure of DNA, one scientist was missing on the podium – the researcher Rosalind Franklin. In fact, she was the person who had taken the X-ray photographs of the double helix that allowed scientists to consolidate their hypotheses of the time. During the ceremony, no one mentioned her, and she was unable to make a claim for her merits because she had died of cancer five years earlier owing to the massive doses of radiation she had absorbed during her experiments. Thus, credit for the revolutionary discovery was taken by two men, Francis Crick and James Watson, who published their study in *Nature*, briefly mentioning Rosalind Franklin only in the footnotes. Yet the role played by this young woman had been decisive.

Displaying a brilliant mind as a child, Franklin studied at Cambridge before working at the laboratory in King's College, London, where the competition was fierce and the others resented the presence of a young researcher who worked in total independence. "Genes," "genomes" and "heredity" were becoming widespread in the common vocabulary, and rumors were spreading in the scientific world of a new theory formulated by Linus Pauling, who was later awarded the Nobel Prize for Chemistry, and Robert Corey. Their hypothesis was that DNA was a three-chain helix fiber structure with phosphate groups in the core, but no one had yet succeeded in demonstrating its existence, and time was running short for those who wanted to be the first to announce the discovery. Rosalind managed to produce an excellent photograph of the structure, but made the mistake of revealing this to Watson, who published the results before she did and got full credit for the discovery. All this became known only years later, and Franklin's story became a sensation. She is now remembered as one of the women scientists who had been denied the Nobel Prize because of her gender, having been stuck with a label that on the whole did not do justice to her true merits and risked losing sight of the brilliant results she achieved in her brief life.

Rosalind Franklin at work, looking into a microscope in 1955. Three years earlier, in May 1952, she had succeeded in producing extremely clear X-ray photographs. One, in particular, known as Photo 51, became famous since it revealed the double-helix structure of DNA.

October 13th, 1925, Grantham, United Kingdom • April 8th, 2013, Westminster, United Kingdom

Margaret Thatcher

A life spent on the front line, always true to her nickname, Iron Lady. She governed the United Kingdom from 1979 to 1990 with her pragmatic approach: "In politics, if you want anything said, ask a man. If you want anything done, ask a woman."

Her nature became apparent when, at the tender age of nine, after winning a school prize, she declared: "I wasn't lucky. I deserved it." That statement embodied the strong character of the Iron Lady, the historic nickname given to her by a Russian newspaper that associated her resoluteness with that of the Iron Chancellor, Otto Bismarck. The nickname fit her to a T. She was the woman who had coped with economic decline and terrorism, subdued the soccer hooligans, and broke the resistance of the miners without batting an eyelid, not even when under the constant barrage of insults and parodies she was subject to. Thatcher was a true warrior who, instead of armor, liked to wear suits with bright colors, in all the shades from blue to purple, always illuminated by the pearl necklace that completed her. "I can change everything, but the pearls remain. They were the gift my husband gave me for our wedding," was her justification for the only quirk in her usual sober dress.

She had made her debut in politics as president of the Oxford University Conservative Association, when she was studying there, and it became a passion. In 1950, she was the Conservative Party candidate at Dartford for a seat in Parliament. She lost but became rather popular in the United Kingdom as the youngest candidate the party had ever had. The following year, she married Denis Thatcher, a well-off businessman, and gave birth to twins, Carol and Mark. She was elected to Parliament in 1959, and in 1970 was given her first government post as Secretary of State for Education and Science, but her first official act was a failure.

Margaret Hilda Roberts was the daughter of the owner of two grocery stores in Grantham, a town in Lincolnshire. She went to Oxford University on a scholarship, earning her BS degree in Chemistry, and from 1947 to 1951 did research in X-ray crystallography under Dorothy Hodgkin, who won the 1964 Nobel Prize in Chemistry. At left, a photograph taken in 1979.

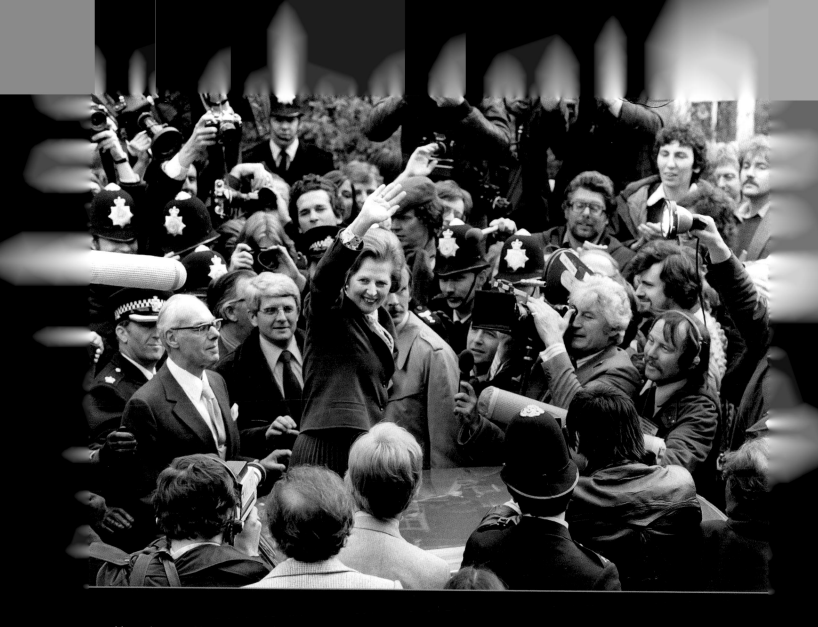

20 May 4th, 1979: Margaret Thatcher celebrates her being elected Prime Minister in Flood Street, Chelsea. She replaced James Callaghan, who had headed the government for three years, and was succeeded by John Major, who remained in office until 1997.

Having to cut spending in schools, she decided to abolish free milk for the young pupils and was immediately called "Thatcher, the milk snatcher." She later described this episode as follows: "I learned a valuable lesson. I had incurred the maximum of political odium for the minimum of political benefit." The experience was indeed valuable, as she made great strides, becoming Prime Minister in 1979. "Where there is discord, may we bring harmony. Where there is error, may we bring truth. Where there is doubt, may we bring faith. And where there is despair, may we bring hope," she said right after the election, drawing inspiration from the words of Saint Francis of Assisi. Photographed wearing her flowery blouse and inevitable light blue jacket in front of no. 10 Downing Street, she had already made history as the first woman Prime Minister in the United Kingdom. Margaret's long term of office – she was elected three times in a row (1979, 1983, 1987) – was marked by her absolute resoluteness.

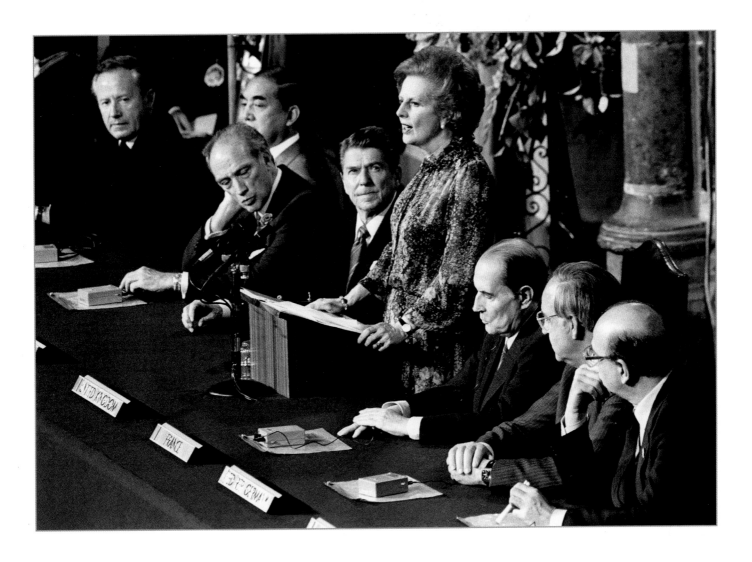

121 Thatcher during a summit of international heads of state held in 1984. The Iron Lady had succeeded in breaking the glass ceiling, playing a key role and setting down the guidelines to the world leaders. She said, "Power is like being a lady. If you have to tell people you are, you aren't."

Despite being subject to a great deal of criticism from both the Laborites and Conservatives, she always doggedly refused to change her policies and come to a compromise, even when her decisions proved to be greatly unpopular. She entered and won the Falklands War, incurred the hatred of the working class, put a stop to the violence of the hooligans, the terrible English soccer fans who terrorized the stadiums every week, and survived unscathed an assassination attempt on the part of IRA terrorists. Politics was her life and Parliament her residence. "Home is where you go when you have nothing better to do," she stated when she resigned as Prime Minister in 1991. She took off her armor and wept only the moment she closed the door behind her at Downing Street, after spending eleven years there. Then she got into the automobile that would take her far away from the media spotlight.

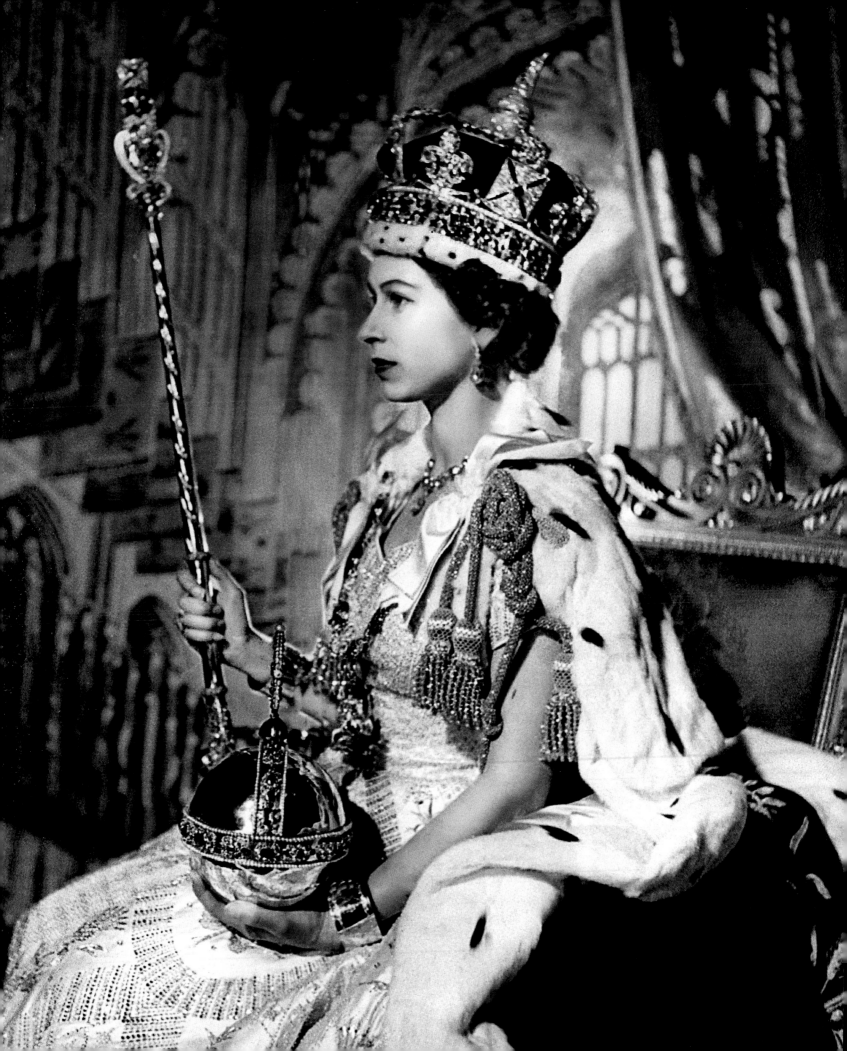

Elizabeth II

She was not destined to ascend the throne, yet she became "The Queen," the indestructible symbol of monarchy, unswervingly faithful to etiquette and moderation, tradition and discretion, despite the family scandals worthy of a soap opera that have scarred her reign.

"I declare before you all that my whole life, whether it be long or short, shall be devoted to your service and the service of our great imperial family, to which we all belong," she said on the radio microphone during one of her first official visits. Without a doubt, Queen Elizabeth has kept her promise. Pragmatic, composed, with a sense of duty and a steely character, she had been taught self-control and respect for etiquette since she was a child, even though at the time she was not expected to become queen. She was only the first-born child of the Duke of York, Albert, who was second in line to the throne after his brother Edward. But then in 1936, Edward, who in the meantime had become king, abdicated in order to marry Wallis Simpson, upsetting public opinion and the life of Elizabeth: when only ten, Lilibet, as she was called in the family circle, became the heir to the throne of England overnight. And even her designation was unexpected. She was in Kenya, at the Treetops Hotel, a resort standing among the branches of trees, when the sudden death of her father, King George V, made her one of the youngest rulers in history. "For the first time in the history of the world, a young girl climbed into a tree one day a Princess and, after having what she described as her most thrilling experience, she climbed down from the tree next day a Queen – God bless her." This is what her guide, the legendary English hunter Jim Corbett, wrote in the hotel guest book to commemorate this historic event. She was only 25 when she found herself the head of the largest empire in the contemporary world. With time "The Queen" broke many other records. Her reign of the United Kingdom is the longest (the Sapphire Jubilee celebrating her 65 years on the throne took place on February 6th, 2017); she has seen the passing of seven Popes and fourteen British prime ministers (when she was crowned, Churchill headed the government and Tony Blair had not yet been born); she has the largest number of coins of different countries with her portrait (the 16 nations in the Commonwealth); and she holds the record for the longest marriage in the British monarchy, 70 years with Philip, the Duke of Edinburgh.

The official photograph of Queen Elizabeth II's coronation, taken by Cecil Beaton on June 2nd, 1953. The ceremony was held in Westminster Abbey and at the Queen's request was broadcast live on television. It seems that in order to get used to the weight of the crown, Elizabeth had practiced wearing it for hours in private.

April 21st, 1926, Mayfair, London, United Kingdom

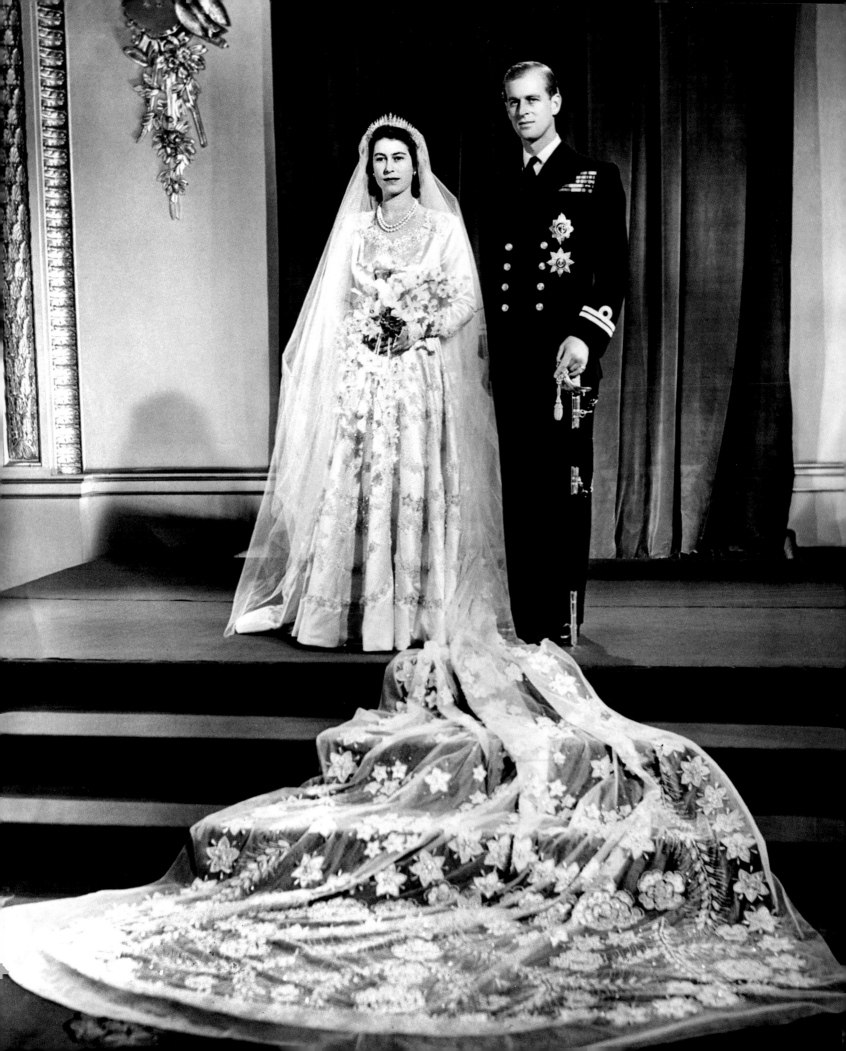

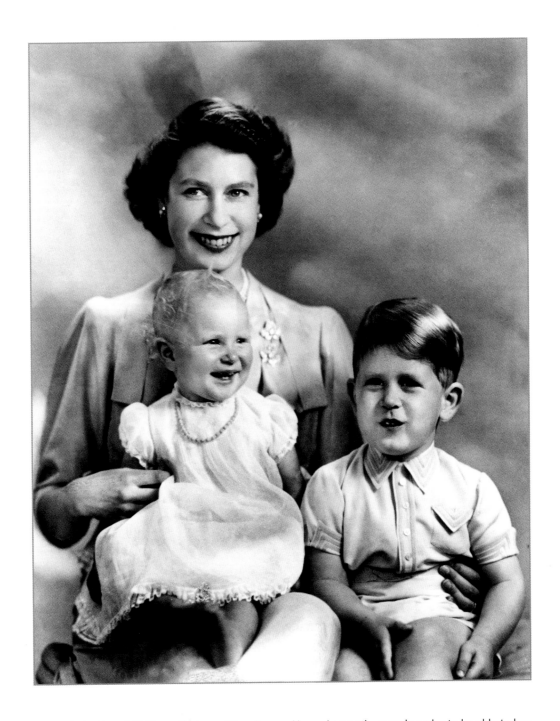

124 Elizabeth and Philip on their wedding day, on November 20th, 1947. In order to be able to buy the material for her wedding gown (England was still recovering from World War II) she had saved up her ration coupons, and the government also offered 200 pounds as a wedding present. The dress was more or less modeled after Botticelli's famous painting *Spring*, a symbol of rebirth after the war.

125 Queen Elizabeth with her children, Charles and Anne, in 1951. Two other children followed, Andrew and Edward. The family relationships were always somewhat difficult owing to her many official obligations and to her authoritarian nature. The only exception to this was her love of horses and dogs. When Elizabeth was 18, she was given Susan, her first Corgi puppy, and she went on to raise dozens more.

Elizabeth's father was not at all convinced that the young naval cadet (Philip) was the right person, but she would not listen to reason, and this, for that time, was one of her great conquests and achievements – marrying the man she loved. Since then, what we know about her private life has consisted of rumors. Totally identified with her role as the impartial representative of the United Kingdom, the Queen has always been wrapped in a sort of aura of mystery – even during her *annus horribilis*, 1992, the darkest moment of her extremely long reign, which was marked by royal divorces, the fire at Windsor Castle, and the tragic death of Diana, the former wife of the Queen's eldest son Charles. She reacted with the usual aplomb, quickly reestablishing the role of the monarchy and its solidity, synonymous with her Corgi dogs, eccentric hats, and a life bearing the hallmark of protocol.

The Queen observing her portrait in Windsor Castle (painted by the English artist Henry Ward) on October 15th, 2016. When she ascended the throne. she decided to keep her name during her reign, thus making an ideal link with Elizabeth I, one of the most iconic figures in British history.

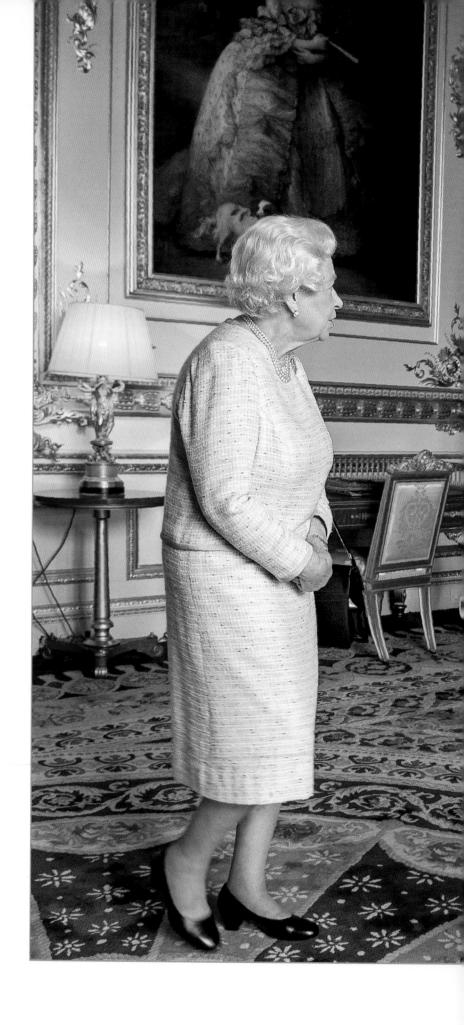

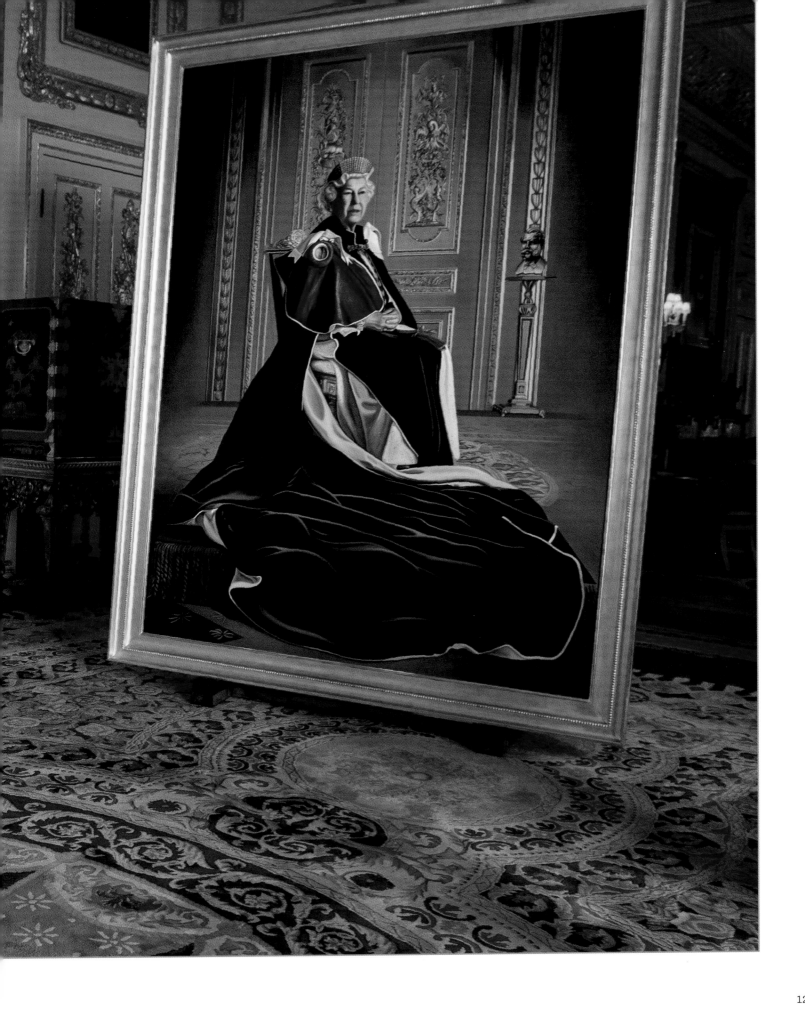

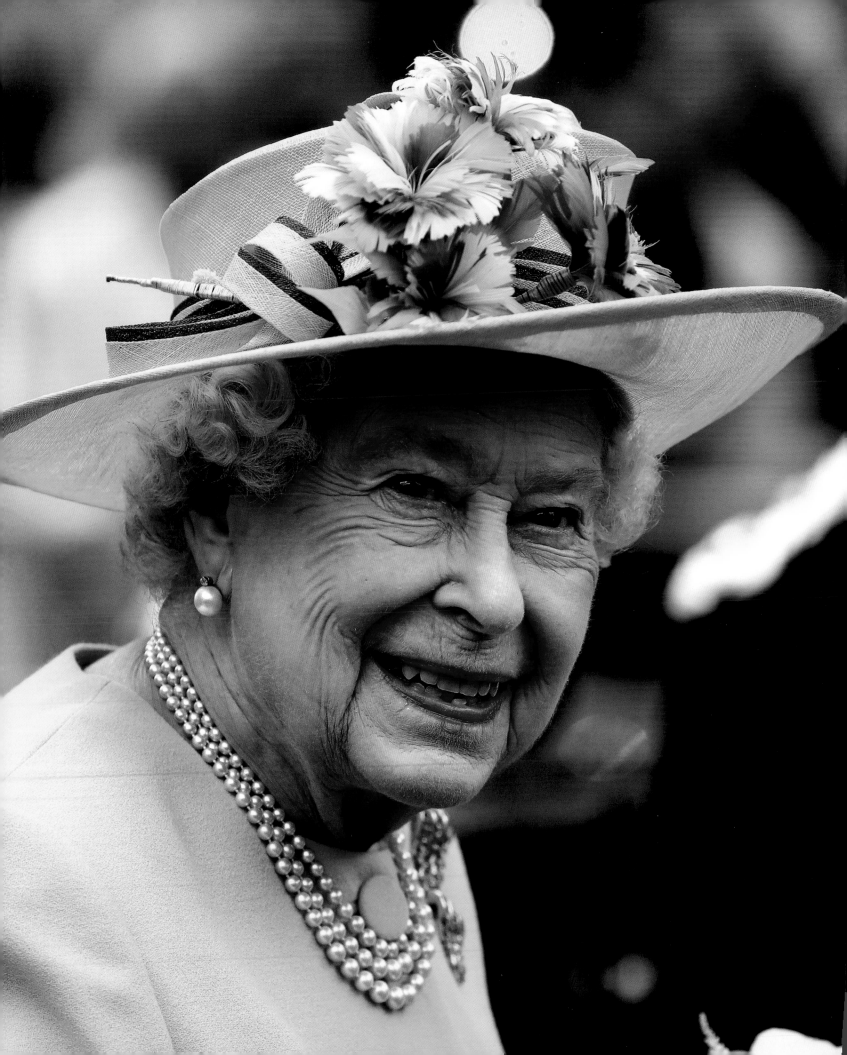

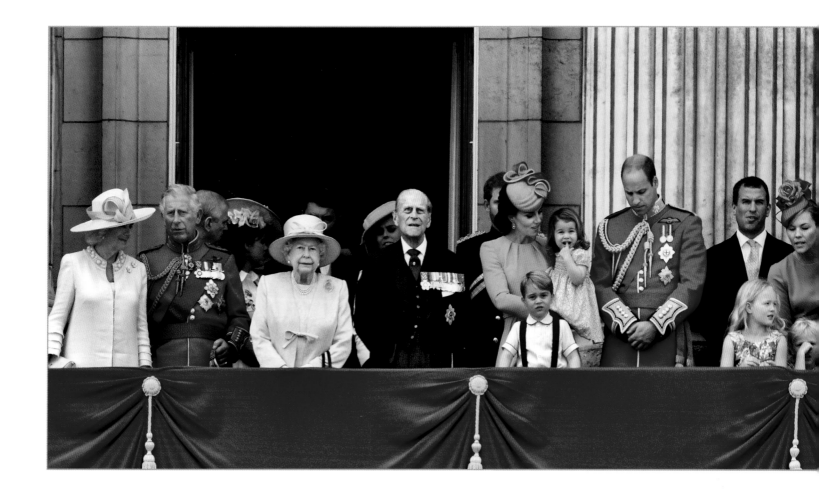

The Queen was also quite judicious in displaying this lifestyle with the media, not making too many appearances before the public, the first royal to send an e-mail (1976), and the protagonist of a host of authentic or presumed memoirs, films, and TV series. She even agreed to impersonate herself in the video of the inauguration of the 2012 London Olympic Games. But on that occasion, she was escorted by a special person: James Bond, always at Her Majesty's service.

128 Elizabeth II prefers to wear brightly colored hats and apparel, and not only for aesthetic reasons. The media and security are two other factors; as regards the latter, she is always easy to spot in the midst of a crowd. Here, the queen is in London on an official visit, in June 2017.

129 Since 1748, Trooping the Colour has been the official parade that celebrates the birthday of the British sovereign. On June 18th, 2017, on the occasion of the Queen's 91st birthday, four generations of royalty gathered together at the Horse Guards Parade, offering a dazzling spectacle of the past, present, and future of the British monarchy.

July 13th, 1927, Nice, France • June 30th, 2017, Paris, France

Simone Veil

The first president of the European Parliament and a minister in various French governments, she had first-hand experience of historic 20th-century events: the Holocaust, the struggle for women's emancipation, and the United Europe project.

On her left arm was the number 78561, which they had tattooed there when, at the age of 16, she entered the Auschwitz death camp, where she had been deported from Nice together with her family. Simone miraculously survived, and as soon as she returned to France, she married the heir of a family of industrialists, Antoine Veil. After earning a degree in law, she began a career as a magistrate, and in 1970 was appointed secretary general of the Supreme Magistracy Council. The following year, she became the first woman in France to head a ministry when Prime Minister Jacques Chirac named her Minister of Health. In that role, Simone Veil fought the mother of all battles, the one in favor of legalizing abortion. The debate in Parliament and throughout the country was especially bitter, triggering a campaign fraught with difficulty, for which she became the standard-bearer, even having to fight against members of her very own party. She later explained that she was leftist when it came to certain problems, especially those connected with the major themes of society, and rightist in the case of others. Her proposal passed, making France the first Catholic country to authorize the termination of pregnancy. In honor of the person who had championed its cause, the new law became commonly known as the *Loi Veil*. In the meantime, Simone became a passionate exponent of the ideal of a united Europe, convinced as a Holocaust survivor that it was her duty to make sure that monstrosities that she herself had experienced firsthand should never be repeated. From 1979 to 1982, she was the first elected president (and first woman president) of the European Parliament. "The European Union reconciled me with the 20th century," she declared, thus closing the circle of a life destined to leave an indelible mark on the history of women.

Simone Veil in 1979. An opinion poll carried out in 2014 named her the "most admired female personality" in France. Many people thought she was the ideal candidate for president of the Republic, but she always rejected this, giving the following motive for her decision: "I am too independent for that role."

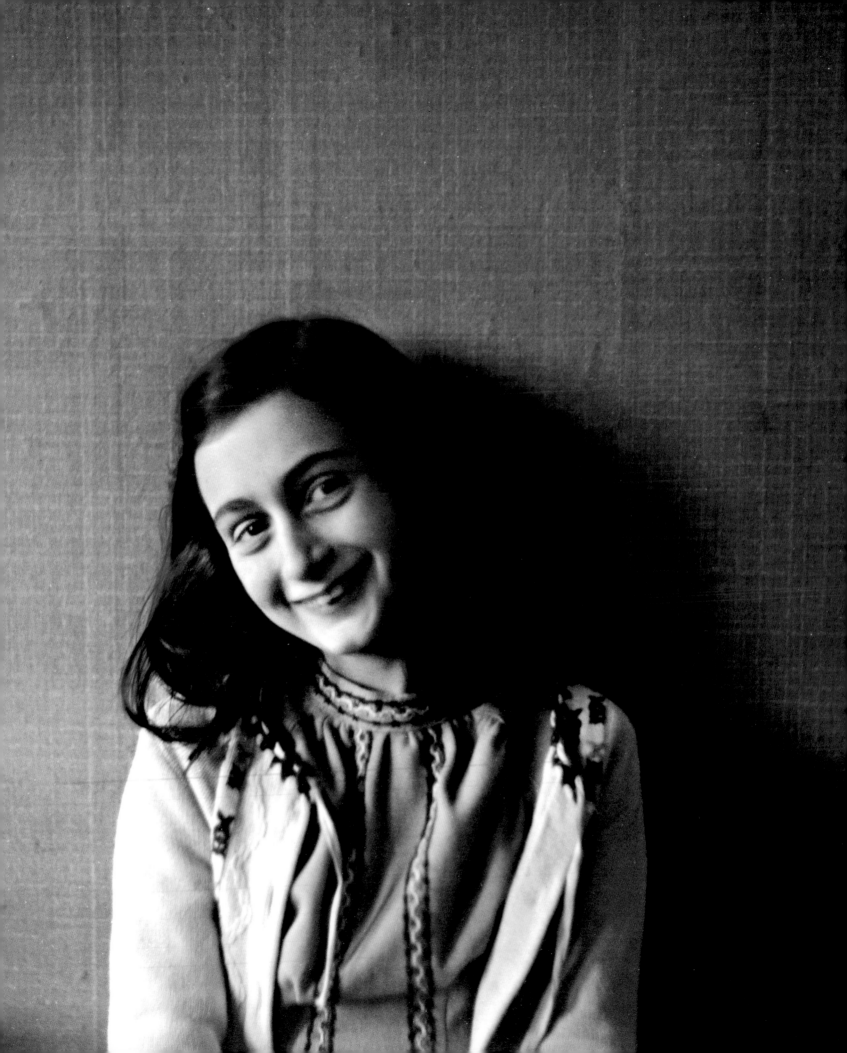

Anne Frank

While hiding in the "Secret Annex," Anne wrote the diary that would become one of the most sensational literary cases in recent history, a shattering testimony of the horrors of the past and a stern warning for future generations.

Anne had seen the gift she wanted for her thirteenth birthday at the stationer's behind her house in Amsterdam. It was a square diary with a lovely white and red cover, and she received it a short time before the Nazi persecution upset her life as well as that of so many other Jewish people. The Frank family had already had a terrible experience a few years earlier, when they had to leave Frankfurt, where Anne was born, and go to Holland in order to escape from Adolf Hitler's anti-Semitic laws. But when Germany invaded the Netherlands, it was clear that persecution and deportation of the Jews would soon begin there as well. And in fact, in July 1942, a few weeks after Anne's birthday, she and the rest of her family (her father, Otto, mother, Edith and elder sister, Margot) moved to a refuge that Otto had found, an apartment just above the offices of the firm he worked for, which had a secret entrance hidden behind a sliding bookcase. They spent two years there without any contact with the outside world, in the hope that the war would end sooner or later. During that time, Anne used her birthday gift to begin an account of her life, written to an imaginary friend, Kitty. By the end of 1942, she had already filled all the pages and continued writing in notebooks and sheets of paper, up to the end of those tragic two years. Her diary is a detailed description of the daily existence of two families (the Van Pels were also hiding there, as was Fritz Pfeffer) that had to share a few square yards of space: their quirks, conflicts, and arguments; the jokes, laughter, and bad moods; and, above all, the constant terror of being discovered.

Besides the famous diary, the photographs also tell us much about the life of Anne Frank, seen here in a photograph taken in 1941. Most of the photos of Anne were taken by her father Otto, who used his camera regularly and immortalized Anne from her infancy on in a series of portraits and snapshots that document the family's daily life.

June 12th, 1929, Frankfurt, Germany • 1945, Bergen-Belsen concentration camp, Germany

134 A 1935 photograph of Anne Frank's class (she is seated next to the teacher) at the Sixth Montessori School in Amsterdam – which is now named after her – which she attended from 1934 to 1941. It was a progressive-minded cultural setting that invited the pupils to talk about themselves and express their feelings.

135 Anne (second from the left) playing in the Lederman family's sandbox in Amsterdam in 1937. After the publication of the diary, Otto Frank replied to the thousands of letters written to him, and often ended his letters as follows: "I hope Anne's book will have an effect on the rest of your life so that insofar as it is possible in your own circumstances, you will work for unity and peace."

The friends who secretly took food and other basic necessities to them also brought books for Anne, which she waited for impatiently and read voraciously, cultivating her innate writing talent. "Be kind and courageous," she wrote on the back of the last notebook on August 1st, 1944... and after that, nothing more. Three days later, the Franks were discovered and arrested, and Anne and her sister Margot were deported to the Bergen-Belsen concentration camp, where they died of typhus. The diary was saved by a friend and at the end of the war was delivered to Anne's father, Otto Frank, who had survived life in a concentration camp and who authorized its publication, omitting only the most private passages. It was first published in 1947 with the title *Het Achterhuis* (The Secret Annex). Since then, over 30 million copies have been sold, bearing witness to the horrors of the Holocaust more than 1000 Nuremburg trials could ever do.

136-137 Anne and her father Otto Frank (in the second row) photographed in an Amsterdam street in July 1941. The family fled from Nazi Germany and went to Holland, where Otto worked as a manager of the Opekta firm, a pectin factory in the center of town. Behind the building, they prepared a secret apartment where they hid for two years.

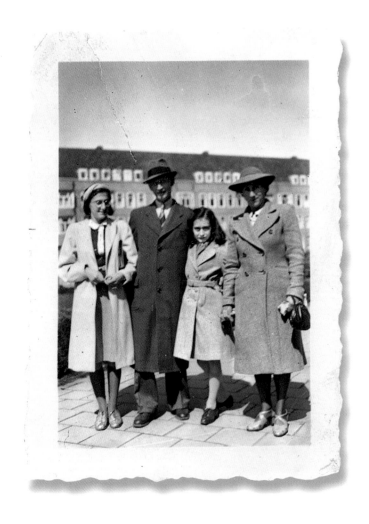

Anne Frank

137 Left to right, Anne's sister, Margot, father, Otto, Anne, and mother, Edith, in a family portrait taken in Amsterdam, near their house in Merwedeplein. A monument to Anne was erected in the square, and the Franks' apartment has been converted into a writers' residence.

Grace Kelly

November 12th, 1929, Philadelphia, Pennsylvania, United States • September 14th, 1982, Principality of Monaco

A fairy tale without a happy ending: this is the story of the Oscar-winning actress who became the princess of the smallest and most talked-about kingdom in the world – an example of refinement and poise that inspired millions of girls.

Once upon a time, there was a fascinating woman with aristocratic features and beautiful blue eyes. She had a regal bearing and an extraordinary appearance that was a combination of natural simplicity and sophistication. She was the highest paid actress in Hollywood, but she left the limelight of cinema to marry a prince with whom she dreamed of living happily, until an accident shattered that magic spell, denying her the happy ending her fairy tale should have had. Grace Kelly was truly a personality worthy of a fable, an example of elegance that fired the imagination of millions of women. But she was also a model of sedateness, always able to maintain a low profile and lead a reserved life despite her worldwide fame. She was always in the spotlight, having made her theater debut on Broadway when still very young, after which she acted in movies, where the list of her conquests sparked a torrent of gossip. She only appeared to be cold, while she was really "a snow-covered volcano," according to Alfred Hitchcock, the famous director, who immediately understood the explosive talent of his muse. He gave her the starring role in *Dial M for Murder* in 1954, and the following year (when she was awarded the Oscar as best leading actress in *The Country Girl*) she was the female lead in his *To Catch a Thief,* the setting of which was on the other side of the ocean, along the French Riviera, where Grace Kelly's destiny changed. The magazine *Paris Match* asked her to be photographed in the royal palace of the Principality of Monaco, where the troupe was welcomed by Prince Rainier, the richest bachelor in the world. Their wedding was announced to the press less than a year later, which meant her leaving not only Hollywood, but the United States as well.

Grace Patricia Kelly was born in Philadelphia to a wealthy family. Her father, a former bricklayer of Irish descent, was a self-made man who had become a millionaire. At left, Grace in a photograph taken in Hollywood in 1954, when she was a movie star.

140 "Boiling ice" was what Alfred Hitchcock called Grace, overwhelmed by her ice-blue irises, which concealed fiery passion. Grace Kelly enhanced her natural beauty with very little makeup, a touch of black eyeliner, and a dash of mascara on her eyelashes, while her cool blond hair illuminated her perfect complexion.

141 Grace Kelly with the Oscar statuette that she won on March 30th, 1955 for her role in *The Country Girl*. That year, she topped the list of actors who earned the most for the Hollywood industry. In five years, she appeared in eleven films.

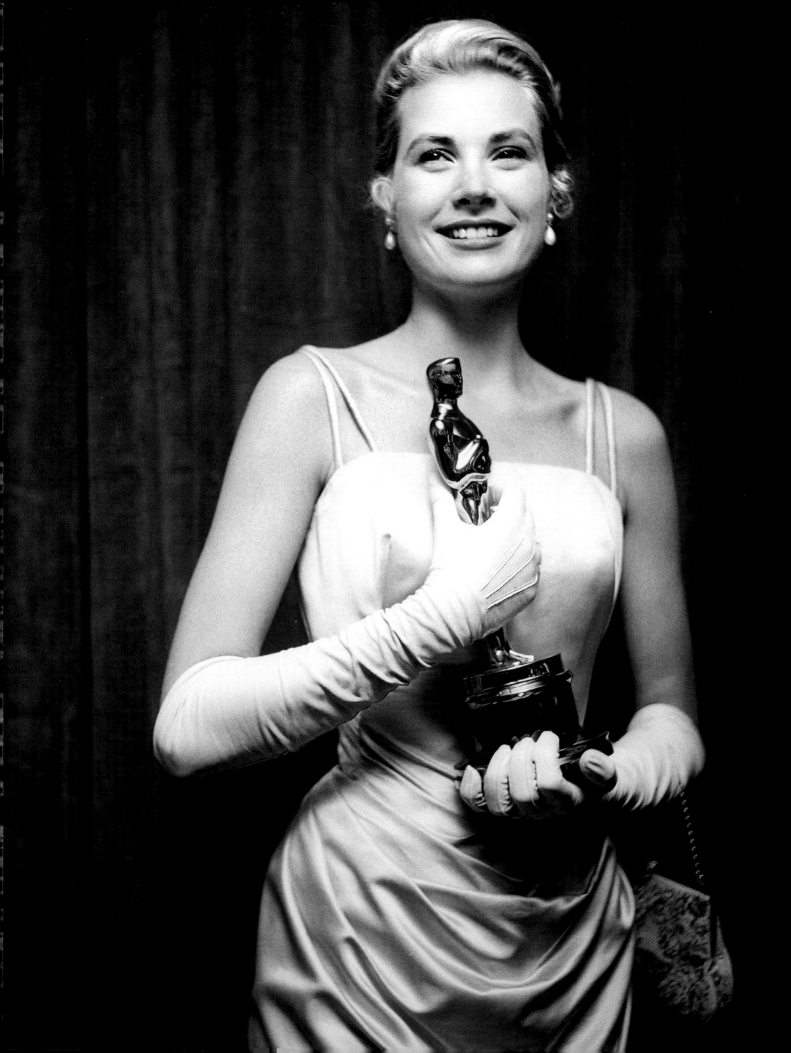

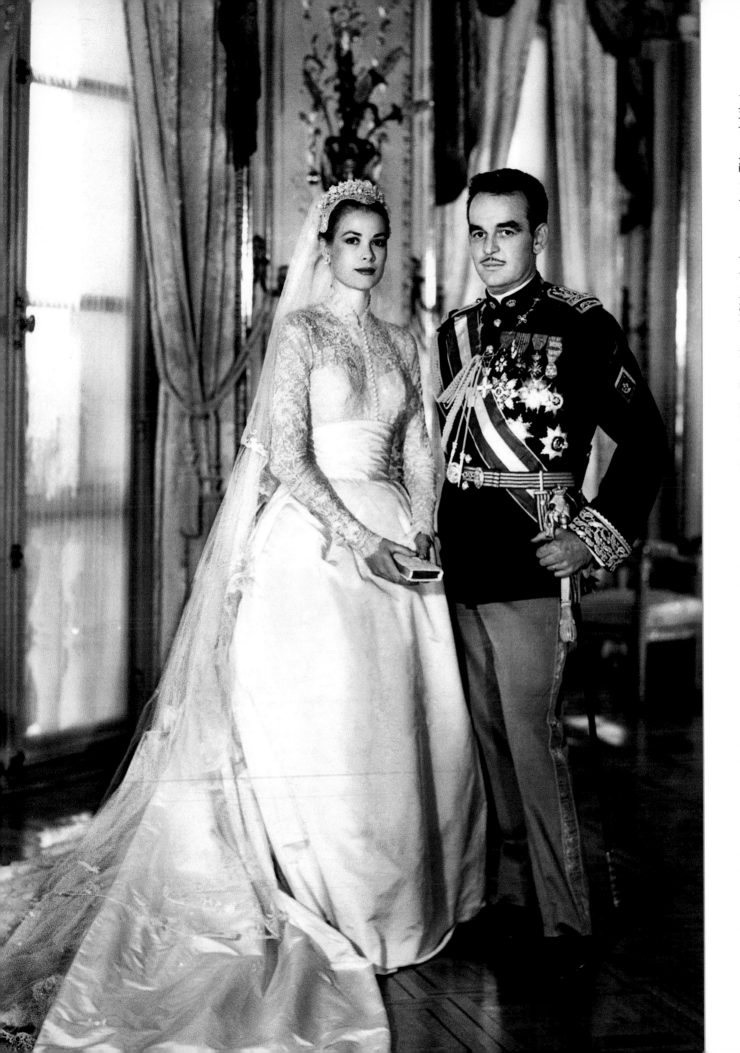

142 Grace and Ranier of Monaco on their wedding day, April 19th, 1956. The ceremony was filmed and distributed in an MGM exclusive, a 31-minute TV special that attracted 3 million spectators throughout the world. The Princess' dress, designed by Helen Rose, peppered with pearls, is on exhibit at the Philadelphia Art Museum, a donation from Grace herself.

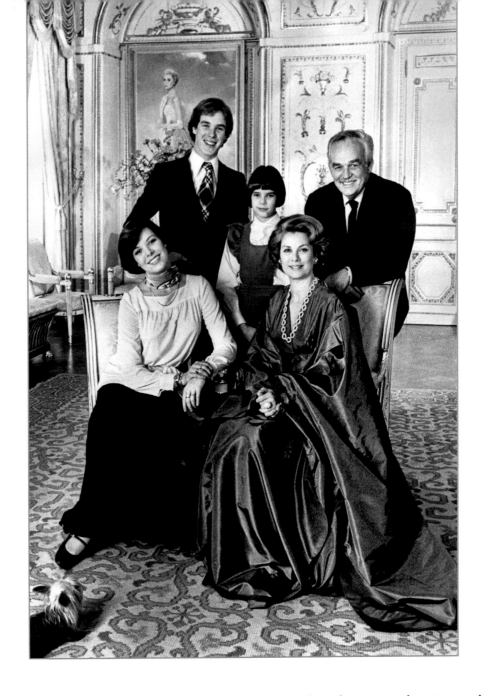

From then on, she was always at her husband's side, at a time when the principality Rainier had inherited was going through a serious financial crisis. Grace contributed quite a lot to the recovery of the small kingdom, attracting major Hollywood stars and jet set VIPs there. But, above all, she was tireless in using her fame in the service of charity, as president of various philanthropic associations and of the Red Cross, establishing the tradition of the Rose Ball gala, which is still going strong. Death was awaiting her at the end of a dangerous curve, which she negotiated at too high a speed, thus depriving the kingdom of its princess and making her story a modern fable.

143 A family photograph taken in 1976: Grace and Rainier with their three children, who later became celebrities. At left is Princess Caroline, born in 1957; behind her, Prince Albert, born in 1958; and in the middle their young sister Stephanie, born in 1965.

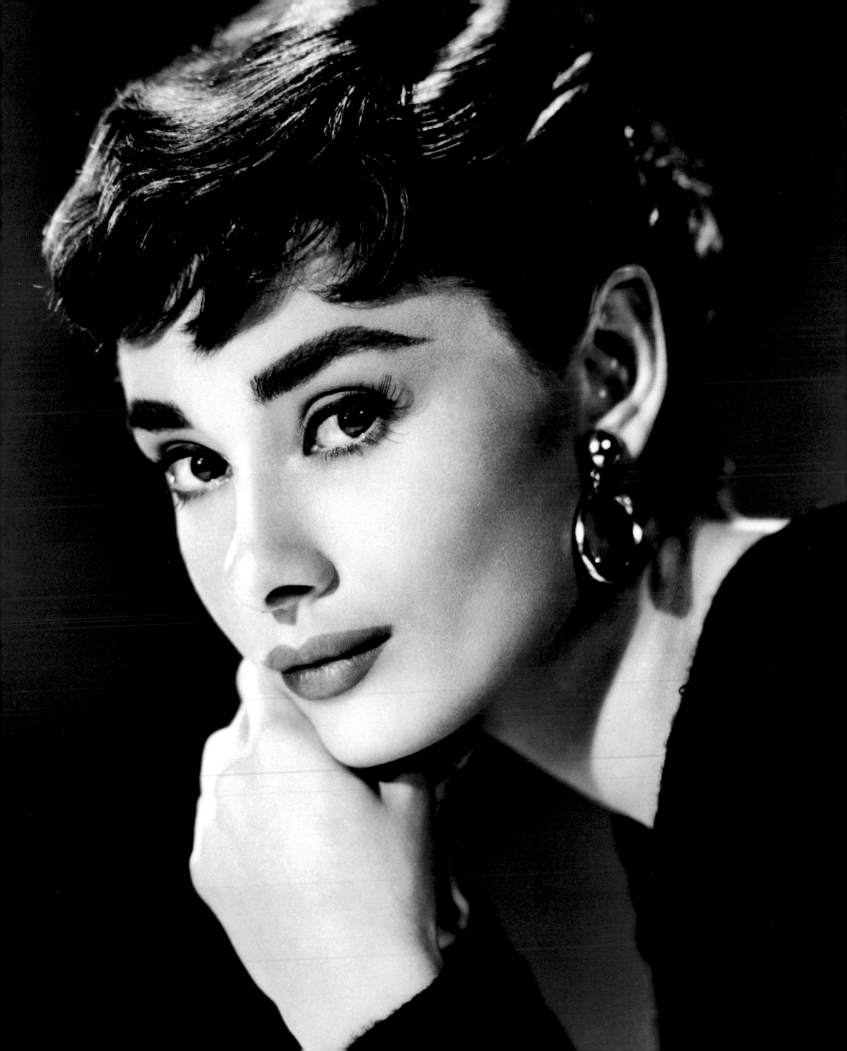

Audrey Hepburn

She was an incomparable icon of style, grace, elegance, and human sensitivity. After conquering Hollywood with her doe eyes and the little black dress created for her by Givenchy, she put her fame at the service of children by becoming ambassador for UNICEF.

In a period dominated by such sex bombs as Marilyn Monroe, Audrey Hepburn achieved stardom with her diminutive physique and ballerina-like posture, rejecting the clichés and concentrating on her being so different. Tall, thin, elegant, and always smiling, she conquered her fellow actors and film directors with her absolutely personal style. "You looked around and suddenly there was this dazzling creature looking like a wild-eyed doe prancing in the forest. Everybody on the set was in love within five minutes," director Billy Wilder commented. Having been deprived of a happy childhood because of the war and the Nazi occupation of Holland, she dreamed of becoming a ballerina. Then she turned to acting and eventually began her career in Hollywood, being awarded two Oscars, three Golden Globes, one Emmy, one Grammy Award, and four BAFTAs for roles that became legendary, such as Holly Golightly in *Breakfast at Tiffany's*, *Sabrina*, Princess Ann in *Roman Holiday*, and Eliza in *My Fair Lady*. Far removed from the self-indulgence and vices of Hollywood stars, she got up at four in the morning to go over her lines and chose her wardrobe for her films herself, opting for the creations of stylist Hubert de Givenchy, with whom she established one of the most solid and extraordinary working relationships and friendships in the history of cinema, which began with an amusing and incredible misunderstanding. As Givenchy said, "I was expecting Katherine Hepburn at my studio [...] She was still unknown but she conquered me immediately and since then I have never stopped dressing her." Her thin silhouette turned the little black dress – the sleeveless dress with a simple and clean line, and delicately tightened at the bottom – into a myth; it soon became the object of desire for millions of women.

Audrey Hepburn was the daughter of a Dutch baroness and an English gentleman. She was born in Belgium and was registered at the British consulate under the name Audrey Kathleen Ruston, obtaining a British passport that she kept all her life. At the end of World War II she changed her family name to Hepburn-Ruston, and then decided to call herself simply Audrey Hepburn.

May 4th, 1929, Brussels, Belgium • January 20th, 1993, Tolochenaz, Switzerland

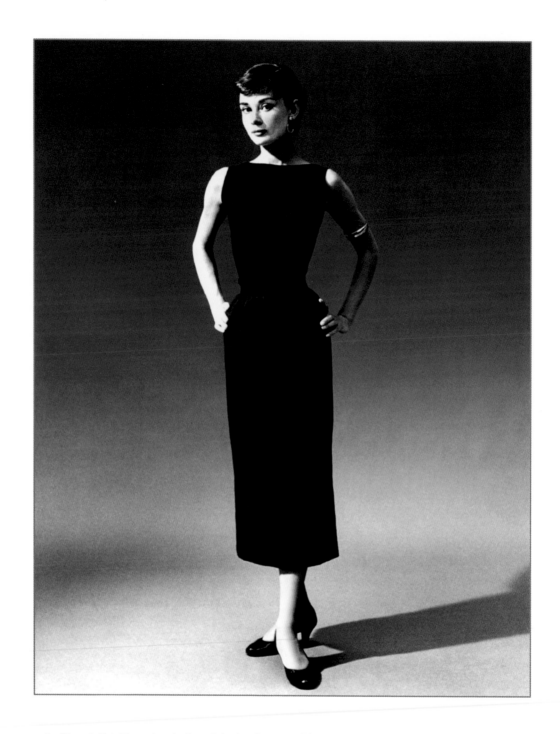

146 The stylist Givenchy designed Audrey's apparel in many of her movies. In 1957, he created a perfume that she had inspired: "For a year it will be for you alone, then I will put it on the market," he whispered to her during a dinner in New York while giving her the crystal bottle. "But it's my perfume, I forbid you to do this!" she replied. Twelve months later, Interdit, the "forbidden fragrance," arrived in the perfume shops.

147 Audrey Hepburn in Paris in 1966, photographed by Douglas Kirkland during the shooting of *How to Steal a Million*. The following year, while on a cruise in the Mediterranean, she met the Italian nobleman Andrea Dotti; they married, and their son Luca was born in 1970. Ten years earlier, when she had been married to actor Mel Ferrer, she had given birth to their son Sean.

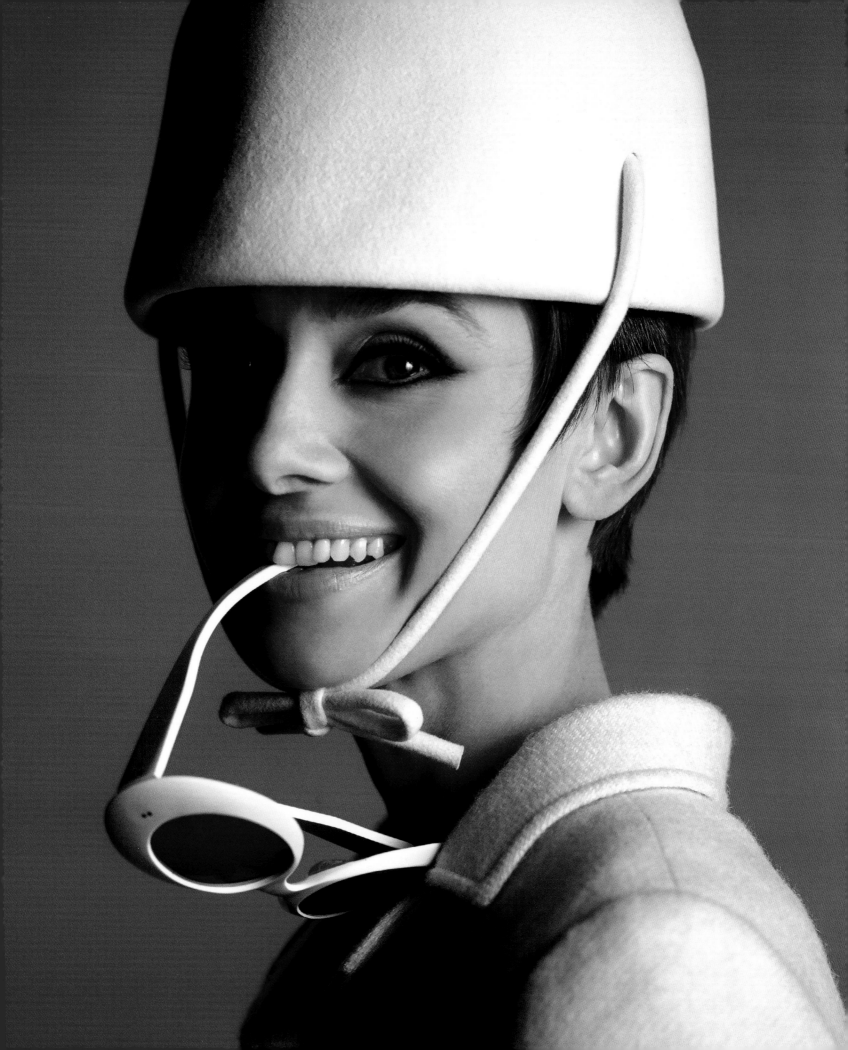

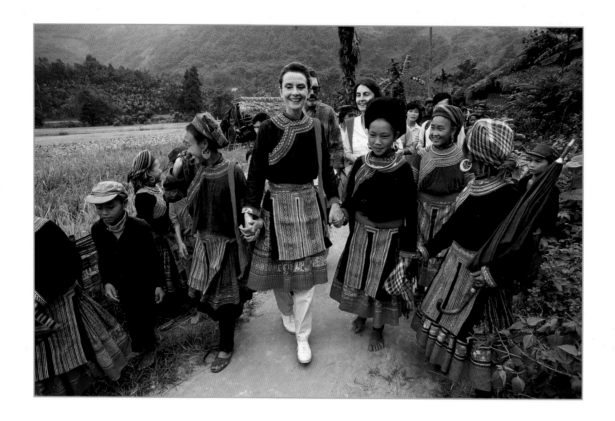

When Audrey turned forty, she decided to retire from the cinema to devote her energy to what meant most to her, her family and children; but she was unable to remain inactive for long. She, successfully, an application to become the UNICEF Goodwill Ambassador, for which she received the symbolic wage of one dollar per year in exchange for an extremely long series of trips to the poorest nations in the world, during which she risked catching contagious diseases and studied for hours and hours to write every speech she made. "I have been offered by UNICEF an *opportunity* to assist with *any project* on which I might be useful – this is for *me* an *immense privilege* and an answer to my longing to help children in whatever small way I *can*." It was a choice she made with her heart and that transformed a Hollywood star into a role model for so many women.

148 and 149 Audrey photographed in Vietnam in 1990, during one of her trips as UNICEF Goodwill Ambassador. In 1992, U.S. President George W. Bush presented her with one of the most important awards given to an American civilian, the Presidential Medal of Freedom. In 2011, her sons Sean and Luca created, in Italy, the Friends of Audrey Association, which in particular supports the project for the fight against child malnutrition in Chad.

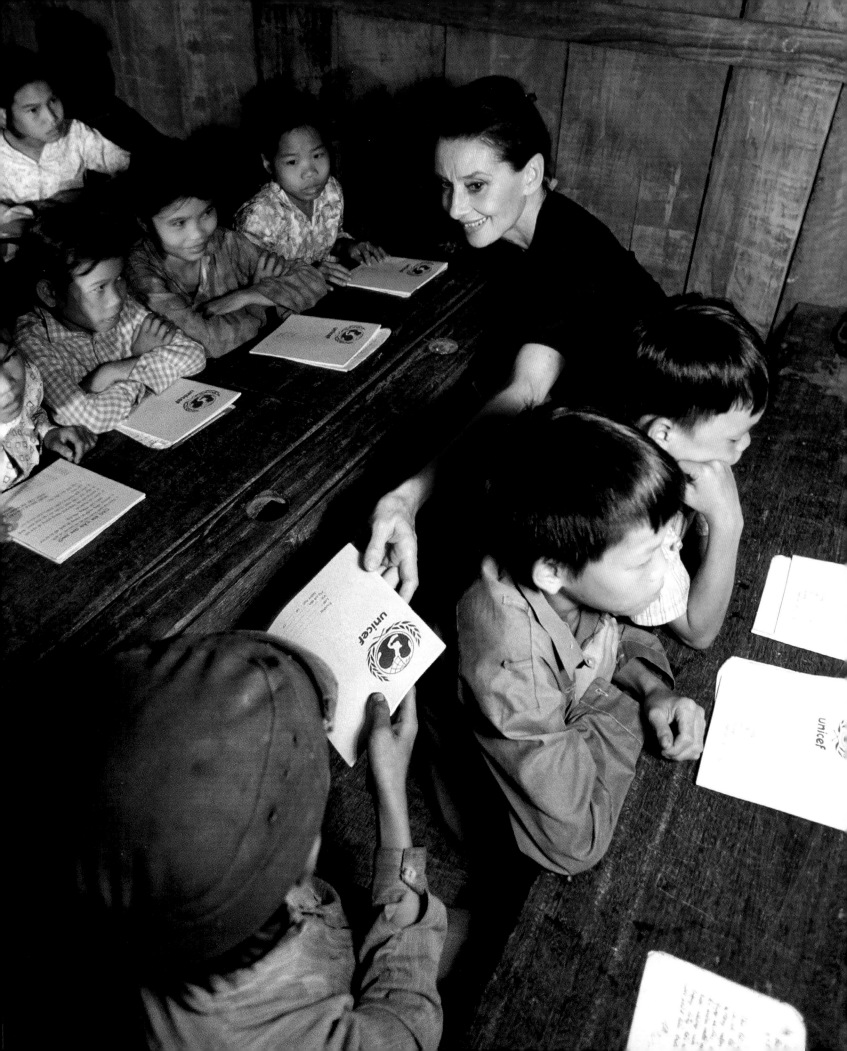

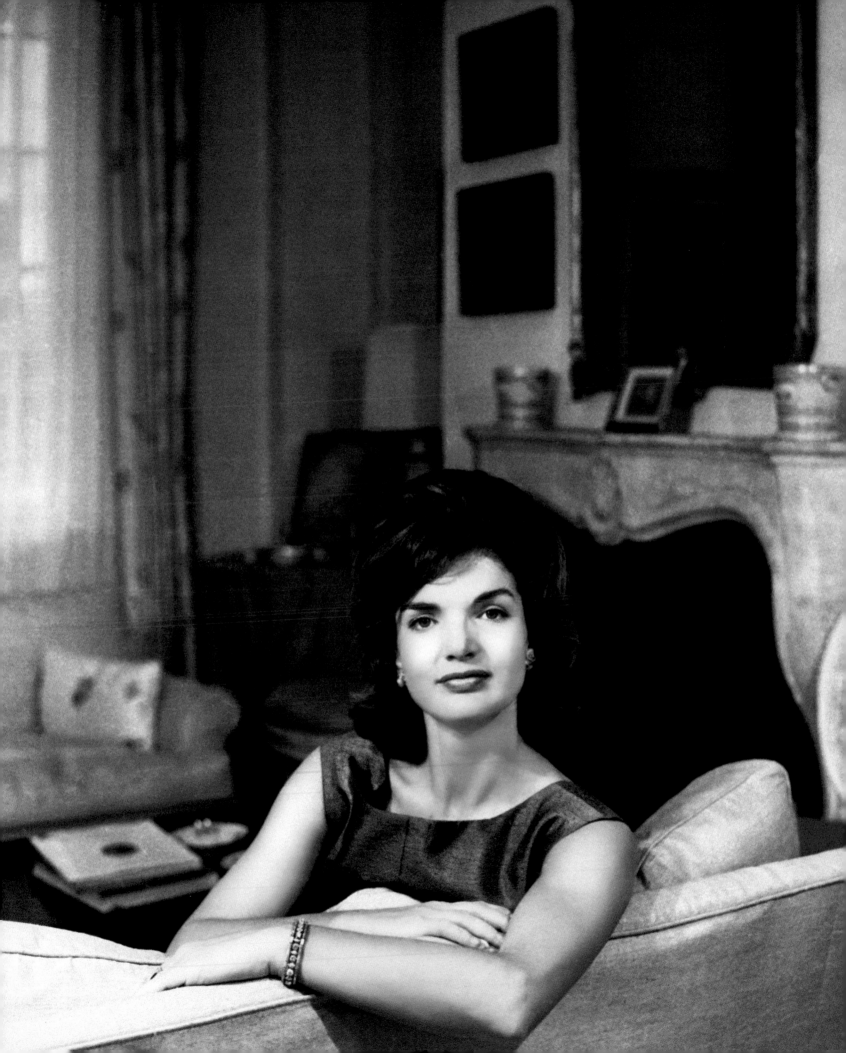

Jacqueline Kennedy Onassis

July 28th, 1929, Southampton, New York, United States · May 19th, 1994, Manhattan, New York City, New York, United States

The First Lady for only three years, she conquered the world with her style, a mixture of good taste and total grasp of the media world, which she had learned working as a photo-reporter, while waiting for a perfect marriage. She had two, both legendary.

"As to physical appearance, I am 5' 7" tall, with brown hair, a square face and eyes so unfortunately far apart that it takes three weeks to have a pair of glasses made with a bridge wide enough to fit over my nose," she wrote in a barbed self-portrait for *Vogue*. And in truth, according to the canons of a period still based on the blond and buttery beauties of the 1950s, she would not be considered so attractive. Yet this modern, active and lithe brunette was a winner. A young Massachusetts senator, John Fitzgerald Kennedy, understood this the first time he saw her. They met during an interview, when she was a reporter waiting to find the perfect husband ("What is sad for women of my generation is that they weren't supposed to work if they had families," Jackie said. "What were they to do when the children were grown – watch raindrops coming down the windowpane?"). Shortly afterward, they were the most glamorous couple in America, and on September 12th, 1953, at Newport, 3000 persons crowded around the church that she emerged from arm in arm with the future president of the United States. In order to be with her husband as much as possible, after the wedding she abandoned her newspaper job and took an interest in politics, and in a very short time proved to be a valuable resource for the Democratic Party during the presidential election campaign. On November 20th, 1960, when she was only 31, Jacqueline became the First Lady of the United States, always elegant, approachable, and with a friendly smile in every photograph.

Jacqueline Lee Bouvier was born into a high-society New York family. She was a brilliant student, and in the part of the high school yearbook devoted to the pupils' ambitions for the future, she wrote quite candidly: "I'll never become a mere housewife." At left, a photo portrait of Jacqueline in 1960, when she became the First Lady of the United States.

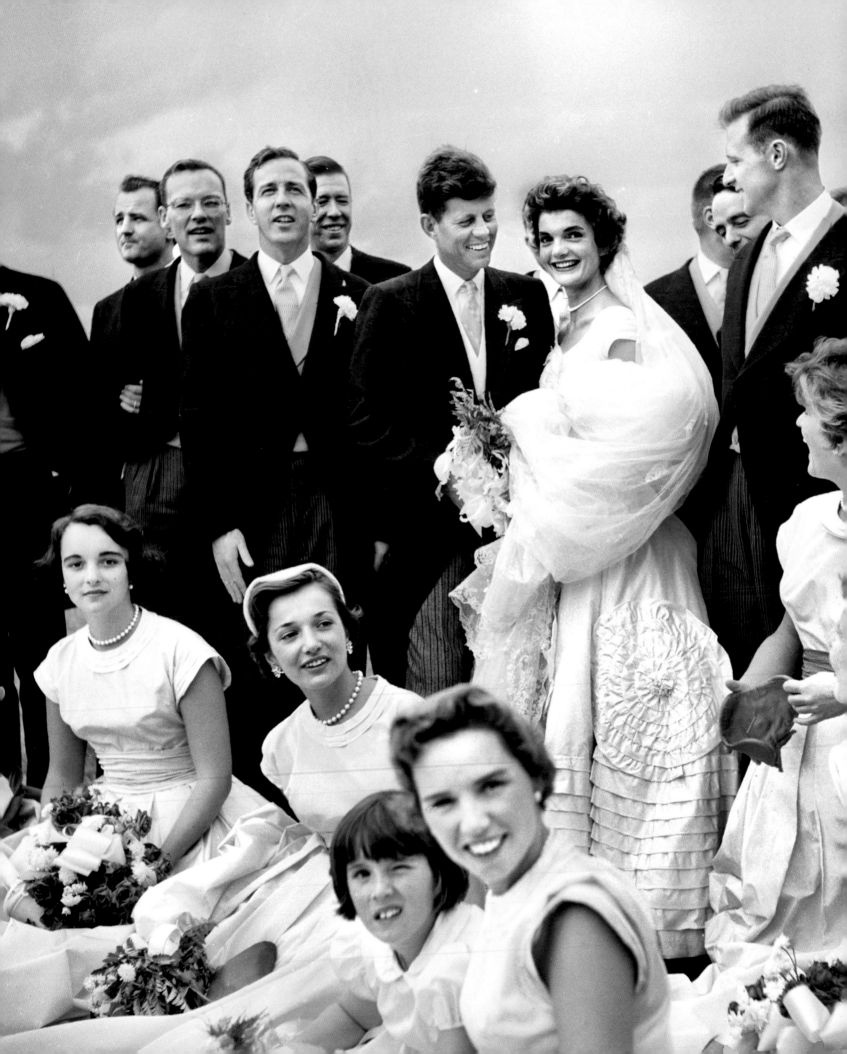

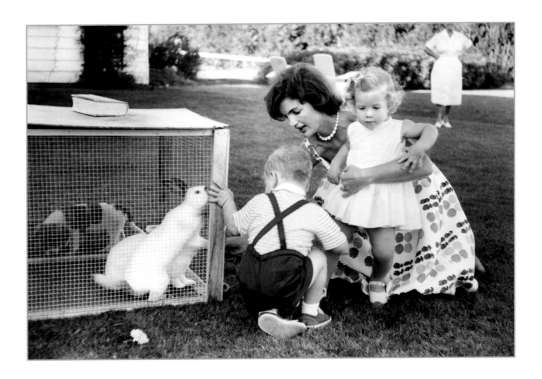

An elegant suit with three-quarter sleeves designed by Oleg Cassini and a small Roy Halston hat were enough to make Jackie a model of style admired by all women to such an extent that during their trip to Europe, President Kennedy stated: "I am the man who accompanied Jacqueline Kennedy to Paris." Jackie became a truly historic figure three years later, when, with her clothes still covered with her husband's blood, she stood next to Lyndon Johnson in the presidential airplane while he was taking the oath of office after JFK's assassination, marking the dramatic and tragic end of an epoch. After her brother-in-law Robert Kennedy was also assassinated, a shattered Jackie abandoned the United States. "If they're killing the Kennedys, then my children are number one targets. I want to get out of this country."

152-153 Jackie and John the day of their wedding, which was celebrated in Newport on September 12th, 1953. The Kennedys gave a sumptuous reception for two thousand guests, the photographs of which went around the world. It took two months and 110 pounds (50 kg) of ivory-colored silk to make Jacqueline's simple and refined wedding dress.

153 Jackie with her children Caroline and John at their vacation home in Hyannis Port. Her marriage was deteriorating because of her husband's well-known and repeated philandering. They became close again only after the premature death of their third son, Patrick, which occurred a few months before the president was assassinated in Dallas.

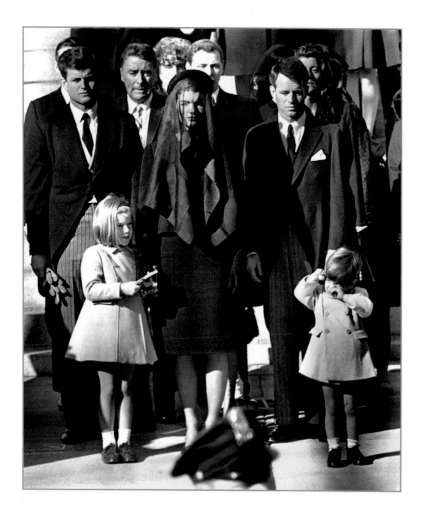

154 Jacqueline Kennedy holding her daughter's hand during her husband's funeral, held on November 25th, 1963, in Washington, D.C. The courage and dignity she displayed while following the bier on foot, with 103 heads of state behind her, elicited the admiration of the world. That same evening, she found the strength to celebrate her son John's third birthday.

154-155 At right, Jackie in the foreground during a speech her husband gave in New York in October 1960, during the presidential election campaign. Kennedy won the election a month later. The couple left a mark on American history, despite the fact that JFK's presidency lasted only three years: he was assassinated in Dallas on November 22nd, 1963.

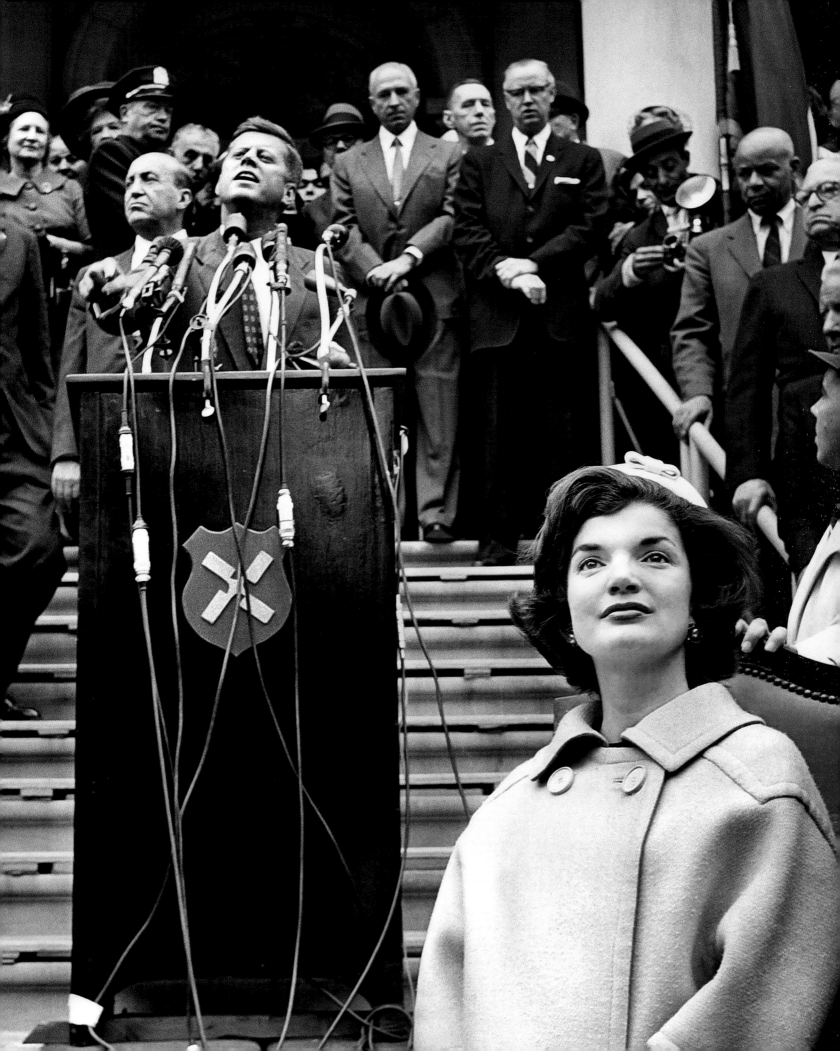

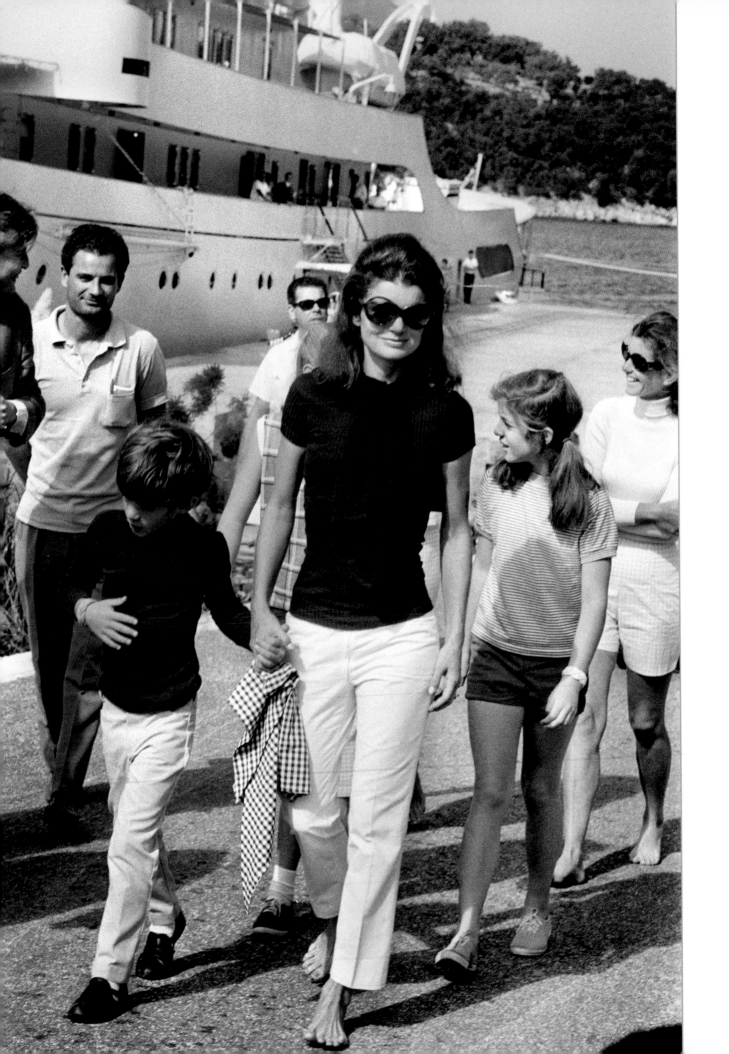

156 Jackie with John and Caroline on the islet of Skorpios, Greece. She set the trend in fashion with her unmistakable look: sack dresses and other elegant apparel, strings of pearls, Capri pants, and large sunglasses. She always said that she liked "terribly simple" clothing and couldn't stand pattern fabrics.

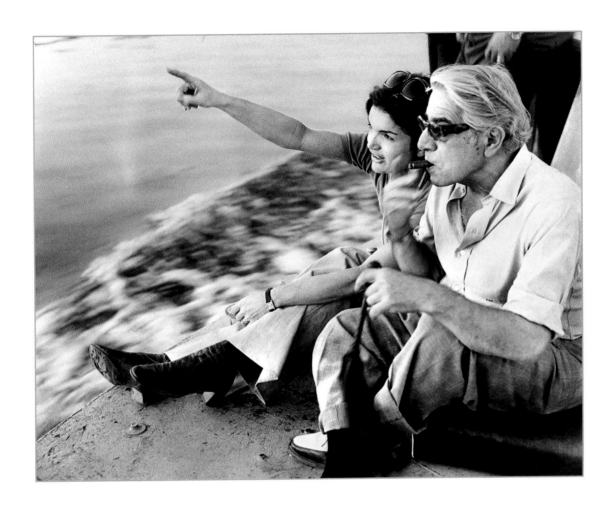

Her refuge was Aristotle Onassis, the Greek shipping tycoon and former partner of Maria Callas, who asked Jackie to marry him by presenting her with a colossal 40-carat Lesotho diamond, accompanied by a rigorous prematrimonial contract. "She was like a diamond", he stated. "Cold, with sharp features, fiery and passionate under the surface." Onassis died in 1975, leaving the former First Lady a widow once again. She returned to New York, using her power to give financial support to the arts and sciences. One case in point was the ancient Egyptian Temple of Dendur, which was saved from the flooding caused by the construction of the Aswan Dam and installed – partly thanks to Jackie – in the Metropolitan Museum in Manhattan in 1979. "The first time you marry for love, the second for money, and the third for companionship," she said, appearing together with Maurice Tempelsman, the man she spent her last years with, and who was also by her side when she passed away at the age of 64. The nation was in deep mourning. It had lost the only true queen America had ever known.

157 Jackie with the Greek shipowner Aristotle Onassis during one of their journeys. They married in the autumn of 1968 on the island of Skorpios, Greece, signing a contract with 170 clauses written by the couple's lawyers, with terms that regulated their relationship in full detail, from the sum she would inherit should she become a widow to their having separate bedrooms.

Dian Fossey

"The more you learn about the dignity of the gorilla, the more you want to avoid people." If this species still exists, it is due to the indomitable spirit of the primatologist Dian Fossey, who realized her childhood dream of working with animals, but paid for her uncompromising principles with her life.

There are twin tombs in the small cemetery at the Karisoke research camp, in Rwanda. One is the resting place of Digit, a large male gorilla who was killed and barbarously mutilated by poachers while trying to defend his family. In the other lies Dian Fossey, the American researcher who dedicated her life to the fight against poaching. It was like ferocious guerilla warfare. In order to make the poachers stop their activity, she put a bounty on their heads, burned their huts and weapons, organized punitive patrols, and even taught the gorillas to put their trust only in her, which triggered strong tension among the local populations. In this way she caused such a stir as to attract the attention of the world to this remote land, which led to the first articles in *National Geographic Magazine* as well as donations to the Dian Fossey Gorilla Fund. What is more, her research activity ended up stimulating a form of ecotourism that with time led to an extraordinary development: the Rwandan authorities increased their repression of poaching. If mountain gorillas still exist, this is undoubtedly due to Fossey's courageous choice, which she paid for with her life. Her assassination was never punished, because there is still uncertaintly about the identity of both the instigators of this murder and the assassins themselves.

Her passionate research contributed the longest and most detailed study of mountain gorillas to the history of science, the result of twenty years of field work. It all began during Dian's first trip to Africa in 1963, financed by her borrowing an entire year's salary as a therapist for disabled children in a Kentucky hospital. In her best seller *Gorillas in the Mist,* she describes the overwhelming encounter that changed her life: "Their bright eyes darted nervously from under heavy brows as though trying to identify us as familiar friends or potential foes. I was struck by the physical magnificence of the huge jet-black bodies blended against the green palette wash of the thick forest foliage. I believe it was at this time the seed was planted in my head, even if unconsciously, that I would someday return to Africa to study the gorillas of the mountains." Three years later, she founded the Karisoke camp, in Rwanda, and for the next twenty years she rarely left Africa, devoting all her energy to studying primates.

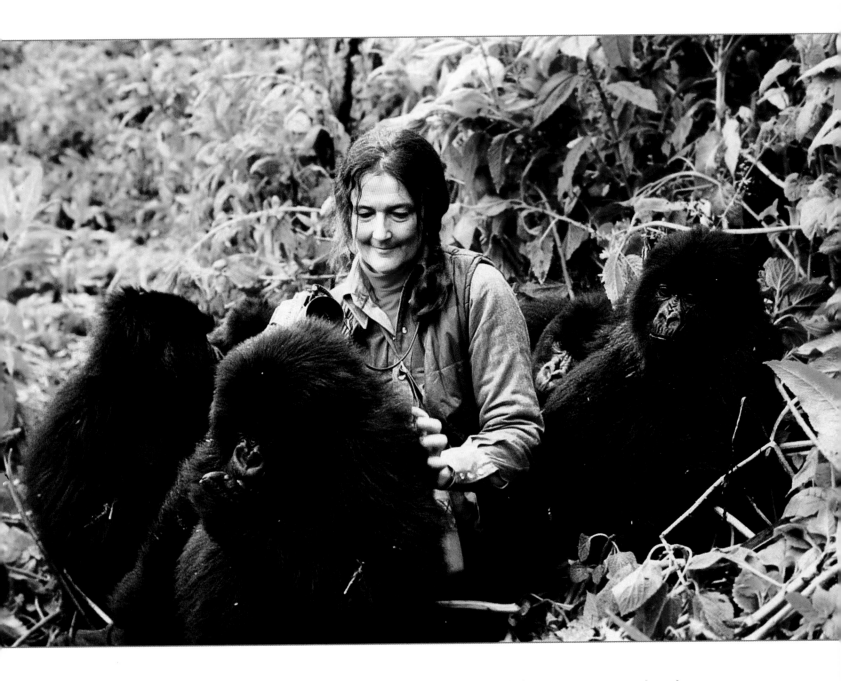

The long hours she spent observing and living with them dispelled the stereotypes regarding this species, which until than had been considered hostile and dangerous, whereas she proved that mountain gorillas are intelligent, gentle, and social. By applying the techniques she learned from her therapist experience, Dian gained their trust and even established a deep bond with each member of the group, loving them as if they were the family that her life had denied her.

Dian Fossey with mountain gorillas in Rwanda. The story of her life and her devotion to the study of primates became famous thanks to the 1988 movie *Gorillas in the Mist*, based on her book of the same title. She was interpreted by Sigourney Weaver.

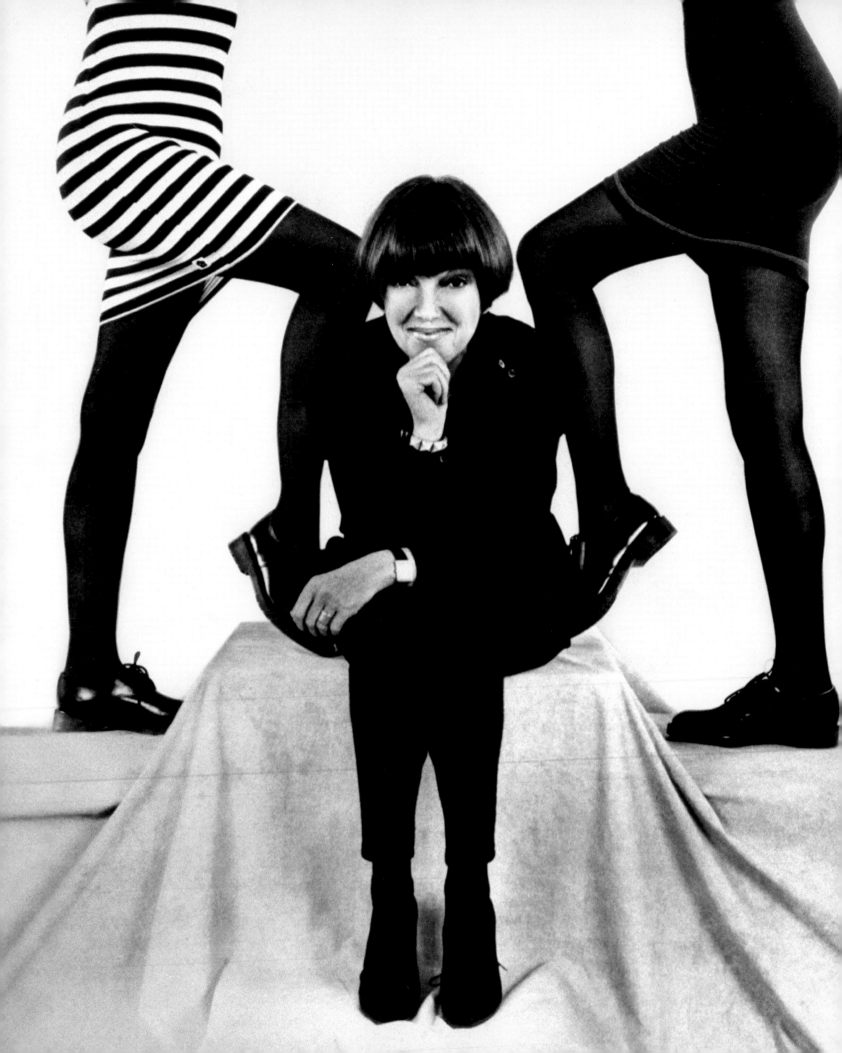

Mary Quant

At times, emancipation comes after a good trimming job, like the one that Mary Quant gave to women's skirts, lending a breath of fresh air to the fashion world. This was back in 1962, when the times were changing at breakneck speed.

Mary Quant was only 21 years old when she decided to open her first boutique, and she had no idea of the rumpus she was about to bring about. She chose a place with two shop windows along King's Road, in the Chelsea district of London, and invested everything she had in a shop destined to change the history of fashion: Bazaar. The first week, the takings amounted to five times the money she had invested: "It was a gamble and it ended up fine," Mary recalled many years later. There were no class barriers at Bazaar: for the first time, countesses and typists were side by side poking about on the shelves, enthusiastic "teammates" in that democratic revolution consisting of articles within everyone's means and bold chromatic combinations that remind one of Pop Art painting. In 1962, the item in the shop window that was admired most was called "miniskirt," not only because of the reduced size of the fabric, but also as a tribute to the automobile that was so popular among the younger generation, the Mini Morris. To develop this creation, all Mary needed was to look around and let herself be inspired, as she herself admitted: "It was the girls on King's Road in London who invented the mini. I was making clothes that would let you run and dance, and we would make them the length the customer wanted. I wore them very short and the customers would say, 'shorter, shorter.'" The reaction was not long in coming, and the conservative newspapers railed against Mary, who in turn reacted by cutting the skirt even more, as much as 4 inches (10 centimeters) above the knee, coupling it with colored stockings that (partly) mitigated the scandal of all that unveiled femininity.

Mary Quant in the 1960s with her most famous creation, the miniskirt. She opened her shop together with her partners Archie McNair and Alexander Plunket Greene (who later became her husband), and everybody there was young: the customers, the shop assistants, and Mary herself. "The woman I wanted to dress was exactly like me: free, merry, exuberant, optimistic."

February 11th, 1934, Blackheath, London, United Kingdom

161

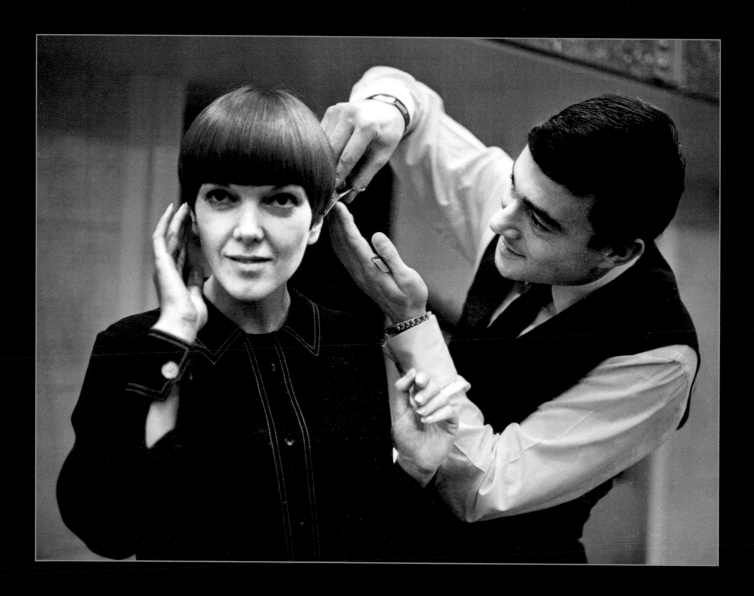

162 Mary Quant getting the famous "five point cut" invented for her by Vidal Sassoon. Commenting on that hairstyle, which became as famous as her creations, Mary declared: "Vidal Sassoon, the pill and the miniskirt changed everything forever in women's lives. Cutting my hair, he created the perfect finishing touch to the style of my garments."

163 Besides miniskirts, Mary Quant's boutique also produced the Swinging London look inspired by pop culture. Colored collars that cost only two shillings and plastic boots with wide and comfortable heels also sold like hotcakes. Here, Mary is photographed during the launch of her new footwear.

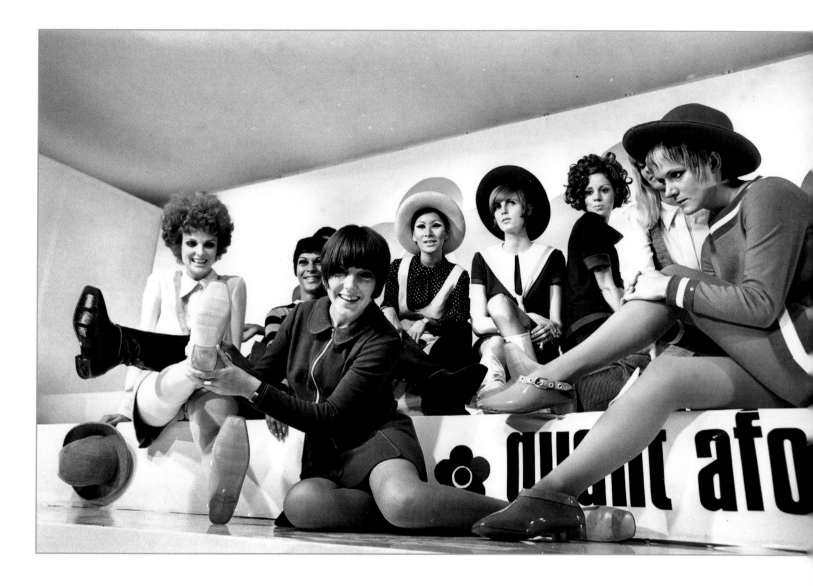

Her articles were such a smashing success with young people that Mary opened another boutique at Knightsbridge, after which she appeared on the pages of the leading fashion glossies and became the symbol of an epoch that was embodied in the ethereal beauty of Twiggy, the model whose name and fame are inextricably connected to the miniskirt. In the 1960s, Mary Quant's innovations and creations were so popular that she became a world figure all over the world, a household name whose daisy logo was to be seen not only on her apparel but also on shoes, accessories, and cosmetics. At that stage, her revolutionary miniskirt was already in the wardrobe of millions of women, and the time when it was considered scandalous already seemed to be light years away when, in 1966, Queen Elizabeth II presented her with the Officer of the Order of the British Empire award "for her outstanding contribution to the fashion industry." She went to the ceremony at Buckingham Palace dressed in her distinctive style – in a miniskirt, of course.

Valentina Tereshkova

The first woman to fly in space was a champion parachutist, but she dreamed of going much higher. When Gagarin accomplished his extraordinary feat, she decided that she would do just as well: "If women can be railroad workers in Russia, why can't they fly in space?"

As an alias call sign between the spaceship and Earth, she had chosen *Chaika*, or seagull in English. Immediately before takeoff, they wished her a safe flight on the radio, but she was already looking at the blue sky and shouted in the microphone: "Hey, sky! Take off your hat, I'm on my way!" It was June 16th, 1963, and Valentina Tereshkova was the first woman to fly in space. She landed on Earth almost three days later, and her name instantly echoed around the world, just as she orbited 48 times on board the *Vostok 6* space capsule. Photogenic and with a winning smile, she was the perfect image for the propaganda of the Soviet Union, which, after Gagarin's historic flight, consolidated its space record by adding this new one. Valentina had been chosen from among five female candidates at the end of a top secret training program precisely because of her strong presence and personality, as well as her proletarian background. "Her colleagues were better prepared, but no one could compete with Tereshkova in the ability to influence crowds, arouse sympathy among people and appear before an audience," stated Sergei Korolev, head of the Soviet space program. Valentina had another valuable resource up her sleeve, her ability as a parachutist, which saved her life during the delicate landing stage of a flight that Khrushchev called a great triumph but, in reality, as Tereshkova herself admitted many years later, was a risky adventure. In fact, owing to a technical problem, the capsule risked moving out of the orbit toward outer space, and it was necessary to prolong the flight in order to correct the trajectory. This meant that Valentina had to stay strapped to her seat for over 70 interminable hours. A sensor on her head provoked continuous itching, and the cosmonaut suffered excruciating pain in her right leg.

March 6th, 1937, Bolshoye Maslennikovo, Russia

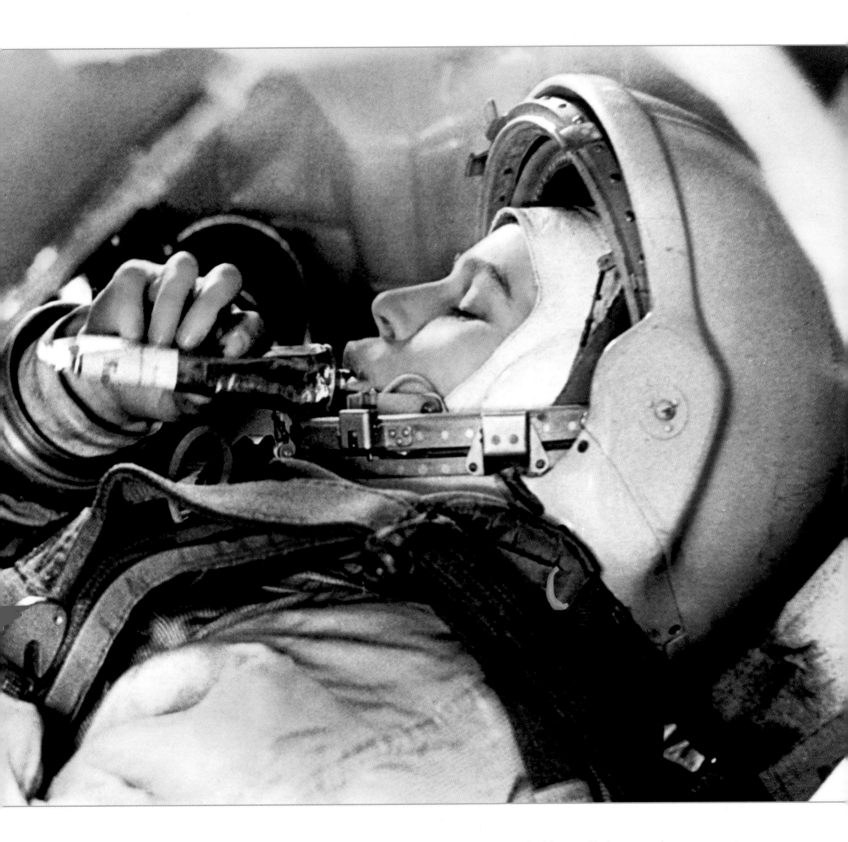

Valentina Vladimirovna Tereshkova was born in a village along the Volga River. She worked in a textile factory and was a seamstress and ironer. She attended evening classes in order to take the examination for the first group of women cosmonauts. In this photograph, taken a few weeks before her historic 1963 launch, she is preparing for her mission by testing the equipment and trying the blended food, which would be her only nourishment during the three days in space.

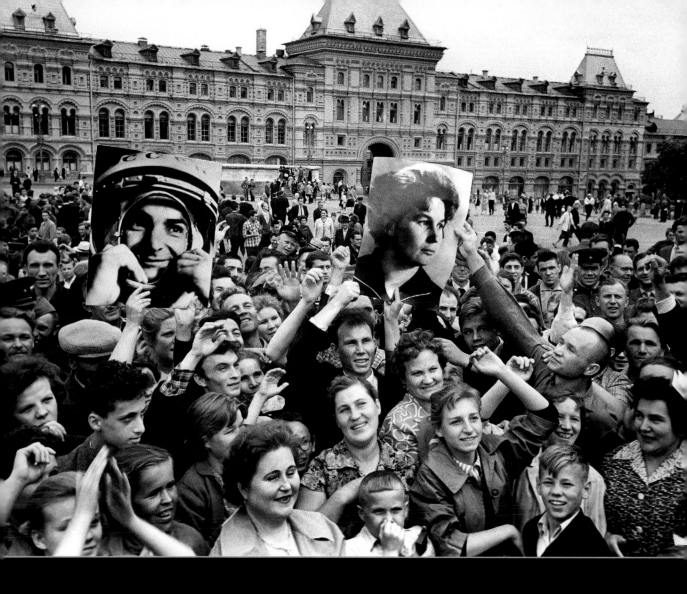

166 The huge crowd in Red Square in Moscow celebrates the success of the *Vostok 5* and *Vostok 6* missions, holding up large photos o[f]
[t]he cosmonauts Valery Bykovsky and Valentina Tereshkova, who were launched into space, within a few days of each other, in June 1963

167 Nikita Khrushchev greets the crowd in Red Square, holding the hands of the spaceflight heroes Valentina Tereshkova and Valery
Bykovsky, on June 22nd, 1963. That same year, the Kremlin was the venue of Valentina's wedding to cosmonaut Andriyan Nikolayev
which crowned her as the ambassador of the Soviet dream. They divorced in 1982, and she married the orthopedist Yuliy Shaposhnikov

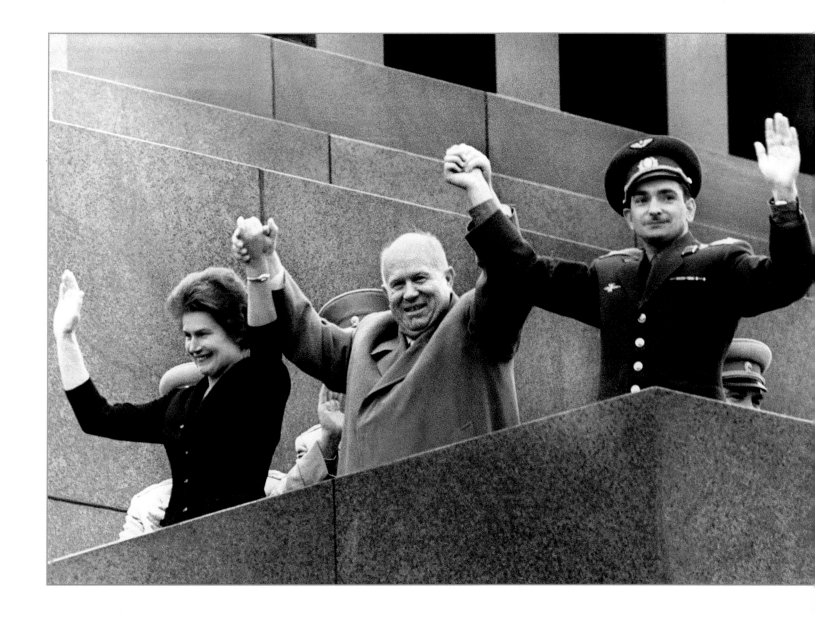

Many years later, the dramatic truth of her flight was revealed. After landing, Valentina had to stay in hospital, since while parachuting a piece of metal had hit her face, causing a bruise that was so ugly that the Soviet propaganda machine was forced to film another, fake, landing, in which she appeared with a huge happy smile. After the celebration of her triumphal feat, Valentina was enlisted in the Air Force Academy, became a member of the Supreme Soviet Presidium, was a Soviet representative at a United Nations conference, and received various awards. She carried the Olympic flag during the inauguration of the 2014 Games, but her eyes were always gazing at the sky: "I would enjoy flying to Mars. This was the dream of the first cosmonauts. If I could I would do it right away. I'm ready to fly without coming back."

Wangari Maathai

With her Green Belt Movement, she planted more than 30 million trees in Africa, supported by thousands of women who believed in her idea, which was simple but revolutionary and led to her winning the Nobel Peace Prize.

In Africa, the women are responsible for farming and are thus the first to become aware of environmental damage that jeopardizes agricultural production, dries the wells, and pollutes their children's food. As a true African, Wangari Maathai was quick to realize that it had to be women who could guarantee the success of the project of sustainable development she had in mind, which derived from a simple but ingenious idea, like so many great inventions that have changed our world. First of all, she distributed young plants among the women who worked in the fields; then she made sure they were rewarded for every plant that grew, thus stimulating them to take special care of the plants, which with time became immense green belts of trees that not only prevented the erosion of the soil, but also afforded shade and were a source of timber.

A biologist, environmentalist, and human rights activist, Wangari Maathai was the pioneer in forest conservation with her Green Belt Movement. Besides winning the Nobel Peace Prize, over the years the "Mistress of the Forests" received numerous international honors and awards, including the Global 500 Roll of Honor as part of the UN Environment Program, the Goldman Environmental Award, the Africa Prize for Leadership, and the Better World Society award.

April 1st, 1940, Nyeri, Kenya • September 25th, 2011, Nairobi, Kenya

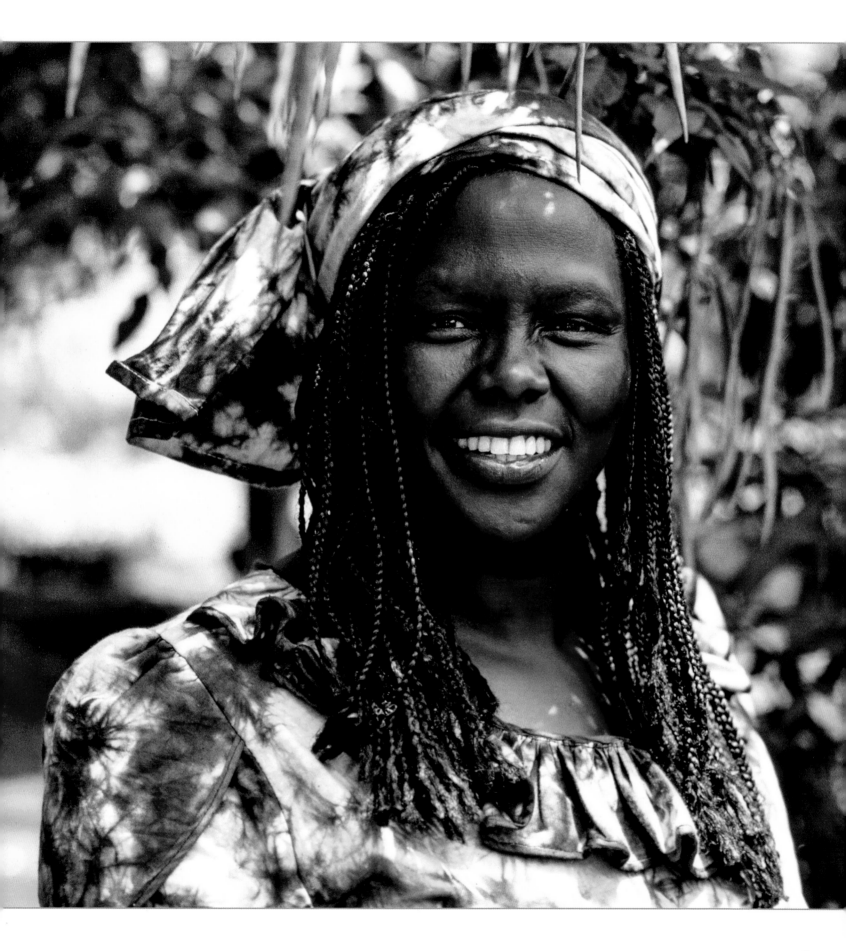

170 Wangari Maathai (left) at Kiriti, Kenya, while explaining the principles of her movement to children. Before she entered the scene, no one in Kenya would have thought that women could plant trees or become forest rangers. Today, 70% of the activists in the Green Belt Movement are women, and the organization has become a model in other parts of Africa and the world.

171 The long procession at Wangari Maathai's funeral, which was celebrated in Nairobi on October 8th, 2011. In the latter years of her life, Wangari's work concentrated on human rights in Kenya, in open conflict with President Daniel Arap Moi, who persecuted and arrested her, denigrated her in public speeches, and called her a "dangerous woman." In 2002, Moi was not re-elected, while Maathai was elected a member of the Kenya Parliament, with 98% of the votes in her constituency, and kept this post until 2007.

Since 1977, when Wangari Maathai founded her Green Belt Movement, more than 50 million trees have been planted across the African continent, and thousands of women have been trained to protect this precious green life belt. The idea came to her when she was studying at university in the United States, where she earned a degree in Biology (at a later stage, she became a lecturer at the University of Nairobi, the first woman in her country to receive such a prestigious post). Thanks to the idea that Wangari Maathai launched, the conservation of the forest ecosystems in Kenya has gone hand in hand with the social and economic emancipation of women. Many of those who participated in Maathai's project have been able to earn their living from this activity, becoming forest rangers and experts in the field of forest systems. Wangari Maathai was the first African woman to receive the Nobel Peace Prize, in 2004, "for her contribution to the causes of sustainable development, democracy and peace."

Joan Baez

From a short love affair with Bob Dylan to the marches side by side with Martin Luther King. From Woodstock to the protests against the war in Vietnam. The icon of pacifism and the civil rights movement has never stopped captivating the world with her nightingale voice.

There was thunderous applause when Joan Baez took the stage at Woodstock. This was in the summer of 1969, and she was six months pregnant. She was wearing a sky-blue tunic, and the downpour that was about to strike the most legendary concert of all time made her look like a Madonna. She sang *Joe Hill* for her husband, who was in prison for having refused to fight in Vietnam, after which she began to sing *We Shall Overcome* together with the 400,000 young people who had come to be part of that memorable event. Her voice transformed that gospel into a symbol of protest and hope. Joan also sang it while marching with Martin Luther King to Washington, when the reverend gave his world famous "I have a dream" speech; at Hanoi, in Vietnam, while it was being bombed; in Latin America against dictators; in Prague during the Velvet Revolution; she dedicated it to the Iranians with some verses in Farsi; and she even sang it in the White House to Barack Obama.

An American of Mexican origin, Joan had experienced racial discrimination firsthand when as a child she was traveling around the United States with her father Albert, one of the inventors of the X-ray microscope, attending one school after the other, where she was promptly isolated because she was half-breed. Things suddenly changed thanks to an unexpected gift. For her 16th birthday, one of her aunts took her to a Pete Seeger concert, which revealed an intriguing and inspiring world to her. She discovered that one can use music to discuss important questions and understood that this would be her vocation. She began to play and sing folk music in the coffee shops of Boston. The following year saw the release of her first record, and when she was only twenty she was already considered the queen of folk music when she met a young

Joan Baez photographed around 1970. Two years earlier, she had married David Harris, who became the father of her son Gabriel. Besides the relationship with Bob Dylan, her lover and professional colleague from 1962 to 1964, in the 1980s she had a much talked-about romance with the historic founder of Apple, Steve Jobs.

January 9th, 1941, Staten Island, New York City, New York, United States

174 On March 25th, 1965, thousands of persons witnessed Martin Luther King's speech at the end of the famous march from Selma to Montgomery, Alabama. The music world came to support the reverend: Pete Seeger, John Stewart of the Kingston Trio, Harry Belafonte, and Joan Baez (in the photograph, seated just behind the cameraman in the white T shirt). Two months later, Congress approved the Voting Rights Act, which paved the way for equal rights for African Americans.

songwriter and singer, Bob Dylan. Joan was the one who first invited him to sing on stage, thus initiating a working relationship that marked a major turning point in the history of music. They also had a short-lived love affair, but the melodies they shared became eternal. They were the voice of a generation, the cry of an angry nation. In 1968, Joan collaborated with Ennio Morricone in the soundtrack of the film *Sacco and Vanzetti* by writing the lyrics for, and singing, *Here's to You*, a hymn against injustice and for freedom that spread throughout the world thanks to the power of music, a universal language that can trigger great changes. With her typical smile, Joan Baez said that we need music more than ever, since it makes courage contagious, and that every revolution that occurred in our time arrived in the wake of new music. Her gentle but powerful voice, accompanied by the pizzicato chords of the guitar, still spellbinds the audience in that tender 1960s atmosphere that has the flavor of pacifist utopias.

175 Mississippi, September 1966: Martin Luther King and Joan Baez accompany African American children on their first day in a public school that until then had been reserved for whites only. Joan once stated that using her voice in the struggle against injustice lent profound meaning and infinite pleasure to her life.

176-177 On stage at the 32nd Annual Rock & Roll Hall of Fame, on April 7th, 2017, at Barclays Center in Brooklyn, New York, Joan Baez (the second from left) performs with Mary Chapin Carpenter and the American folk song duo Girl. This event celebrated her 60-year career and her induction into the Hall of Fame, which honors the greatest artists of all time.

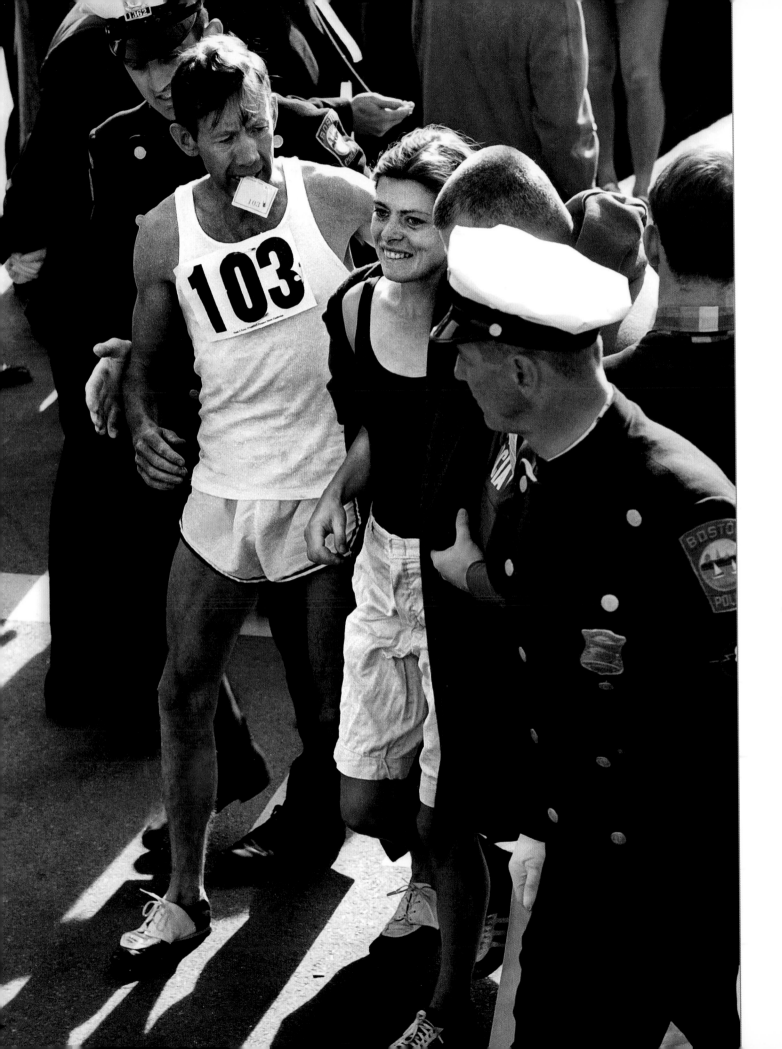

November 2nd, 1942, Cambridge, Massachusetts, United States

Roberta Gibb

On April 19th, 1966, a 23-year-old woman sneaked her way among a group of male runners in the historic Boston Marathon. It was Roberta "Bobbi" Gibb, and she was the first woman to arrive at the finish line of a race considered too tough for females. Yet her story remained in the dark for years.

Like so many other things, the Boston Marathon was long considered a men's only affair. When in 1966 Roberta Gibb received the reply from the organizers of the race to her request to participate, she could not believe what was written there: the committee had excluded her because "the race is open only to male competitors and furthermore, women are physiologically incapable of running a marathon and they are not allowed to enter a men's division race." This was too much for a young woman used to challenging, and even beating, her boyfriend during training. Now there was only one choice: she had to run to prove that they were wrong. She went near the starting line disguised in a hooded sweatshirt, her brother's Bermuda shorts, and a pair of Red Cross nurse's shoes, because at the time running shoes for women did not exist. Afraid she would be recognized as a woman and thrown out of the race even before it began, she hid among the nearby bushes and then, when the gun went off, she stole into the group of runners. When the runners realized she was a woman, Roberta was amazed by their reaction: "We won't let them throw you out. It's a free road," they said while they "escorted" her toward the finish line. So her race became a symbolic gesture; she simply had to demonstrate that she could do this and she did. In reality, for decades this record was associated with another woman, Kathrine Switzer, a 20-year-old who managed to participate in the Boston Marathon by writing only her initials in place of her first name in the application form. She was immortalized by journalists, while the race director tried to take her out of the starting pack of runners, creating such a scandal that public opinion was convinced it was ridiculous to exclude women from such competition. Yet this episode occurred only a year later, in 1967. The woman who really set the record was Roberta, who, out of sheer willpower, encouraged millions of female marathon runners to try to arrive first at the finish line.

Roberta Gibb at the end of the Boston Marathon on April 19th, 1966. She ran the race in 3 hours 21 minutes and 40 seconds. In 1972, the women's marathon was officially established, but in order to compete in the Olympic Games program, women had to wait for many more years, until the 1984 Los Angeles Games.

180 Gibb absorbed in shaping the model for the bronze statuettes used as trophies to honor Joan Benoit Samuelson, Julie Brown, and Julie Isphording, the first three female marathon runners who qualified to represent the United States in the 1984 Olympic Games women's marathon.

180-181 Roberta Gibb training in 1983. She now works as a sculptor and researcher at the University of Massachusetts, but she still runs to collect funds for studies on Lou Gehrig's disease and to aid women and children in distress.

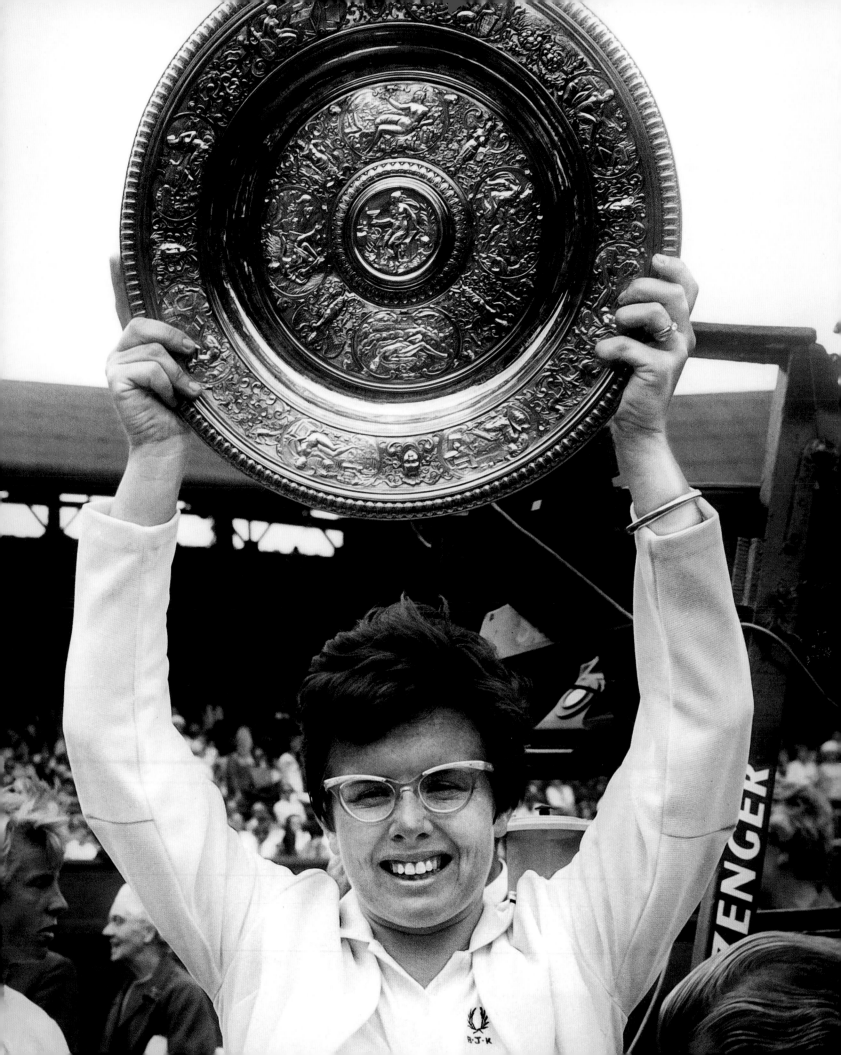

Billie Jean King

A champion not confined to the court, she challenged a male tennis player so that women could have equal prize money. The match that Billie Jean King and former champion Bobby Riggs played on September 20th, 1973, changed the history of tennis... and of women.

One of the most famous tennis matches in history was played in Houston, Texas, in the early 1970s. It was called The Battle of the Sexes because it pitted a man against a woman, both famous American tennis players: Bobby Riggs and Billie Jean King. He was 55 and had retired from professional tennis after having won once at Wimbledon and two US Opens, and thought the right place for women was "in bed and in the kitchen, in that order." She was a ferret 5 ft 5 in (164 cm) tall who burst around the court like lightning and could not tolerate the preferential treatment the tennis establishment reserved for the male players, first and foremost the salaries and prize money, which could be as much as ten times more than that earned by the women. When she accepted Riggs's challenge, Billie Jean knew quite well that that match wasn't only about her, but concerned all women. She pretended to go along with the circus-like aspects of the event, but in fact practiced like Rocky Balboa and made her entrance to the Houston Astrodome on a litter carried by musclemen. The stadium was packed (30,000 spectators, which is still a record in the United States for a tennis match), while 90 million persons eagerly watched the two on television. She demolished him in straight sets, in a memorable match played same months after the approval of Title IX of the American Constitution concerning equal rights between men and women, and the same year that the jury of the Roe-Wade trial made its historic sentence legalizing abortion. The victory in the Battle of Sexes was not the only challenge that Billie Jean won. In 1987, she and her husband had an amicable divorce, she openly declared she was bisexual, and was the first sportswoman in history to become a standard-bearer of LGBT rights.

Billie Jean King at Wimbledon holds up the trophy after defeating Ann Jones in the women's singles final on July 9th, 1967. She won the title again the following year and, in an impressive series of successes in the following years, also won the US Open, Australian Open, and French Open. In 1968, she became the world's number one woman tennis player.

November 22nd, 1943, Long Beach, California, United States

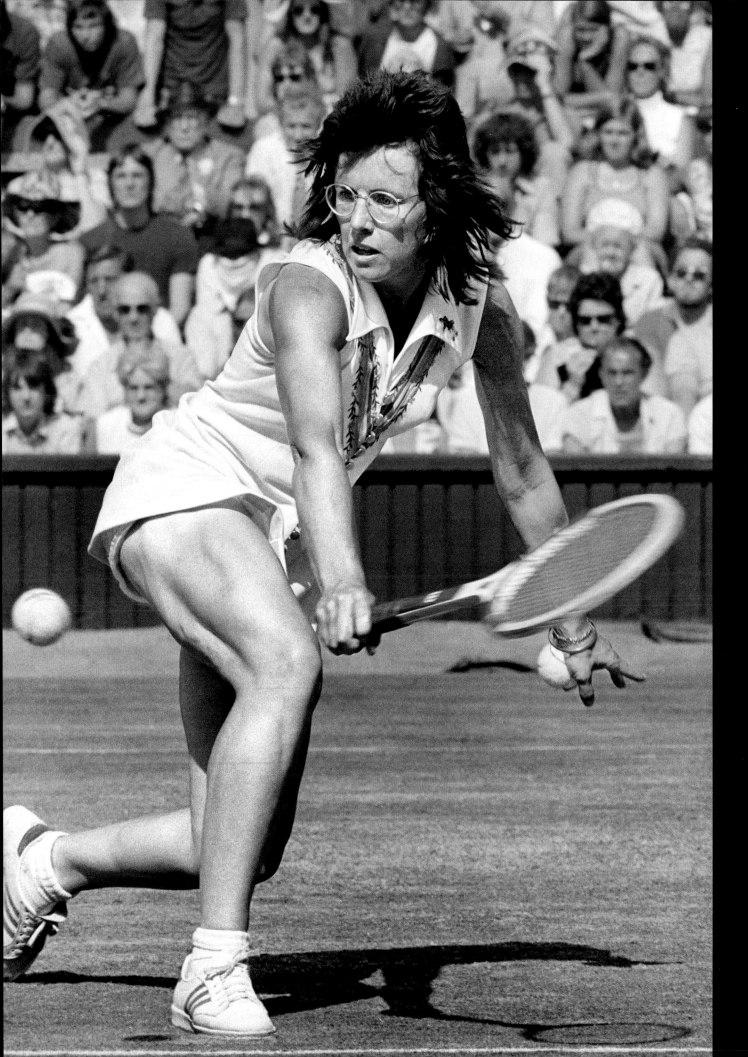

184 Billie Jean King began playing tennis when she was eleven. At fifteen, she was already a champion, and in 1961, she and Karen Hantze Susman set the record as the youngest woman players to win the doubles title at Wimbledon. While attending California State University Los Angeles she met Larry King, whom she married, taking his family name. Here she is competing at Wimbledon in 1973.

★★★★ FINAL | **DAILY ☺ NEWS** | 10¢
NEW YORK'S PICTURE NEWSPAPER ®

Vol. 55. No. 76 Copr. 1973 New York News Inc. New York, N.Y. 10017, Friday, September 21. 1973★ WEATHER: Sunny and cool.

BILLIE JEAN KING OUTLIBS THE LIP

Wallops Riggs in Straight Sets

**6-4, 6-3, 6-3,
And No Love
For Bobby . . .**

Billie Jean King gives former super-
man Bobby Riggs comforting pat on
back after she beat him, 6-4, 6-3, 6-3,
in their "Battle of the Sexes" at
in their "Battle of the Sexes" at
Houston Astrodome, last night. Billie,
29, took mere two hours and five min-
utes to destroy 55-year-old hustler's
myth of masculine superiority before
an exuberant crowd of 30,000 fans.

Stories on page 3

UPI Radiophoto

King is venerated by younger generations, including the millennials, has had a long rela-
tionship with her female life partner, has been inducted into the International Tennis Hall of
Fame, and was the captain of the American Olympic tennis team in 1996 and again in 2000.
In 2006, the stadium complex that hosts the US Open was renamed the Billie Jean King
National Tennis Center in her honor. In 2009, she became the first woman athlete to receive
the Presidential Medal of Freedom, the highest civil honor in the United States. Yet despite
all this, she has never stopped fighting for women's rights, which shows she really is a great
champion, with or without a racket.

185 The front page of the *Daily News* on September 21st, 1973, announces Billie Jean King's sensational victo-
ry against Bobby Riggs. Years after this world famous battle, she declared that with time she and Riggs ended
up becoming friends. Shortly before his death in 1995, they had had a telephone conversation and, reminiscing
about that extraordinary match, they said, "We really made a difference, didn't we Billie?" "Yes we did."

Zaha Hadid

She was the first true "star architect" in history. A globetrotter since she was a baby, for thirty years she redesigned the future of cities with the powerful curved shapes of her architecture, establishing her exuberant femininity in a "man's profession."

Zaha Hadid had a difficult temperament; she herself admitted that diplomacy was not her forte. But this woman, with a determined expression and magnificent dark eyes, had many other gifts and qualities. A pioneer in an almost totally male world, she was the first woman to win, in 2014, the prestigious Pritzker Prize, which is considered the Nobel Prize of architecture, as well as the Royal Gold Medal from the Royal Institute of British Architects. Hadid was a citizen of the world. When not even thirty years old, she had already lived in three countries and two continents. She traveled and moved about continuously, disseminating throughout the world architectural works that seemed to have arrived directly from the future and to have landed softly on the landscape, like a spaceship. In 1972, after earning a degree in mathematics at the American University of Beirut, Zaha Hadid began her journey into architecture, flying to London to build her empire, in the city she had chosen as her base. After studying with two superstars, Rem Koolhaas and Elia Zenghelis, she began working at their Office for Metropolitan Architecture (OMA) for a few years before starting her own independent practice, opening the Zaha Hadid Architects firm in 1980. She was already a celebrity, but for almost ten years she had a very small body of work. "You're an artist" or "You're okay for a girl" were typical comments she received for her projects. In the 1980s, women had a hard time establishing themselves. She once became very irritated during an interview, stating that it was assumed that women could not have an idea, while a man could not only have one but could also presume to be demanding.

Zaha Hadid in her London studio in 1985. It is in a former Victorian school building at Clerkenwell and is still one of the most important in the world, with a staff of 246 architects. In fact, even after her death her firm continues to create buildings and design collections in Hadid's hallmark in her deconstructivist style.

October 31st, 1950, Baghdad, Iraq • March 31st, 2016, Miami, Florida, United States

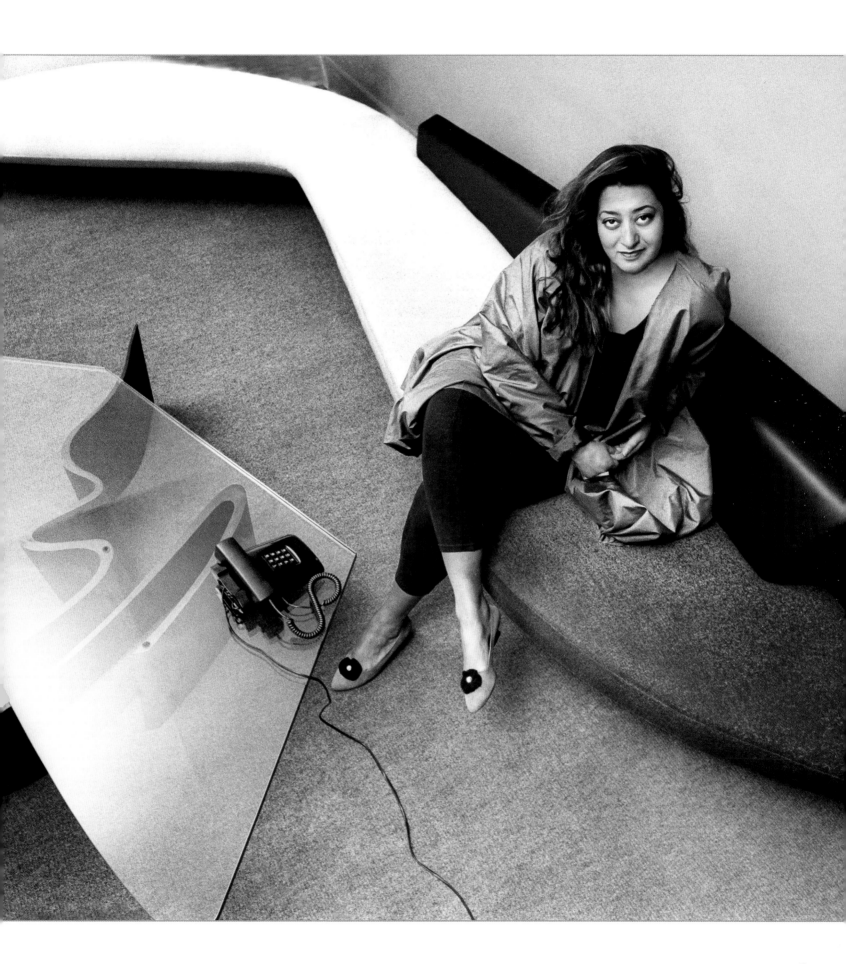

Her first international success arrived in 1993 with the Vitra Fire Station in Germany, and from then on she never stopped, designing, one after the other, dozens of spectacular constructions with audaciously curved lines, instinctive celebrations of the female figure. True visionary that she was, she had immediately understood the great potential of digital design as an indispensable resource to create her bold combinations of architecture, landscape, and abstract painting that technology could transform into powerful buildings, as well as such design objects as the Perrin Paris clutch bags, Cassina sofas, and Superstar shoes. Whether small or large, Hadid's creations all have a common denominator of an unmistakable touch of originality and extravagance, something comparable to the feeling one has when visiting a new country, as she explained in her raucous voice caused by thousands of cigarettes, impeccably dressed in the softly folding garments designed by Issey Miyake, one of her favorite stylists. She did not want a partner or children. Work was her creed. "I chose to do it this way. No compromises. I like children, really. But I couldn't have done both things together."

Among Zaha Hadid's most famous projects are the Guangzhou Opera House in China, the London Aquatics Centre built on the occasion of the 2012 Olympic Games, the MAXXI Museum in Rome, and the Bergisel Ski Jump in Austria. Here, Hadid is posing in front of the Riverside Museum of Glasgow, Scotland.

Benazir Bhutto

June 21st, 1953, Karachi, Pakistan • December 27th, 2007, Rawalpindi, Pakistan

She was head of the Pakistan government twice, the first woman premier in the Islamic world. Beautiful and rebellious, courageous but accused of corruption, she was a mixed bag of contradictions, exactly like her country.

"When I was a girl I was convinced that a woman could achieve any goal. It's true, but she must be ready to pay the price." And she paid the highest price; she was assassinated when only 54 years old while trying to realize her dream of making her country, Pakistan, a modern and democratic state. Like an ancient Greek heroine, she had followed the destiny marked out for her by her father, Zulfikar Ali Bhutto, who was hanged at the behest of the military government that had deposed him through a coup d'état. When the sentence was carried out, Benazir was 26, and she too was in prison. She saw her father for only a few moments before his execution, without knowing that he would be dead a few hours later, as she related in her poignant autobiography, *Daughter of the East*. Pakistan was her country, but her life was made up of departures and returns until she was sent to study in the United States and then England. "I was a very shy girl who led an insulated life; it was only when I came to Oxford, and to Harvard before that, that suddenly I saw the power of people. I saw the press attack the government, and it was then that I decided I would go back home to give my people the freedom of choice that I saw around me in the West." In 1988, Benazir Bhutto was elected the first woman in the Islamic world to head a government. She was loved by her people and considered an unprecedented enemy of Islam and the Pakistan military establishment: she was 35, beautiful, modern, and emancipated. While Benazir was in power she made quite an effort to help women, who were still under the yoke of the economic power, wielded by men in a profoundly conservative country, and she committed herself to the emancipation of her gender through education and employment.

Benazir Bhutto in 2007, a few months before her assassination. The mother of three children – Bilawal, Aseefa, and Bakhtawar – she always wore traditional clothes made of colored silk, her head always covered with a white veil. Her age and many worries have hardly affected her beauty.

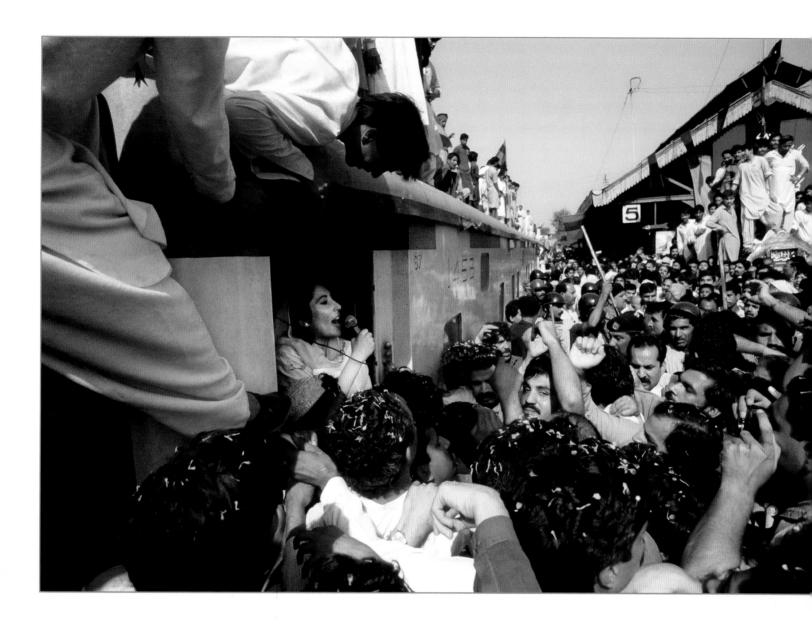

192 A photograph taken on October 18th, 2007. Benazir Bhutto had just returned to Pakistan after a long period of exile and was heading to the venue of her first public appearance, with thousands of her supporters acclaiming her along the streets, when two huge explosions struck the procession, killing around 140 persons but did not touch her.

193 Benazir Bhutto speaking to a crowd from the carriage of a train in Punjab province, in November 1988. A few days later, she was elected Prime Minister. Accused of corruption, she was deposed in 1990. During the trials, the role played by her husband, Asif Zardari, appeared to be very controversial. He was called Mister 10% in Pakistan, alluding to his presumed embezzlement of public funds.

Benazir Bhutto

She was deposed in 1990 owing to more or less well-founded accusations of corruption (the same that also ended her second term of office in 1996). Benazir spent the following eight years in self-imposed exile, in both Dubai and London, with her three children. Then the United States government persuaded the Pakistani government to hold free elections and allow Bhutto to return. She agreed, though well aware of the dangers she would face, "because I'm an optimist and one must always try," she said. But her return in 2007 ended in a bloodbath: an attack against her rally and cavalcade led to the death of dozens of persons, including Benazir. Beautiful and courageous, she had always been targeted by Islamic fanatics because she was for women's rights and was a symbol of democracy that respected religion but was secular, and the period of exile had made her even more determined and liberal. "A ship in the harbor is safe, but that's not what ships are built for," Benazir explained, and her example inspired all women who are oppressed.

The crowd surrounds Benazir during her visit to the home of one of the victims of the attempted assassination in October 2007 that she survived unscathed. But in December that same year, at the end of a rally, she was killed by two bullets while was waving to her supporters by standing through the sunroof of an armored jeep. The suicide bomber then blew himself up next to the vehicle, killing 25 other persons.

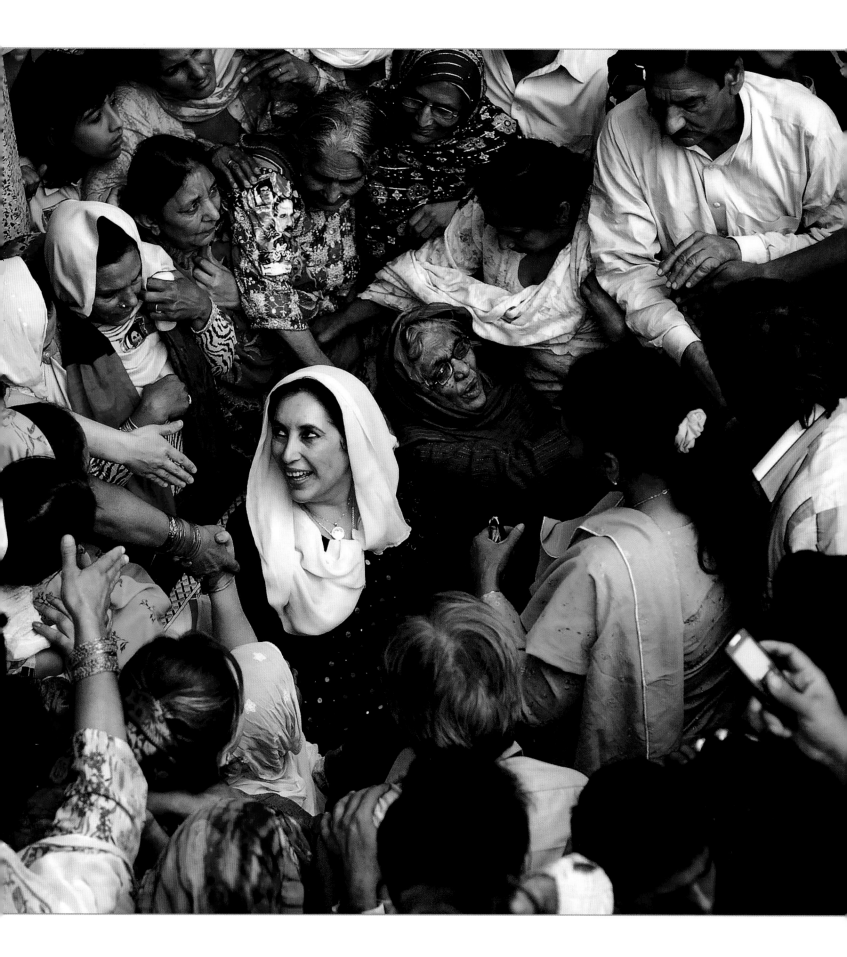

195

Christiane Amanpour

She wanted to be a physician but didn't pass the examination, so she became the highest paid war correspondent in America. After years along the front line, she now describes war from the TV studios, because "when you have a child it is your duty to stay alive."

CNN's chief international correspondent followed the Gulf War, the revolutions in Eastern Europe, the Balkans, Somalia, and the Katrina hurricane; she has interviewed Ahmadinejad and Mubarak and has reported many other major, and often extreme, stories in real time. She did all this with the determination to show reality to the world, as well as the fear of being killed, as she confessed several times. Christiane was born in England and grew up in Teheran, raised by her Iranian Muslim father and British Catholic mother ("I'm an immigrant," she often points out). When she was a girl, she dreamed of becoming a doctor but ended up studying journalism in the United States. All things considered, for her the two professions are not really that distant: "A Red Cross doctor is like a reporter at the front," she stated in an interview. "Naturally, it's not the same thing; they have lives in their hand, but we have the truth, war and peace." Her being a woman never put her at a disadvantage in the field of war correspondence, which is a man's world. On the contrary, she was able to go to places that were inaccessible to men and benefit from their initial underestimation, as she declared. Amanpour was able to establish herself, becoming the highest paid journalist in America and earning a place as one of the 100 most influential women in the world, according to *Forbes* magazine. In this neck and neck competition with her male colleagues, Amanpour always managed to push hard without losing a drop of her femininity. And she was so sure of her intelligence and credibility that she could maintain her authority even when she confessed her preference for Tom Ford's suits ("I would not wear them in the field, obviously, but I do wear them when I'm in the studio and to interview heads of state.") and the Tod's boots that she has worn since the Bosnian war and has always considered her good luck charm.

In the course of her career, Christiane Amanpour has won a great many prizes. In October 2010, she became a fellow of the American Academy of Arts and Sciences and also received a Commander in the Most Excellent Order of the British Empire award from Queen Elizabeth for her highly distinct and innovative services to journalism. In 1998, the city of Sarajevo made her an honorary citizen for her exhaustive coverage of the war in Bosnia.

January 12th, 1958, London, United Kingdom

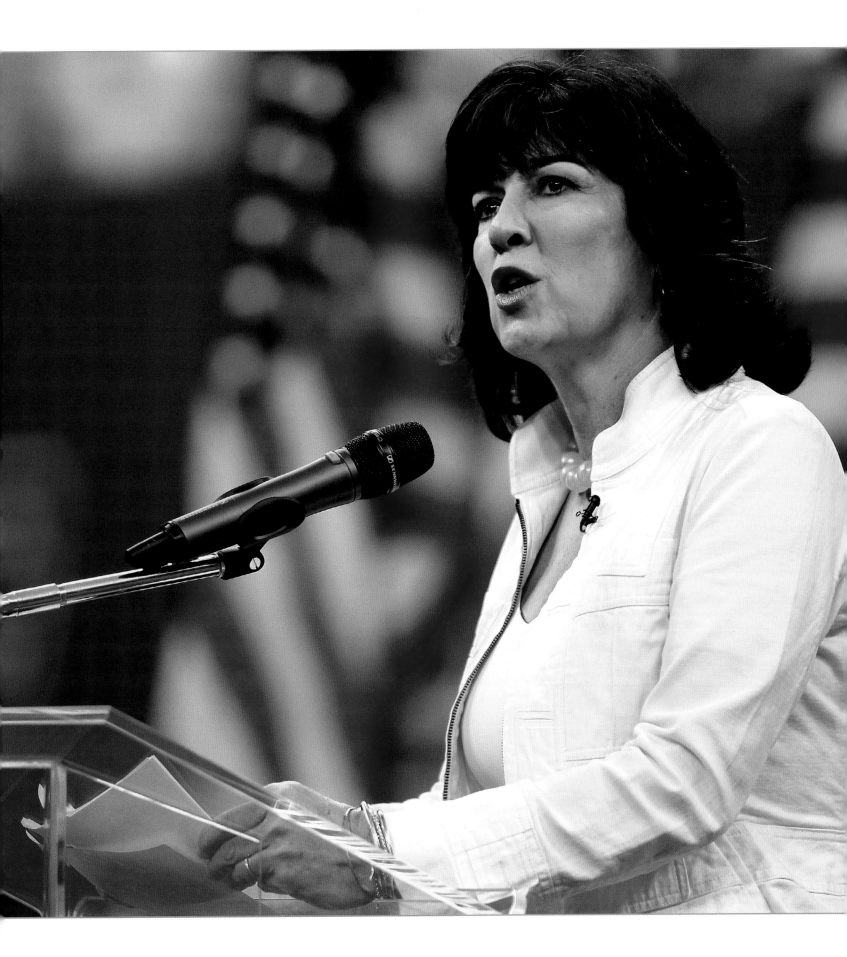

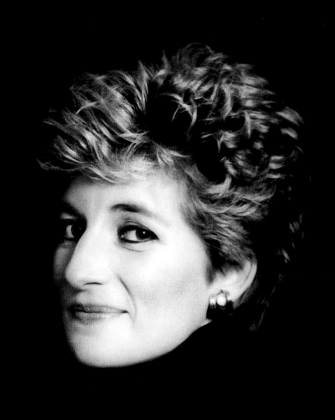

Diana Spencer

July 1st, 1961, Sandringham, United Kingdom • August 31st, 1997, Salpêtrière, Paris, France

Equally at ease on the cover of *Vogue* and in the minefields of Angola, the Rose of England upset the British monarchy and enchanted the world before her tragic, untimely death in an automobile accident, which ironically was caused by her very own obtrusive popularity.

For all young women, a wedding is the most wonderful day of their life. Who knows whether Diana Spencer had the same idea while entering St. Paul's Cathedral to marry the heir to the British throne. Veiled in a cloud of white silk of a dress that is every bride's dream, this timid 20-year-old with a dubious smile certainly could not imagine what was in store for her. She was welcomed at the court by rigid and old-fashioned protocol, a cold husband and hostile queen. Outside were the media, always ready to breathe down her neck and pry into her private life to find something they could splash on the front page. Overnight, Diana became Lady D, the most famous (and most photographed) woman in the world, the woman who danced with John Travolta in the White House and bared her soul to Elton John. But she was also the betrayed wife who spoke quite openly on television about her marital problems, causing a split in public opinion between those who admired her frankness and those who accused her of giving the dignity of the royal family to the lions. With time, Diana became beautiful, even glamorous, without losing a bit of the spontaneity that made her an affectionate mother always taking care to show her children the reality of the world. "I want my boys to have an understanding of people's emotions, their insecurities, people's distress, and their hopes and dreams," she said during an interview, adding that she had chosen not to wear gloves during official meetings, disregarding etiquette, because she could make immediate contact with the person whose hand she shook. It was precisely with apparently small gestures like this that Diana succeeded, perhaps unintentionally, in modernizing the image of an antiquated monarchy and retaining the title of "the people's princess" (as Tony Blair called her) even after divorcing Prince Charles. While her private life was dotted with affairs, her public image became that of a tireless activist who went to the minefields in Bosnia and

Diana was ill at ease and somewhat ungainly the first years of her marriage, but later became an icon of style partly thanks to the help afforded by leading fashion designers. One of these was her friend Gianni Versace, who helped her to highlight her femininity. Lady D is seen here in a photograph taken by Gemma Levine on 27 September 1994.

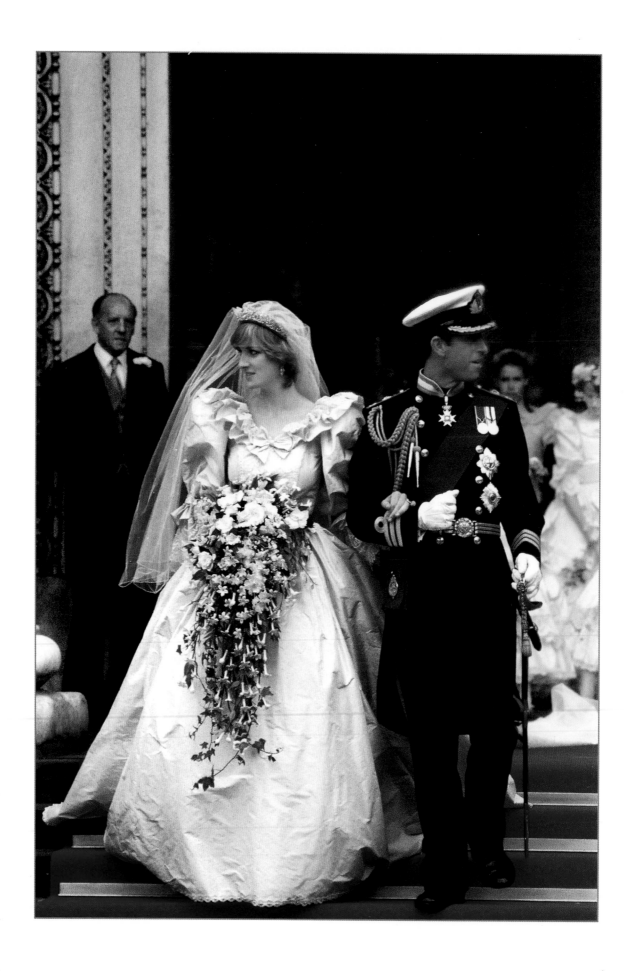

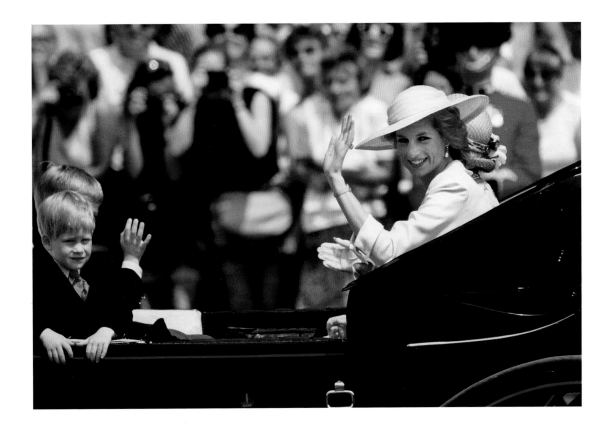

Angola, to India to speak about the fight against poverty, and in Africa to warn the world about the spread of AIDS. In 1992, she met Mother Teresa for the first time and supported her cause, even posing for photographers while touching and comforting lepers in Calcutta, just as she had done with the victims of AIDS, to demonstrate that there is no need to be afraid of those suffering from these diseases. "I am not welcoming a princess, but a young woman in difficulty, anxious to do good works and strengthen her faith," Mother Teresa said of her. When the Pont de l'Alma tunnel in Paris swallowed the lives of Diana and her companion Dodi Al-Fayed, the entire world stood still, and the area outside Kensington Palace became a huge field of flowers watered by the tears of a mass of shocked and deeply moved people.

200 Diana and Charles leaving St. Paul's Cathedral in London after their wedding on July 29th, 1981. She was wearing an ivory taffeta gown designed by the English stylists David and Elizabeth Emanuel, with antique lace and a train almost 26 feet (8 m) long. The ceremony had worldwide satellite coverage that was followed by 800 million spectators.

201 June 17th, 1989: the Princess of Wales with her sons William and Harry passing in a carriage among the crowd during the Trooping the Colour parade in London. "She was our mother and she still is. For us she was the best mum in the world. She smothered us with love, that's for sure," the princes declared during a moving interview on the BBC to commemorate the 20th anniversary of Diana's death.

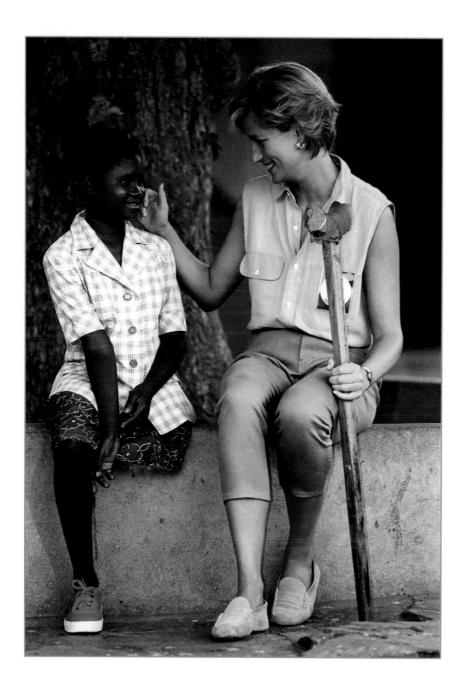

202 and 202-203 Diana in Angola in January 1997. The country was destroyed by twenty years of civil war, and millions of landmines were scattered a bit everywhere. Diana strongly supported the eradication of minefields, just as she had done in Bosnia. She did not limit her contribution to merely posing for photographs, but actually risked being hurt by walking in single file together with deminers in fields that had been only partially cleared and by meeting the victims of the explosions. While speaking about her commitment to humanitarian projects, she said: "I don't consider myself the queen of this nation. I'd like to be a queen in people's hearts."

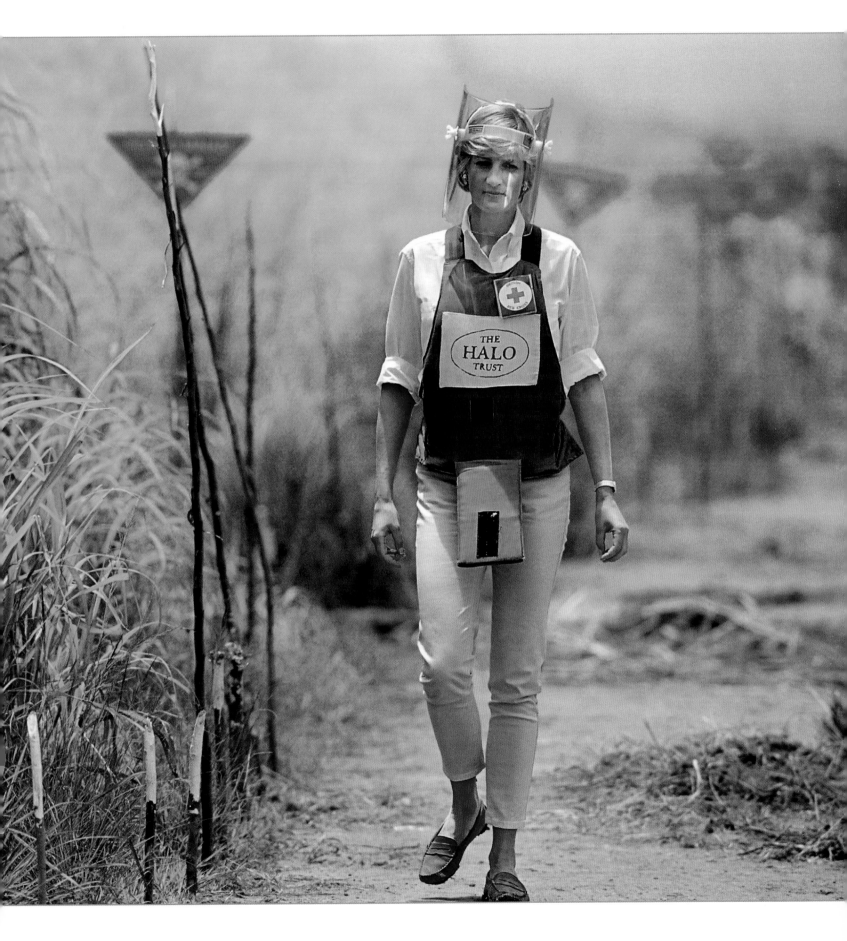

Samantha Cristoforetti

A steely character, nerves of titanium, and a high-tech heart. With her *@AstroSamantha,* she shared her adventure in space with the world, but she passed the medical exam to enter the ESA by a hair's breadth, since her height of 5 ft 4 in (165 cm) was just above the minimum allowed.

Two lives are not enough to have a résumé like hers. She earned a degree in Mechanical Engineering (specializing in aerospace propulsion) at the Technical University of Munich, and in Aeronautics Sciences in Naples. Then there is her experience in Euro-NATO Joint Jet Pilot Training in Texas, and the fact that she is licensed to pilot various types of aircraft. Besides Italian, she also speaks German, French, English, and Russian. She has been awarded the Knight Grand Cross and the Commander of the Italian Republic Order of Merit. What's more, she holds a record that is all her own: according to all the surveys, Samantha Cristoforetti represents the ideal female model for the majority of Italian girls. But she plays this down: "An astronaut is not a genius, but one who knows how to get about everywhere and how to do a bit of everything." Modest but blunt, when in 2009 she became a European Space Agency astronaut, being one of the six persons chosen from among 8500 candidates, she immediately replied to those who asked her if she felt the weight of being a woman in a field almost totally dominated by men: "For me there's no difference between males and females. Here I'm a lieutenant, soon I'll be the astronaut Cristoforetti. The only difference is between those who are competent and those who are not."

Samantha Cristoforetti is quite reserved as regards her private life. She gave birth to a girl, Kelsey Amal, in November 2016. Here she is preparing for her space mission at the Gagarin Cosmonaut Training Center at Star City, near Moscow, in December 2013.

April 26th, 1977, Milan, Italy

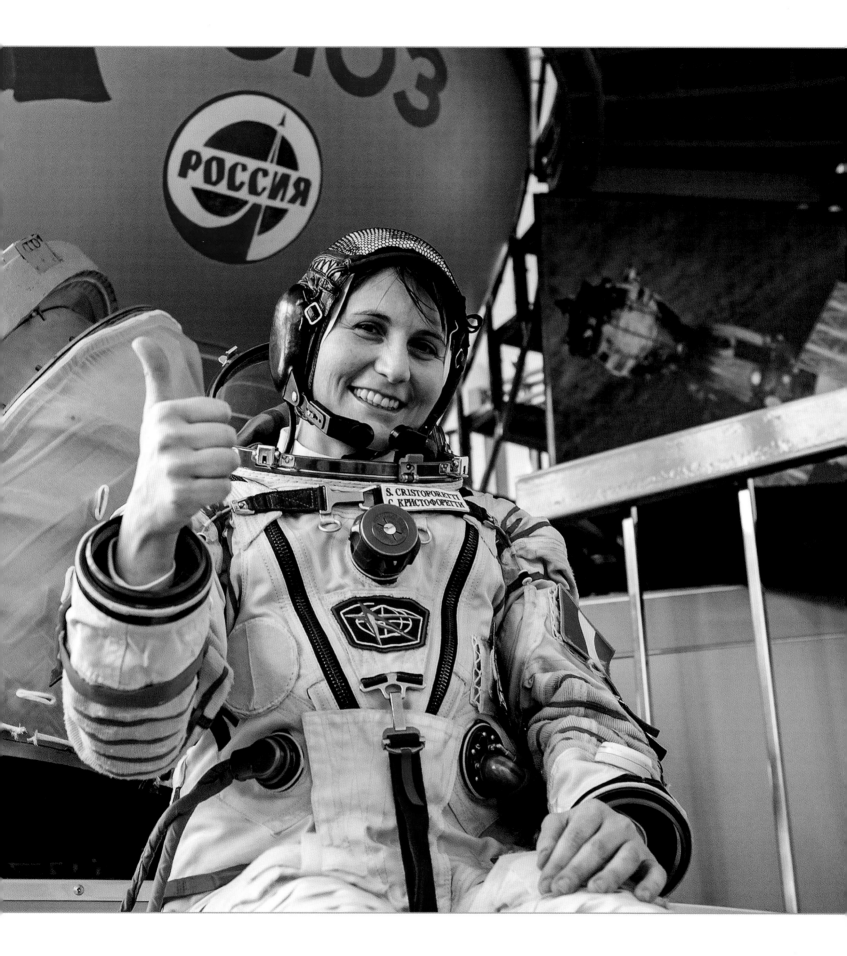

Five years later, on November 23rd, 2014, she boarded a Soyuz spacecraft that went to the International Space Station and was so relaxed and nonchalant as she said goodbye to Earth that it was as if she were at home in her living room. During that 199-day trip in space – which covered more than 80 million miles (130 million km) – she was constantly in contact with the world through social media, giving interviews and tweeting photographs and updates that attracted a great number of followers, who were captivated not only by her courage and professional competence, but also by her cheerful resourcefulness – always with a dash of her typical reserve. And no sooner did she return from her mission than she withdrew into almost absolute silence, interrupted only by the occasional declaration: "I am not and do not want to be a celebrity. Astronauts are not professional celebrities, we merely relate our assignments and the experiences we were fortunate enough to have."

After spending 199 days in space, Samantha Cristoforetti and the Russian commander Anton Shkaplerov landed at Kazakhstan on June 11th, 2015. They both wore the famous Sokol ("falcon" in English), the well-known white and blue pressure suit made in Russia and used in the most delicate phases of space missions, takeoff and re-entry.

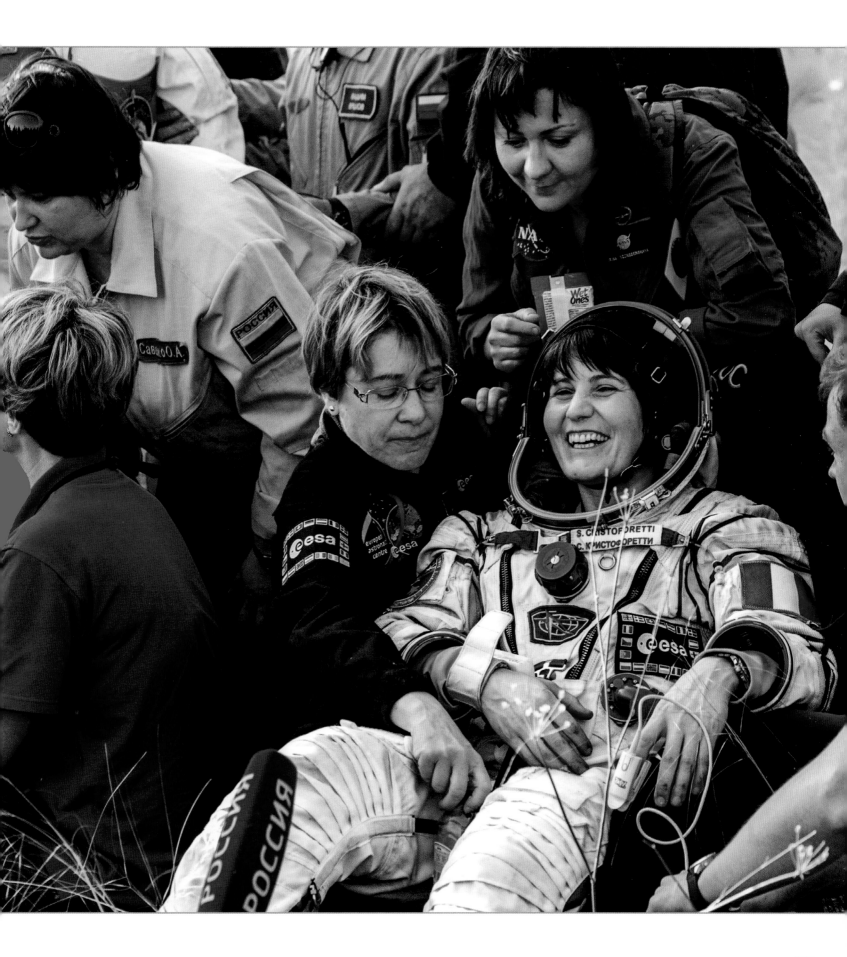

Misty Copeland

She was a homeless child, and now she's the star of the American Ballet Theatre, based in New York – an authentic black swan who won her battle against poverty and prejudice, overcoming barriers with her engaging smile and masterful pirouettes.

To see her now, twirling on the stages of half the world, no one could even imagine that this dance star grew up in a very poor Missouri family and slept in motel rooms with her mother and five siblings. Even more surprising is that she discovered ballet when she was thirteen, an age considered much too old to begin to embark on a classical dance career. But she had plenty of talent, as well as remarkable willpower. Indeed, in only three months Misty was already dancing on the tips of her toes, and many people, first of all her dance instructor, immediately bet on her and gave her free lessons and clothing. She later said that when she wore the right things and had mirrors she could see herself in, the feeling was staggering. "I'd never experienced anything like that." After training for three years, she began to win prizes, and then the great moment arrived – the starring role as Firebird in the Stravinsky ballet of the same name choreographed by the Russian Alexei Ratmansky. The evening of the performance at the Metropolitan Opera House of New York, Misty immediately knew something important was happening: "I had never seen an audience that was 50% African American. It was overwhelming to know that so many of them were there to support what I stood for." When she was 17, a scholarship gave her the chance to work with the American Ballet Theatre, where she was a student and then rapidly made her way up to the ballet corps until she became principal ballerina in 2015.

As beautiful as a fairy tale, Misty Copeland's story is related in her autobiography, *Life in Motion: An Unlikely Ballerina*, a best seller that is about to become a Hollywood movie. Much has been said about her "curvy" body, which when viewed up close is something quite different. Five feet two inches (1.58 m) tall, Misty Copeland is lithe and toned, an athlete on loan to ballet, with broad shoulders and a large bust. This photograph shows her performing at the John F. Kennedy Center for Performing Arts in Washington, D.C., on December 7th, 2014.

September 10th, 1982, Kansas City, Missouri, United States

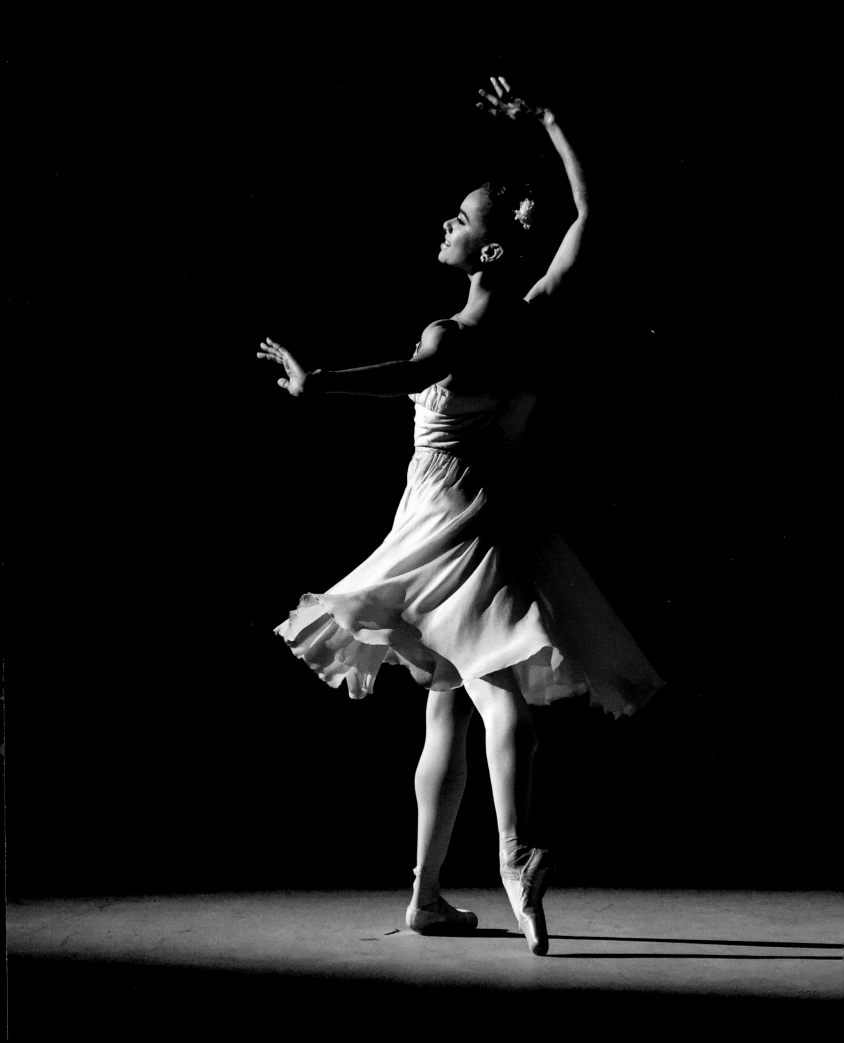

Misty tore down all the racial barriers one by one, defying prejudices and the iron-clad aesthetic canons that demanded only lily-white ethereal dancers who were virtually anorexic, in keeping with the criteria imposed by choreographers like George Balanchine in the last century. In a BBC interview, she declared that people are so used to a certain type of ballerina for specific roles that they find a "black swan" incredible. True, the times are changing, yet Misty is still an exception. She once stated that she had not been totally prepared to be the only African American in the American Ballet Theatre in the last twenty years. "The realization that so very few persons of color are in the world's most important dance companies was the biggest shock I had to deal with in my career. I believe there must be more diversity in all spheres – on the stage, in the audience, in the management – and that the new generations should be pointed in this direction." She certainly did her part, partly thanks to the publicity of a sports clothes brand. The title of the ad was "I will what I want," and Misty was filmed while practicing, with a little girl's voiceover reading the rejection letter she had received from a small dance academy. The video went viral and chalked up millions of contacts; Barack Obama and Beyoncé called her a role model; *Time* magazine chose her as one of the 100 most influential persons in the world. And Misty has become the embodiment of a dream, as well as the idol of young African American girls searching for an inspiring example in a society that is still much too white.

The new Barbie has Misty Copeland's face and body and wears the same red costume she wore in *Firebird*, her first leading role. The doll is part of the *Sheroes* collection, which also has reproductions of Ave DuVernay, Zendaya, and Emmy Rossum. Here, Misty is dancing in *Don Quixote* at the Metropolitan Opera House of New York, on May 16th, 2017.

Laura Dekker

Dolls? No way. Armed with courage, determination, and passion, this teenager with the sea in her veins is the youngest person to sail around the world alone.

She was born in a boat, and this is no metaphor. Laura Dekker came into this world in the harbor of Whangarei, in New Zealand, while her parents, who are expert sailors, were sailing between the Indian and Pacific oceans. Laura spent the first four years of her life in the sea, landing only occasionally before settling down on dry land in Holland. But the call of the waves did not wait long to tempt her again. When she was six, she asked for her first boat as a birthday present, an Optimist, which she learned to pilot by herself, coping with waves, knots, and a few capsizes. Then she received a new and larger "toy," a two-mast, 38-foot (11.5 m) ketch that she called Guppy. With that sailing boat, Laura realized her dream and set an astounding record for her age (she was only 16 years old), circumnavigating the globe by herself. To accomplish this amazing feat, she had to battle against waves ten times her height and strong contrary winds, and, above all, against the bureaucratic complications imposed on her. Despite the total support of her parents, the Dutch social services declared their opposition to the project; at that age, they stated, one goes to school and not all alone on a sailing boat. But Laura, besides being brave, is also stubborn, and after a nerve-racking legal battle, she finally succeeded in setting sail from Gibraltar on August 21st, 2010, and sailing 27,000 miles (more than 43,000 km) in 518 days – all by herself, in all sorts of conditions and at all latitudes. One concession was made to ensure her safety: her navigation was not to be continuous but divided into various stages. Laura documented her feat with a video camera, filming herself during her stops in the Galapagos Islands, Australia, and South Africa while preparing a meal ("Ravioli are not fit for the sea in a gale," she said with a wink), repairing the sailboat and observing the dolphins that accompanied her on her journey, making her feel a bit less lonely.

Laura on board her sailboat *Guppy*. After completing her round-the-world voyage, she continued to sail, establishing her base in New Zealand. In 2017, she donated her famous boat to a nonprofit Los Angeles organization, LifeSail.

September 20th, 1995, Whangarei District, New Zealand

214 Laura leaving the harbor of Den Osse, Holland, on August 4th, 2010. The first stage of this trip, with her father on board, was planned to test the boat by navigating to Portugal. Her circumnavigation of the globe, heading westward, began officially from Gibraltar on August 21st, 2010.

215 In order for Laura to meet her scholastic obligations, the Wereldschool, an institute specialized in correspondence education, provided her with textbooks so she could study on her own, but she never managed to graduate from high school. However, after passing a series of examinations, she was accepted in a New Zealand university.

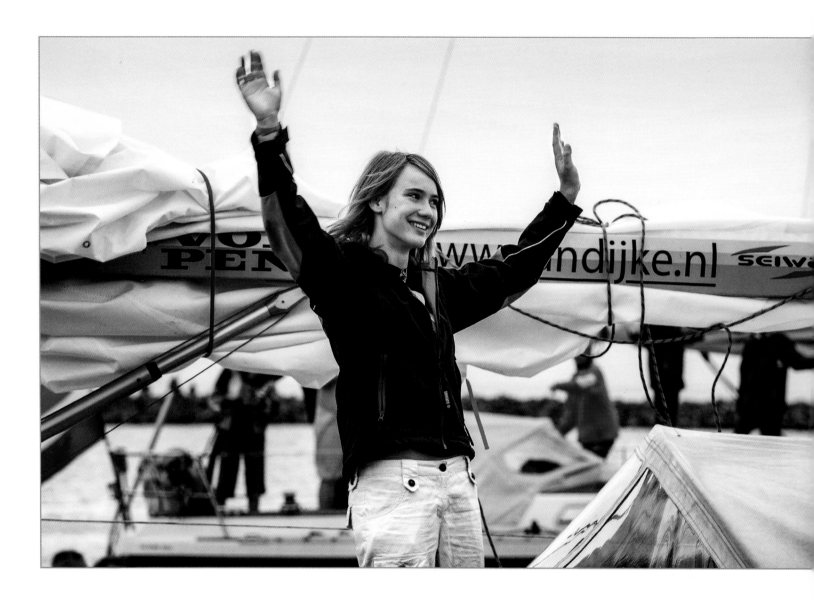

On January 21st, 2012, this yachtswoman, at the age of sixteen years, four months and one day, concluded her long crossing when she reached the harbor of Saint Maarten Island in the Caribbean Sea. Neither the Guinness World Records nor the World Sailing Speed Record Council recognized her record (the latter organization's justification was: "For us it is speed that counts; the competitors' age is not grounds for a record"). So it was up to true sea dogs , the Ocean Cruising Club, an international organization of ocean sailors, to reward Laura for her astounding accomplishment. The official motivation cited when they presented the Award of Merit to her was: "For her courage and determination in sailing 1.5 times around the world, all for the love of sailing."

education?" she asked in the posts she wrote for the BBC, documenting the conditions in which children had to live under the regime. She was only eleven years old, and her activism caused a sensation, but it also inevitably aroused the fury of the Taliban, who decided to murder her. It is truly incredible that anyone should resolve to harm a little girl, yet on October 9th, 2012, the unimaginable occurred. They shot her in the head as she was leaving school. While the terrible news of the attack was spreading throughout the world, Malala was battling for her life. A steely temperament and an infinite number of operations helped her to get on her feet again, and on her sixteenth birthday, her voice resounded in the United Nations General Assembly hall, where she gave a moving speech to the UN Secretary Ban Ki Moon, the delegates and 400 young persons. "Let us pick up our books and our pens, they are our most powerful weapons. A child, a teacher, a pen and a book can change the world." While she was speaking, Malala knew that the Taliban had sworn revenge, but she always said she was not afraid any longer: "When they shot me, weakness, fear and hopelessness died." And she added, "With that shot strength, power and courage were born. Their bullets will not reduce me to silence."

Malala Yousafzai, the Pakistani activist and 2014 Nobel Peace Prize winner, had always dreamt of being able to study at Oxford University. In August 2017, she was able to enroll there, where she now studies Philosophy, Political Science, and Economics. At right, Malala during the inauguration of the new Birmingham Library on September 3rd, 2013.

July 12th, 1997, Mingora, Pakistan

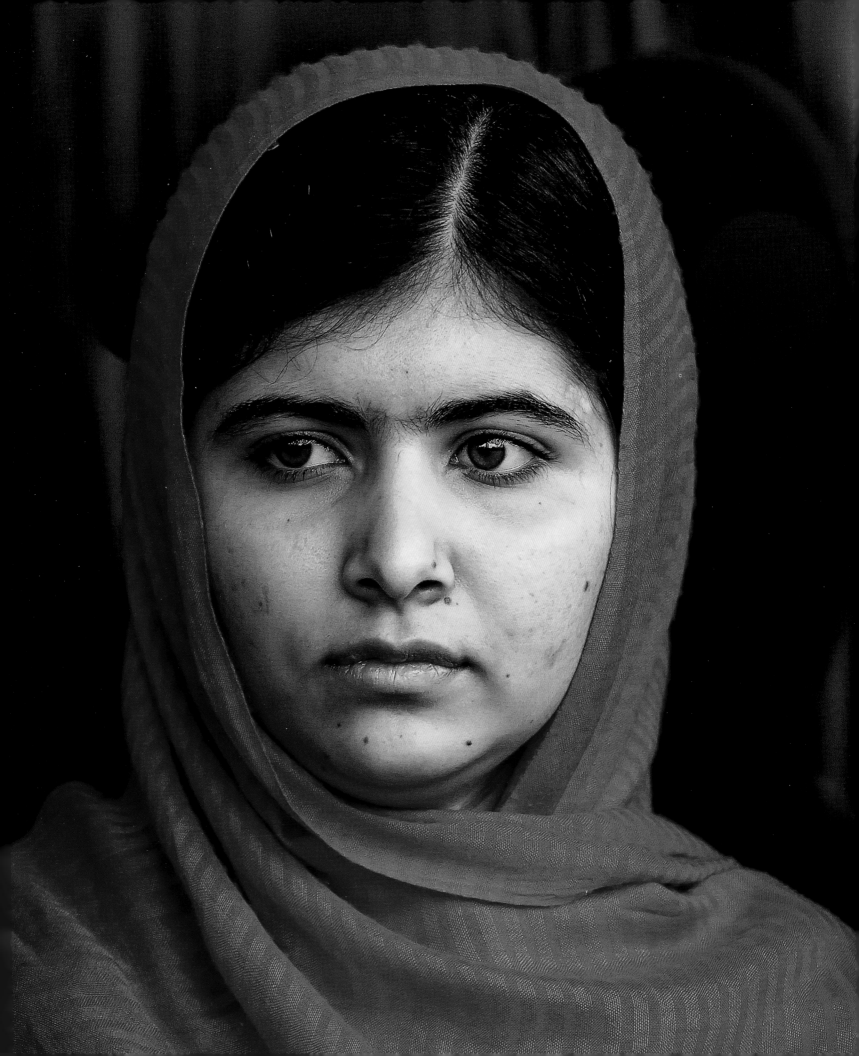

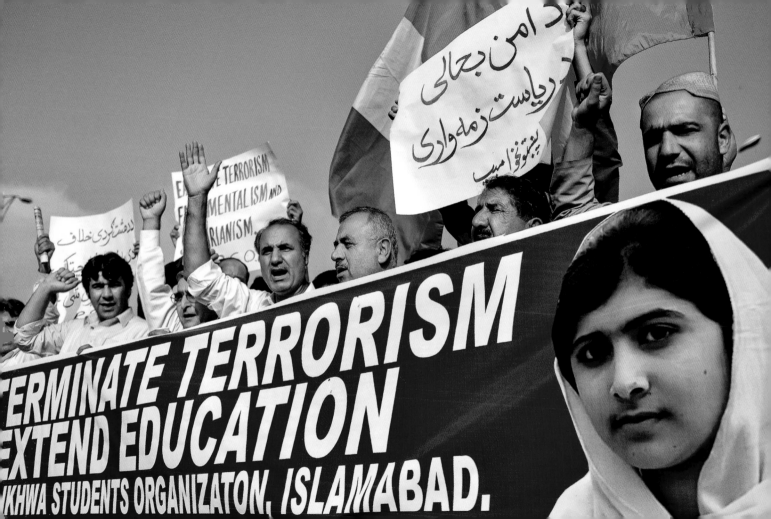

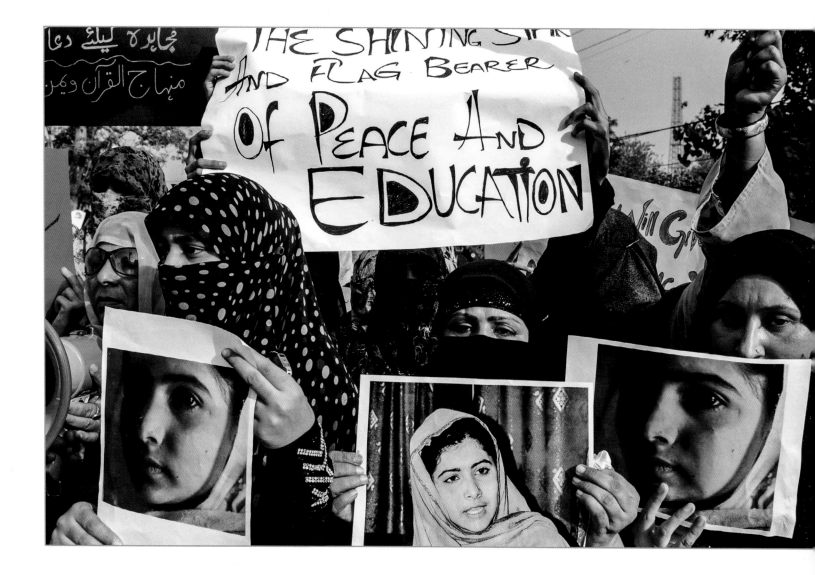

According to Malala, the roles have been reversed, and now it is the Taliban who fear her: "The power of education frightens them. They are afraid of women. This is why they kill, why they are afraid." Her courage was rewarded with the prestigious Nobel Peace Prize in 2014, when Malala was only seventeen, which made her the youngest Nobel laureate. She was named the United Nations Messenger of Peace, with the task of promoting girl's education. A year later, through her fund, she celebrated her eighteenth birthday by opening a school for Syrian refugees in Lebanon, clarifying once again the priorities to create a better world: "I ask world leaders to invest in books, not bullets." Instead of eliminating her, the Taliban made Malala an international figure, the loudest sounding board to denounce their evil abuse of power. In social network language, we would call their attempted murder an epic fail.

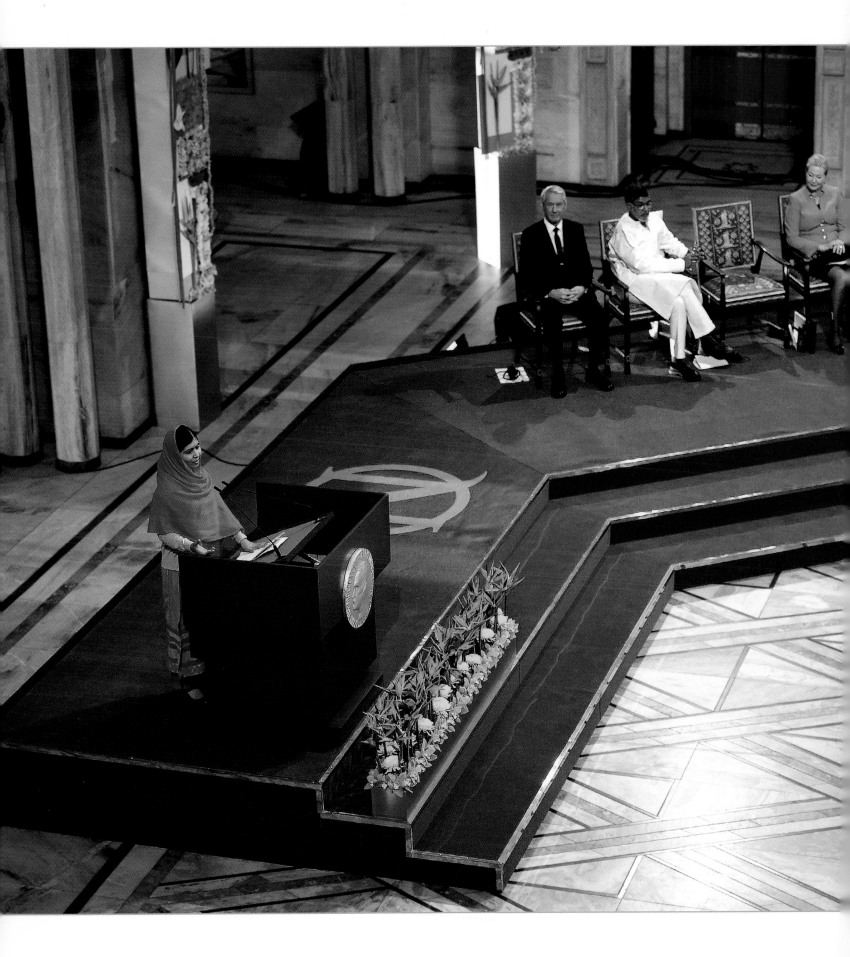

Malala Yousafzai giving her speech during the Nobel Peace Prize award ceremony at Oslo on December 10th, 2014. She was seventeen years old and is still the youngest person to receive this award, which she shared with the Indian activist Kailash Satyarthi, who at that time was sixty and also was rewarded for his activity against child slavery and labor.

The Author

Chiara Pasqualetti Johnson, is an Italian of English origin who lives and works in Milan. After earning a degree in Art History at the University of Milan, she began writing for the love of it and then decided to make it her career. She has been active in journalism for fifteen years, writing accounts of the lives of contemporary artists for the monthly *Arte* and book reviews for the periodical *Antiquariato*. Johnson is also a correspondent for *Dove* magazine, contributing travel and lifestyle articles, and has edited books and series concerning modern and contemporary art for the important publishing houses.

Photo Credits

Cover - Top from the left: Granger Historical Picture Archive/Alamy Stock Photo, Mondadori Portfolio/Getty Images, Anders Tukler/ Alamy Stock Photo/IPA, Lipnitzki/Roger Viollet/Getty Images, Frans Dupont/Anne Frank-Fonds Basel/Getty Images, MARCO DE SWART/AFP/Getty Images, Bettmann/Getty Images, Wendy Stone/ Corbis/Getty Images, Oscar Graubner/The LIFE Images Collection/ Getty Images, Bandeep Singh/The India Today Group/Getty Images, Granger Historical Picture Archive/Alamy Stock Photo, Christopher Furlong/Getty Images, Terry Smith/The LIFE Images Collection/Getty Images, Sharland/The LIFE Images Collection/ Getty Images, ullstein bild/ullstein bild/Getty Images, Arnold Newman/Getty Images, Bettmann/Getty Images, Keystone-France/ Gamma-Keystone/Getty Images, American Stock/Getty Images, Fred Kaplan/Sports Illustrated/Getty Images, Imagno/Getty Images, Michael Ochs Archives/Getty Images, Barbara Morgan/Getty Images, Carlo Bavagnoli/The LIFE Picture Collection/Getty Images, Keystone-France/Gamma-Rapho/Getty Images

Back cover - Top from the left: BOTTI/Gamma-Keystone/Getty Images, Bettmann/Getty Images, AFP/Getty Images, ullstein bild/ ullstein bild/Getty Images, Christopher Pillitz/Getty Images, World History Archive/Alamy Stock Photo, Nick Laham/Getty Images, Bentley Archive/Popperfoto/Getty Images, Granger Historical Picture Archive/Alamy Stock Photo, KEYSTONE-FRANCE/Gamma-Rapho/ Getty Images, Peter G. Veit/National Geographic Creative, Alfred Eisenstaedt/The LIFE Picture Collection/Getty Images, Bettmann/ Getty Images, Bettmann/Getty Images, Hulton Archive/Getty Images, Michel Artault/Apis/Sygma/Sygma/Getty Images, ullstein bild/ ullstein bild/Getty Images, IanDagnall Computing/Alamy Stock Photo/IPA, Alexandra David-Neel © Ville de Digne-les-Bains, Gemma Levine/Hulton Archive/Getty Images, Bettmann/Getty Images, Granger Historical Picture Archive/Alamy Stock Photo, Kevin Mazur/ WireImage/Getty Images, Bettmann/Getty Images, Universal History Archive/UIG/Getty Images

WS White Star Publishers® is a registered trademark
property of White Star s.r.l.

© 2018 White Star s.r.l.
Piazzale Luigi Cadorna, 6 - 20123 Milan, Italy
www.whitestar.it

Translation: Richard Pierce

ISBN 978-88-544-1306-1
1 2 3 4 5 6 22 21 20 19 18

Printed in Italy by Rotolito - Seggiano di Pioltello (Milan)